Johnny Depp

Anatomy of an Actor	

Johnny Depp

Corinne Vuillaume

Introduction 6

1 Cry-Baby 16
Cry-Baby (1990)
John Waters

2 Edward Scissorhands 30
Edward Scissorhands (1990)
Tim Burton

3 Axel Blackmar 46
Arizona Dream (1994)
Emir Kusturica

4 William Blake 60
Dead Man (1995)
Jim Jarmusch

5 Raphael 78
The Brave (1997)
Johnny Depp

6 Raoul Duke 92
Fear and Loathing in Las Vegas (1998)
Terry Gilliam

7 Jack Sparrow 106
Pirates of the Caribbean (2003)
Gore Verbinski

8 John Dillinger 124
Public Enemies (2009)
Michael Mann

9 The Mad Hatter 142
Alice in Wonderland (2010)
Tim Burton

10 Tonto 156
The Lone Ranger (2013)
Gore Verbinski

Conclusion 171
Chronology 174
Filmography 178
Bibliography 184
Notes 186
Index 190

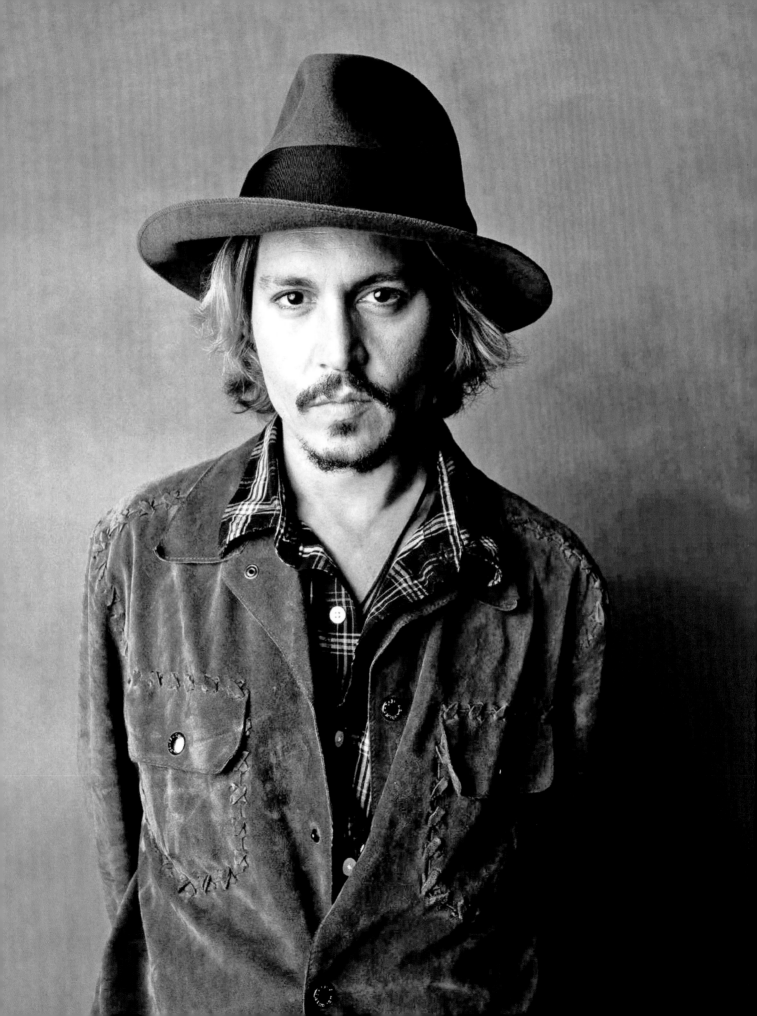

Introduction

Assuming the defining feature of being an actor is to be seen, Johnny Depp's biggest paradox may be his continuous wish to avoid the camera, with the aid of prosthetics, make-up and costumes, but also in roles that are seldom pretentious or academic, playing 'against type', as lover, absent nephew or father, uncompromising hero, sad clown, fugitive or ghost. Or, with his taste for animated films and documentaries, letting his young Adonis-like face recede in favour of his voice alone, as in *Corpse Bride* by Tim Burton in 2005, and, in 2009, as the narrator of *When You're Strange*, a film about The Doors, by Tom DiCillo. Depp's acting is often soft, non-verbal, devoid of tears or violence. His story is essentially that of a handsome guy who dreamt of being a freak, a Hollywood actor who wanted more than anything to be a musician and a poet, and who finally designed and shaped himself as a zany creature, a unique model, at the heart of the establishment.

Becoming someone

John Christopher Depp was born on 9 June 1963 in Owensboro, Kentucky, the youngest in a family of four children. His father, John Depp Senior, was an engineer and his mother, Betty Sue, a waitress in the café round the corner. She swore like a trooper and chain-smoked. She and his beloved grandfather, whom Depp lost at the age of nine, were his biggest influences, as was his maternal great-grandmother, of Cherokee or Creek ancestry. The future actor had German and Irish roots too, but it was predominantly the family's moving around that marked his personality. He grew up in a typical 1960s American suburb. When he was seven, the family left Kentucky for Florida and settled in Miramar, a working-class town, which in the actor's own words 'was like Endora, the town in *What's Eating Gilbert Grape* [the 1993 Lasse Hallström film in which Depp played the title role]. It had two identical grocery stores opposite each other and nothing much ever happened there'.[1]

The family constantly relocated and had to sleep in motels. When Depp was fifteen, his parents divorced. For his mother, for whom it was a second marriage, the process was painful. The actor remembers his parents' endless arguing and his mother's despair. He went off to live with her, and, in the absence of a paternal figure, the ordeal brought Depp and his mother very close. To honour his heritage, he had the picture of a Native American tattooed on his right arm, and his mother's name inscribed on his left arm. Depp's body in fact turned into a kind of journal, a sign perhaps of what he would evolve into: one of film history's most graphic artists.

School left Johnny with bad memories. He found it boring and was often made fun of because of his surname, which got turned into nicknames with sexual connotations. He was called 'Dipp', 'Deppity Dawg', or 'Johnny Deeper'.[2] Becoming Depp was not easy. His teachers never encouraged him, even though, some years later, they were happy to ask for his autograph.[3] From the age of twelve, as he became obsessed with the electric guitar, the young Depp began to smoke, and started taking drugs over the following two years. He continued to smoke and often made use of cigarettes in his films, not just as an accessory but also as a comment on the 'hygienist' Hollywood milieu. When he was fifteen, and strongly interested in all the arts, he devoured Jack Kerouac's *On the Road*, a book that moved him deeply. No matter how many small jobs he held – he worked as a bricklayer, petrol pump attendant, mechanic and telemarketing pen salesman – he understood more than ever, thanks to Kerouac and his fellow travellers, the notion of being a crazy dreamer, of being free like the wind. He stole a pair of bell-bottom trousers from his mother, hung out with Sal Jenco, a musician like himself, whom he met again on the set of *21 Jump Street* (1987–90), and opted out of high school to concentrate on his music. He played guitar in various small local bands, The Flames and The Kids, with whom he soon set off for Hollywood.

Becoming a musician or an actor?

For several years Depp played rock music without actually earning a living. After the gigs, he used to do the bar round, during which, he would sometimes bump into some big names, such as Iggy Pop. At the time, The Kids were

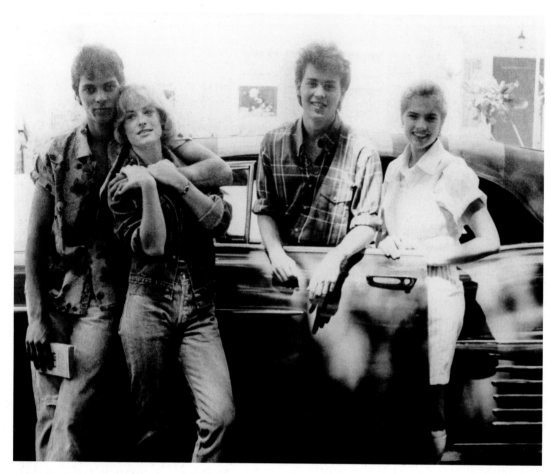

Left: Depp (centre) on the set of *A Nightmare on Elm Street* (1984) by Wes Craven.

Opposite: The actor in the role that brought him to the attention of the public, that of Officer Tom Hanson in the TV series *21 Jump Street* (1987–90).

Following pages: *Benny and Joon* (1993) by Jeremiah S. Chechik.

writing their own songs and opening for the B-52s and Talking Heads. When he was twenty, Depp married Lori Anne Allison, a musician five years his senior, whom he divorced two years later. Living in Los Angeles, and aware of how difficult it was to find one's niche, he met, through Lori, Nicolas Cage, who suggested he try his luck as an actor. He successfully passed an audition for Wes Craven's *A Nightmare on Elm Street* (1984) and, as he was well paid – much better than for playing music (he indeed finds it unbelievable that one can earn so much for being an actor) – he carried on and enrolled for drama lessons at the Loft Studio. The Kids split up. Depp was not part of the 'Brat Pack', a band of young actors led by Tom Cruise, who played in various popular films destined for a young audience throughout the 1980s. He nonetheless had a part in the teen film *Private Resort* by George Bowers (1985), and in the thriller *Slow Burn* by Matthew Chapman (1986). After that, he was out of work for almost a year and contemplated giving it all up, but was then offered a small part as a soldier in Oliver Stone's *Platoon* (1986), for which he went through a thirteen-day-long training course in the jungle.

In 1987, Depp's life changed dramatically. He was given the main role in a new TV series, *21 Jump Street*, produced by Stephen J. Cannell, the creator of *The A-Team* and *Rick Hunter*.

At first, Depp was wary and said no, fearing that an exclusivity contract would commit him for too long. After trying their luck with another actor, whom they quickly dismissed, the producers asked Depp again, who ended up accepting the role of Tom Hanson, a young cop who infiltrates a high-school. He was told that he would only be needed for one season, but signed up for six. The young actor was paid $45,000 per episode and became famous overnight. In addition to acting, his job entailed posing for magazines and giving interviews. He received thousands of fan letters, starred in a Pepsi advert and was included in *Rolling Stone's* 1988 list of noteworthy newcomers in TV and film. Depp was turned into a brand, but he began to criticize the doubtful morality of some of the episodes in the series. He tried to modify the dialogue and suggested that his character smear himself in peanut butter or end up in a psychiatric hospital, all in the hope of being told to leave, but in vain. He began to understand that 'when you're doing a series like that there's really no creative controls – the word creative doesn't really exist in their vocabulary'.[4] It was a lesson he would not forget when writing his own legendary story.

Becoming Johnny Depp

In the early part of his career, Depp appeared to be afraid of his own voice, but he gradually

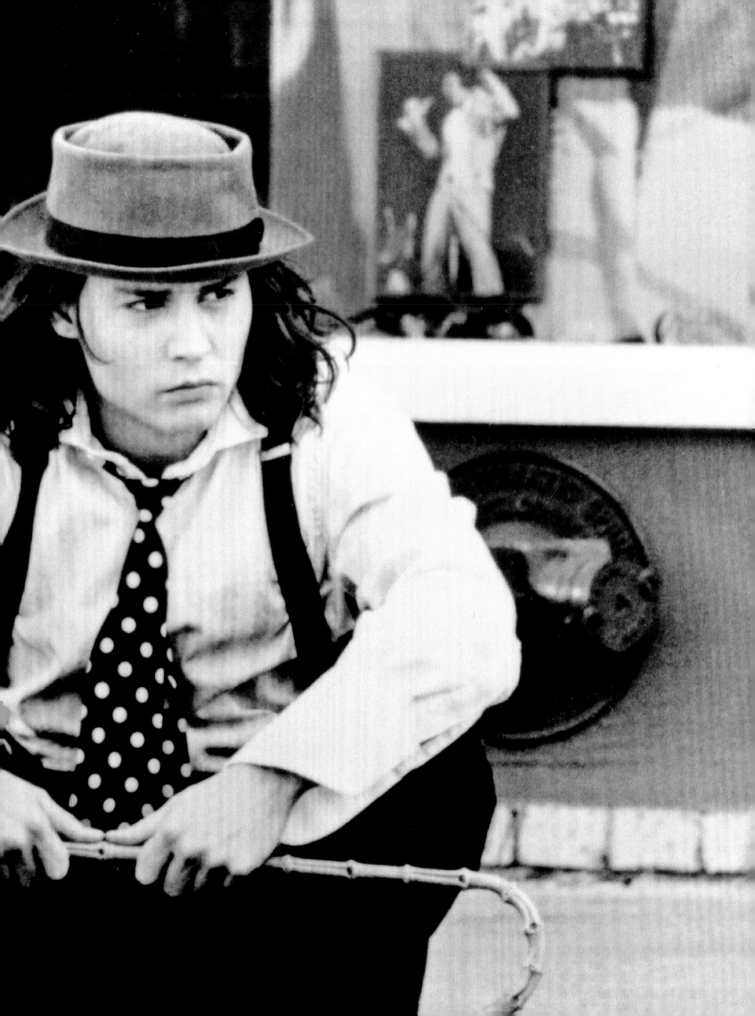

began to play with it through the use of accents, intonation, words and singing. The culmination of this approach was perhaps the film musical *Sweeney Todd* from 2007. He could see that to become an actor – a profession he had fallen into slightly by chance – he also had to be what he had initially wanted to be: a musician. In time, these two professions would meet. And so, he became the rock 'n' roll actor Johnny Depp.

The majority of the books on Depp that have been published to date talk at length about his tumultuous life and his romantic relationships, and generally stick to the films that have achieved good box-office returns. Since his acting debut, he has adorned the cover of countless magazines but remains an intriguing figure. 'Over the years, Johnny Depp has developed the art of giving sympathetic interviews during which he reveals strictly no more than he wants to', Steven Daly stated.[5] He has been described as a kind of Hollywood Scarlet Pimpernel.[6] His acting is of a similar nature.

Depp enjoys working on movies but is uninterested in the final result. As with music, he loves 'the moment'. In 1998, he said: 'Making music is immediate, and it's all about you. If you're playing guitar, the feeling comes through the way you bend the note, the intensity with which you hit the strings. With making films, although it's real emotion, it's false emotion. You're lying'.[7] Throughout his career, he has maintained a passionate relationship with music. 'The weird thing is, I think I approach my work the same way I approached guitar playing – looking at a character like a song. If you think of expression musically – it goes from wherever it comes from inside to your fingers, and on to that fretboard, and then on to the amplifier, through whatever. It's the same kind of thing that's required here, with acting: What was the author's intent? What can I add to it that maybe someone else won't?'[8] As a lover of the stage, it is surprising that he has not been tempted to do theatre. For Depp does indeed remember his mentor Marlon Brando's advice: 'Why don't you just take a year and go and study Shakespeare, or go and study *Hamlet*? Go and work on *Hamlet* and play that part before you're too old'. He regrets having not yet acted on the impulse, 'I thought, well, yeah, yeah, I know *Hamlet*. Great. What a great part, great play, you know, this and that. I never did it. I never got the chance to do it [...]. And I would like to. I'd really, really like to'.[9]

In his book, *Johnny Depp, Le Singe et la statue* (The Monkey and the Statue),[10] Fabien Gaffez traces several strategies within Depp's acting: silent quotations (burlesque, expressionism, transformism), palimpsest and reinterpretation, reconstitution. But Depp also personifies the art of collision, of superimposition, of 'splicing' with his preferred characters: at the 'edge' of their environment, geographically, temporally,

heroes often landing too late in societies in rapid change, free agents finding it hard to adapt, often perishing as a result.

Depp, who frequently, and not without a hint of nostalgia, brings up the 1960s (the era of his heroes, Marlon Brando, Hunter S. Thompson and Keith Richards), has always felt he 'was meant to have been born in another era, another time'.[11] And with his fondness for historic figures, he is one of those rare actors to somewhat revive the Romanticism of the nineteenth century, with his paleness and his dark gaze, notably in *Sleepy Hollow* (Tim Burton, 1999), or *From Hell* (Albert and Allen Hughes, 2001), in which he plays Fred Abberline, a Scotland Yard officer pursuing a criminal. Fabien Gaffez likens Depp's face to Courbet's self-portrait, *The Wounded Man*. Depp is not an enthusiast for romantic comedies or social films, apart from *What's Eating Gilbert Grape*, in which he again plays a man who is not really there. He has done few action movies (*Nick of Time* by John Badham in 1995) and sci-fi films (*Intrusion* by Rand Ravich in 1998, *Transcendence* by Wally Pfister in 2013), but his proximity to the fantastical is ongoing. In *The Imaginarium of Doctor Parnassus* (Terry Gilliam, 2009), in which he replaced Heath Ledger at short notice, 'Depp is the first to step in – as though only he could make the audience accept the strangeness of this substitution. As though he were, to the letter, an intermediary between two worlds'.[12] And we are going to see that, even in his very realistic roles, he gets a perverse pleasure from playing the 'absent' and making us believe that he does not exist.

With his eternal adolescent physique, Depp is attracted to distortion. He is constantly playing with his hands, and interacting with whatever is going on around him; he adores listening, observing. So, is he a silent-screen actor, as has often been stated? Why does his face inspires so many directors? Which themes does he specialize in? What exactly, deep down, is a 'Deppian' character? Social outcast, stranger to the world, melancholic, naive, innocent, holding back, isolated, humble, eternally starting from scratch, in family ruptures, furtive, magician, conjurer, in transit, incomplete, changing, alienated, animated? And how can we describe his acting? An almost psychedelic profusion of references (pictorial, literary, musical), an excess of accessories and hairpieces, a permanent need to hide, to faint, to fade, to smear, and to reinvent genres and boundaries?

At the heart of a labyrinth

Depp's art is profoundly marked by his encounter with Tim Burton, and their eight collaborations alone could form the subject of a separate work, because the roles are so consistent and represent a major oeuvre in and of themselves. From this

intense output we shall therefore select the actor's most emblematic characters, those driven by his strong involvement in a given project, his collaboration with a filmmaker, the quality of his interpretation (independently of the film itself, its box-office returns or reviews). This is a matter of choosing the roles that are meaningful to him and giving a representative insight into his art. Likewise, we will present roles from his post-1990s period, a particularly successful time in his career: in the space of five years, from 1990 to 1995, Depp made several masterpieces and some very good films, including *Benny and Joon* by Jeremiah S. Chechik (1993), *Donnie Brasco* by Mike Newell (1997) and Roman Polanski's *The Ninth Gate* (1999).

From this phase in his career (perhaps his greatest), three films would deserve a (bigger) place in this book. First of all, *What's Eating Gilbert Grape*, the depiction of a young man looking after his obese mother and autistic brother. This role touched Depp on a personal level not only because it was filmed during a difficult time in his life (marred by too much alcohol), but also because the story reminded him of his own adolescence. He even took inspiration from a school friend, 'Bones', and dyed his hair red. Another important film was Tim Burton's *Ed Wood* (1994), in which Depp enjoyed depicting a penniless, naive but enthusiastic director. Burton encouraged him to go the extra mile and discovered the potential clown in him, hitherto only lightly touched on. When the actor played Ichabod Crane in another film by Tim Burton, *Sleepy Hollow*, he played an irresistible part, that of a cowardly, city-dwelling, Cartesian detective confronting the legend of the Headless Horseman.

So as to better define the actor Johnny Depp, we have chosen ten iconic roles. In the creation of his artistic work as an actor, he initially aimed to deconstruct it, by defying his image as teenage star. He partially succeeded with John Waters (*Cry-Baby*, 1990), before finding the 'tailor-made' title role in *Edward Scissorhands* (1990), the innocent freak, virtually mute within an unfinished body, isolated from the world, who lands in an American suburb that ends up ostracizing him. In *Arizona Dream* (1994), Depp, now on a winning streak, played Axel, a young man exiled in his own country, the twilight years of 1990s America, kissing goodbye to its failed dreams. With *Dead Man* (1995), the actor seemed at the peak of his career in his role as William Blake, a dead man who goes on dying, a poetic and very symbolic character on his way across America at the time of the pioneers. Depp then tried his hand at directing, with a single feature film, *The Brave* (1997), the story of a man willing to sacrifice himself in a snuff movie in order to save his family from poverty. He then metamorphosed into Raoul Duke,

the drug-fuelled, ultra-lucid '70s writer, in *Fear and Loathing in Las Vegas* (1998). With *Pirates of the Caribbean* (2003), Depp cemented his taste for parodies and the unconventional, for twisting genres, and for elusive characters. Now a superstar, he played the notorious gangster John Dillinger, who, in the film *Public Enemies* (2009), believes himself to be invincible and invisible. His version of the Mad Hatter in *Alice in Wonderland* (2010), both moving and terrifying, showed him to be a master in the art of sartorial camouflage and changing his voice. Finally, with his role as Tonto in *The Lone Ranger* (2013), the Comanche warrior banned from his own tribe, Depp took the organic and spectral dimension of his acting to the extreme. Ten stories, ten steps, ten stages, and as many bends, mirages and faces along the performing path of Johnny Depp.

With Martin Landau (who played Bela Lugosi) in *Ed Wood* (1994) by Tim Burton.

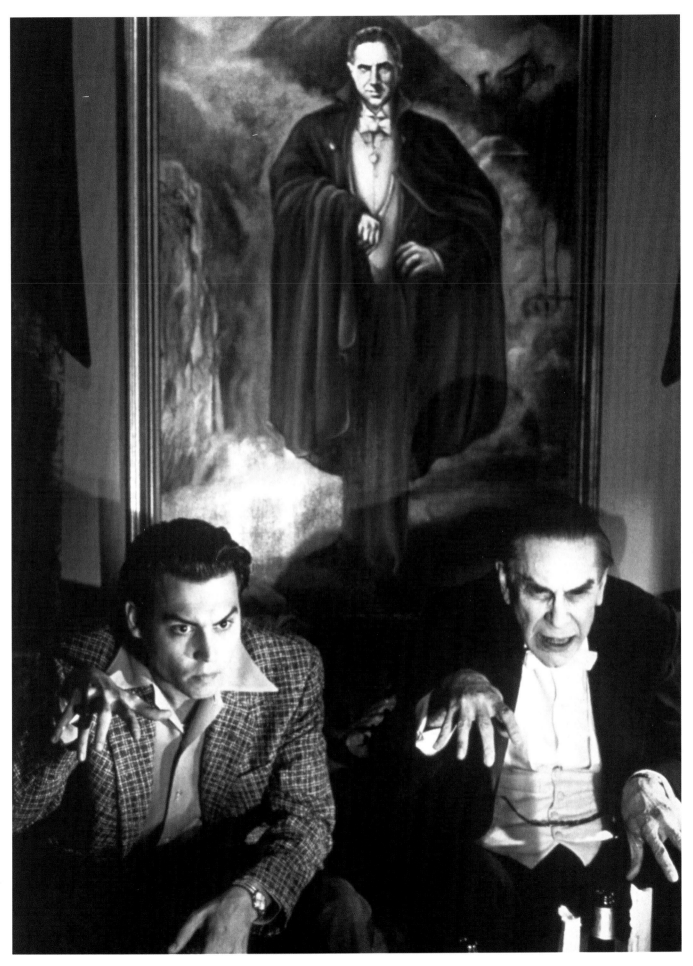

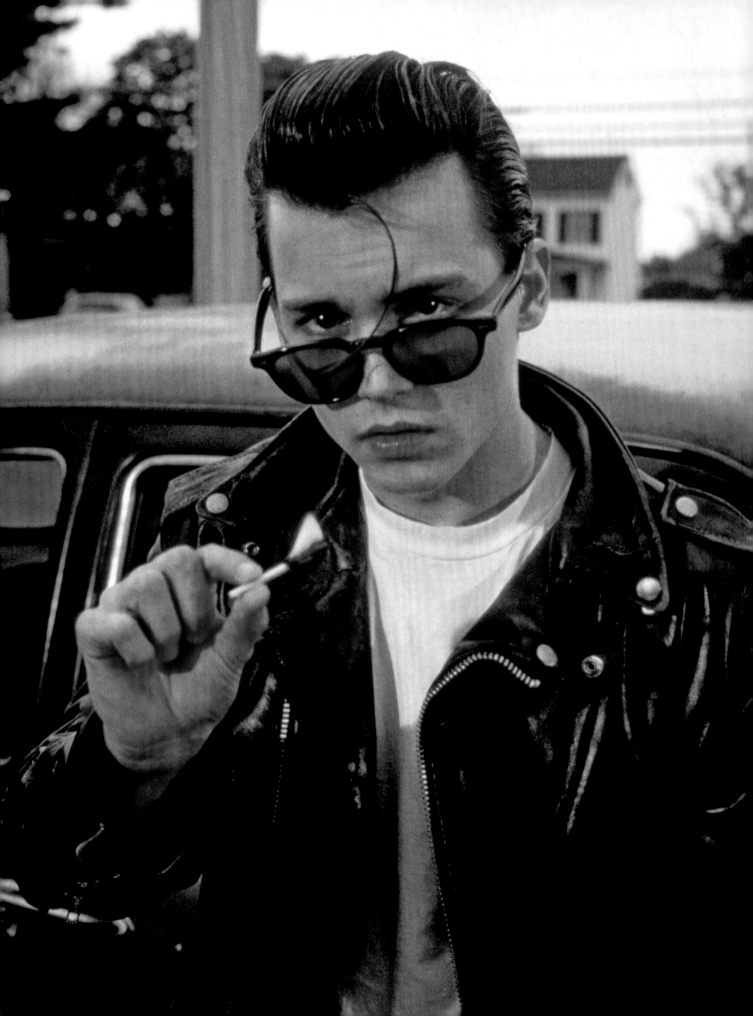

1

Cry-Baby

Cry-Baby (1990)
John Waters

'Whenever a young actor comes out, they have to pin him with some sort of label, so they call him a bad boy or that horrible word, rebel, which is so played out and stupid'.[13]
Johnny Depp, 1990

In 1990, Depp found himself at a dead end. The series *21 Jump Street* had been a huge success and the press had created 'this character called Johnny Depp',[14] a twenty-seven-year-old good-looking kid, posing in teen magazines in ripped jeans, holding a gun while showing off his tattoos, receiving thousands of letters from hysterical fans. The only way out of this predicament was some self-mockery, and it was director John Waters, the king of 'trash', who gave Depp the opportunity. Following his success with *Hairspray* (1988), Waters had secured funding from Universal for his next film, *Cry-Baby*, a screwball musical comedy and parody of teenage films of the 1940s and '50s – Maxwell Shane's *City Across the River* (1949), Paul Henreid's *Live Fast, Die Young* (1958) and, of course, Nicholas Ray's *Rebel Without a Cause* (1955) – which was one of the first films that dealt with youth and the middle-class. This time, Waters' budget was no longer $10,000 but $8 million, and for the title role he trawled through the entire adolescent press, as his producer Brian Grazer wanted to firmly fix the film within his generation and shoot 'a slick 1990s *West Side Story*'.[15]

When Depp, the idol of the moment, received the call from Waters, who said to him, tongue-in-cheek, 'I have this movie about a juvenile delinquent whose father got the electric chair', he burst out laughing. 'I just wanted to make sure he had a sense of humor', said Waters. 'He did this one little sneer in our first meeting which summed it all up, and I knew that, hey, Johnny Depp *is* Cry-Baby'.[16]

The film depicts the clash between two Baltimore teen gangs, the Drapes, led by Wade Walker, who goes under the name Cry-Baby, and the Squares, one of which, Allison (Amy Locane), is in love with Cry Baby. This story of young people testing their popularity through dangerous challenges was Water's own Baltimore adolescence, but not really that of Depp, who never belonged to a gang. 'I was just a curious kid. I was bored with high school so I dropped out; I wanted

to play music so I kept doing that. I wouldn't say that I was one of the cool kids in high school at all, but I also wasn't square. I probably was perceived as a burnout because I had long hair and played guitar and didn't really work much in high school. I wanted to be more what John probably was, which was one of the really smart kids. I always envied those guys'.[17]

Interviewing Depp, Waters straightaway sensed some hidden facet waiting to be exploited. And, despite fans trying to talk him out of working with this unconventional director, Depp felt that this was an unexpected chance to steer his career in another direction.

Parodying the star, parodying the rebel

By combining a black-and-white vintage Universal Picture logo and a 1950s jive in the film's opening credits, Waters put his stamp on a big Hollywood production. Similarly, the Depp 'brand' seemed to have been hijacked from the perfectly willing actor. His first appearance announced his future roles, namely those of a young man on the margins of society, driven into an inhospitable environment: Cry-Baby refuses to be vaccinated like the other pupils and has to be dragged to the doctor's. When he appears, to the sound of a saxophone solo, he alters the rhythm of the scene. A tear falls from his left eye, in response to Allison's troubled look. Then the name Cry-Baby appears on Depp's arm, right below his Indian chief tattoo, while the director's name is inscribed below his tear. Cry-Baby, orphan and rock singer, must fall into line. The role seemed tailor-made for the actor.

To create a parody of the self-confident 'juvenile delinquent' (the director played on the terminology of the press cuttings of the time and found inspiration for the costumes and accessories in his personal books and souvenirs), Depp first of all exploited the difference in physical appearance: black leather bomber jacket, white t-shirt, short, slick hair, bare neck, jeans and boots. The actor instinctively followed in the footsteps of Marlon Brando in *The Wild One* (László Benedek, 1953) and James Dean in *Rebel Without a Cause*. Only, his body language was contemporary. At the age of twenty-four, James Dean's body was quite muscular, almost stocky

John Waters enabled Depp to shed his bad-boy teenage heart-throb image with a character, Cry-Baby, who redefined the conventions of the genre.

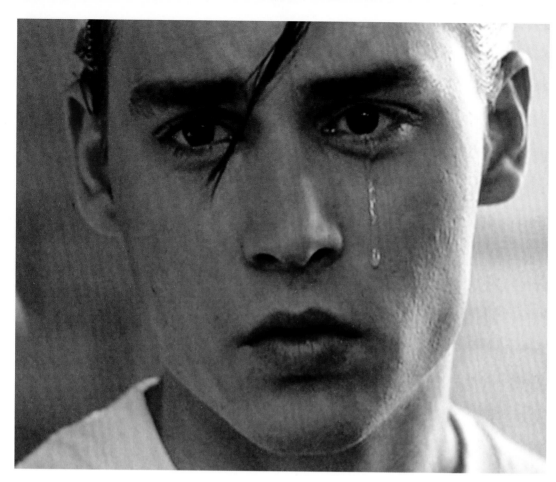

and already looked like an adult's. Depp was built very differently and appeared much more slender in the film. In 1990, the young girls' idol still had the body of an adolescent.

For his breakthrough role, the young actor betrayed his shyness and appeared almost thin-skinned. Cry-Baby accentuates the big stars' mannerisms and makes fun of the new post-war youth and their ultimate 'cool' (a vilified word, too close to jazz). Depp walks with a slight swagger, strikes a match on his palate so as to seduce Allison, and hovers over her silently, like a wild animal sniffing its prey. He imitates some of James Dean's expressions, such as the looking over the top of his glasses and lifting his eyebrows or, later, the subdued, emphatic cry, hands glued to his ears. He runs his hand through his Brylcreemed hair, flicks up his collar (a very important detail of the time in order to look cool), hitches up his crotch to shock the middle-class citizens and conspicuously holds out his hand to Allison to steal her from the Squares.

Depp uses his mouth and nose a lot in the film, alternating between a sulking pout and twisting his lips, sniffling and swallowing, in a repertoire of expressions that would become signature traits in subsequent roles. He even borrows from Tex Avery when he frenetically scratches his ear in the prison courtroom, where he falls asleep, his hands folded to one side, as though praying. But Depp's whole style of acting, accentuated by the cinematography, is very theatrical. He does not always seem comfortable performing the operatic gesticulations that were imposed on him by Waters.

A face longing to get dirty

In 1990, Depp had Cry-Baby's angelic features, a smooth baby face. The press indeed made frequent reference to his cheekbones, forming a perfect triangle, 'the best cheekbones since Gene Tierney', Stephen Rebello wrote in *Movieline*.[18] Even John Waters made fun of them in *Interview Magazine*. 'I still think you should marry Raquel Welch, and I'll sell the children, because she's part Indian too, and you could have the kids with the best cheekbones in America. And we could sell 'em to rich yuppies'. To which Depp answered, deadpan, 'We could start a cheekbone-implant business'.[19]

At first glance, Cry-Baby is nothing like a Drape, and judging by Depp's soft and polished voice, he could just as well belong to the Squares. Only a single lock strays from his Brylcreemed hair. Depp is the sole good-looking Drape, with his white shirt and hairless chest. Whereas the stars of the 1940s and '50s had been advised to lose weight in order to acquire finer, more feminine features, Waters cast his actors as an array of disfigured, gaunt, fat, ugly, overly made-up, rascally faces. In contrast to the physical

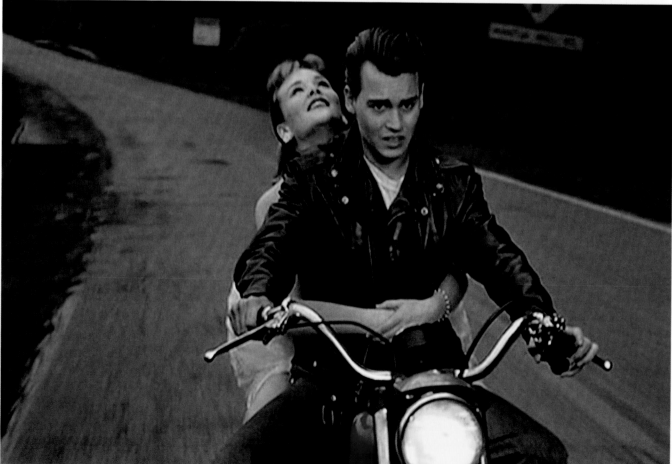

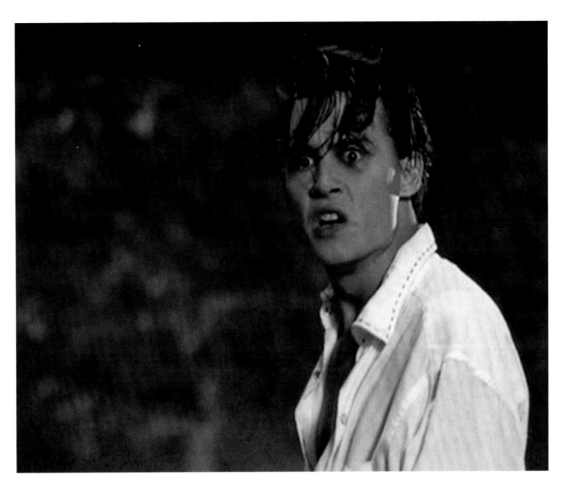

perfection of a young Elvis, Brando, Dean
or Depp, Waters celebrated ugliness and fought
the culture of the right-thinking majority.

Depp didn't shy away from playing fairly
crude scenes. Cry-Baby teaches Allison how
to kiss, exposing her to a spectacular play
of tongues, to which all the other actors and
extras in the ball scene respond by giving each
other wet, vigorous kisses. In prison, he licks
the window, using his whole tongue, like a toy-
boy behind a display window. Waters here won
the bet to make the actor let out this hidden
organ. Unafraid of the sexual metaphor, Allison
responds by licking his one tear, and then
drinking a bowlful of them. Throughout the film,
Depp is strongly sexualized, especially when,
as he escapes prison, he loses his trousers
and finishes the whole scene in his underpants.
The photography of Waters, an openly gay
director, appears overtly desirous of its actor.

Despite the risk-taking, the role remained
ambiguous and potentially harmful, for Depp
had trouble breaking his image, and the 'letting
go' was still timid. He continued to play the pretty
boy, simpering at times. A lot of sweat and tears
were needed to dent that image. The little lock
that falls so neatly over his brow, cuts itself loose
like a flash from the kissing scene onward.
Once the lightning has struck and the kissing
is done, Depp no longer looks like a young
middle-class guy. With his hair all tousled,

prefiguring his dishevelled mop as Edward
Scissorhands, the swollen vein, palpitating
during his fit of anger, lifted eyebrows, eyes wide
open, as in silent movies, Depp was already
verging on the gothic imagery of Tim Burton.
His expression has changed from a smooth
face to that of a serial killer, the dark face
of America. He has become a strange werewolf,
minus the hair.

Cry-Baby is a guy who snivels, who pretends
to be crying. Since the death of his parents he does
something bad every day to avenge them, and
weeps – a bit – over the pain he causes. 'A single
salty tear is all you'll ever get from Cry-Baby',
he explains to Allison. Depp, who began his
career shedding a crocodile tear, has rarely cried
in his subsequent films.

But Cry-Baby is also one who shouts, who
yells even, and Depp certainly doesn't hold his
character back from doing so in the film. In
contrast to *Rebel Without a Cause*, John Water's
film does not refocus on relations between the
generations, the break-up of the family unit or
the difficulties of growing up, but on the class
relationship between the very poor and the very
rich. And when Cry-Baby falls asleep in prison,
his hair in a mess, his complexion a little dull,
with bags under his eyes, he becomes
a kind of hybrid, a hideous cherub, a freak,
an American's vision of the proletarian:
wild, barbaric and uncontrollable.

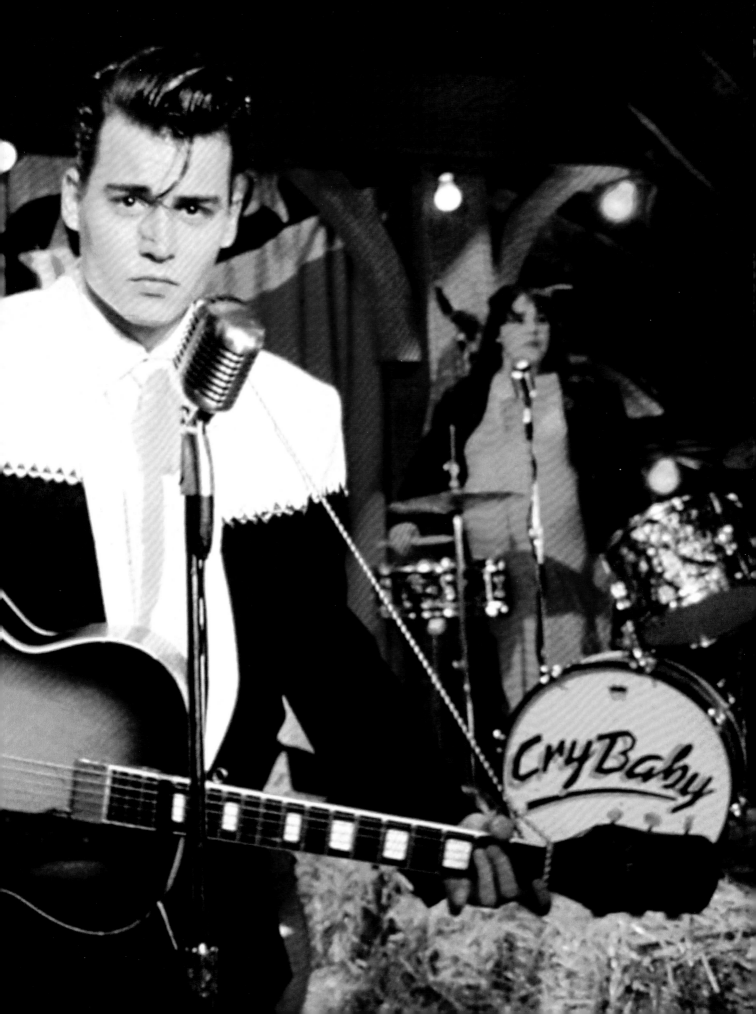

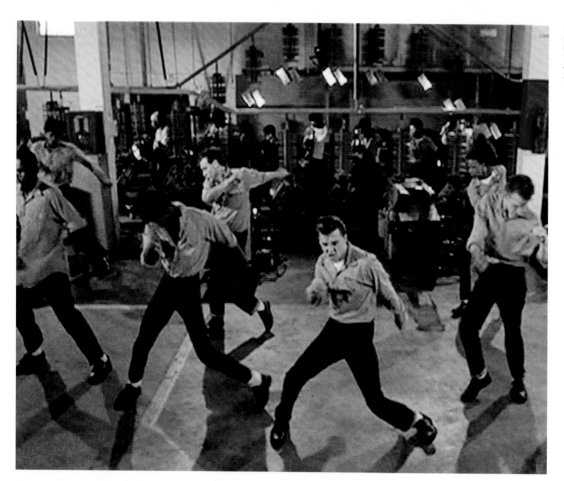

Left and opposite: Cry-Baby
the convict in two sequences
that pay tribute to *Jailhouse
Rock* (1957) by Richard
Thorpe: 'Doin' Time for Bein'
Young' and 'Please Mr. Jailer'.

A body that needs to loosen up

It is no coincidence that Depp began his career
with a film musical. In 1990, he was missing the
stage, and music would play an essential part in
his future roles. From this point on, he uses it
to nurture his acting (placing the voice, rhythm,
approach, choosing the personality). Preparing for
Cry-Baby, Depp listened to rockabilly artists like
Hank Ballard, Billy Lee Riley and Carl Perkins.
'What I used a lot… was my stepfather', he
recalled in 2008. 'He was a guy who grew up as a
greaser. He was a full-on greaser in Chicago in the
'40s and '50s. So he became the primary, sort of,
basic model for Cry-Baby for me. That combined
with, certainly, Eddie Cochran, Gene Vincent and
young Elvis'.[20] It is through sound and speed too
that the two social classes in *Cry-Baby* go to war
with one another. Rock 'n' roll replaces doo-wop,
the Squares' music, which is slow and syncopated,
derived from rhythm and blues.

Although Depp does not actually sing in the
film, he did work with a coach for the playback
and says that he found it easy thanks to his
knowledge of music. He moves quite comfortably
on stage when acting the musician and finds
the right rhythm, but admits to feeling much
less confident when dancing. Years later, he still
remembered his fears: 'I said to John, I don't know
how to dance, it's not my thing. He just told me
not to worry'.[21] Brian J. Robb, in his book about

the actor, writes that 'instead of just telling him
that he wanted him to be like Errol Flynn or
something, [Waters] ran up and sang 'Ride of the
Valkyries' to him'.[22]

Depp confronts his inhibitions in the film's
main dance scene: the liberation in the prison.
When Allison calls Cry-Baby a coward, the
prisoners in their blue shirts set the tone by
tapping their hammers, like pieceworkers in a
factory. Depp manages to produce, from deep
within, a long, husky cry. One senses that this is
a body not accustomed to dancing, and that his
too-well-mannered leg movements have to be
accompanied by the other dancers to produce a
fluid choreography. But the music illuminates his
face, and the actor applies his rage to the song
'Doin' Time for Bein' Young', as he shouts: 'So get
those shackles off of me. This kind of suit don't
set me free'. Iannis Katsahnias wrote, in *Cahiers
du cinéma*, 'Waters uses songs from the 1950s by
way of scenario; not major hits, but those having
remained on the periphery of the charts'.[23]
At the end, Depp delivers a hybrid performance,
flawed and endearing at the same time, worthy
of Elvis in *Jailhouse Rock*, revised and reshaped
by Michael Jackson in *Beat It*.[24]

A family of actors

By taking a role in a John Waters film, Depp was
entering into a family of actors, and this notion

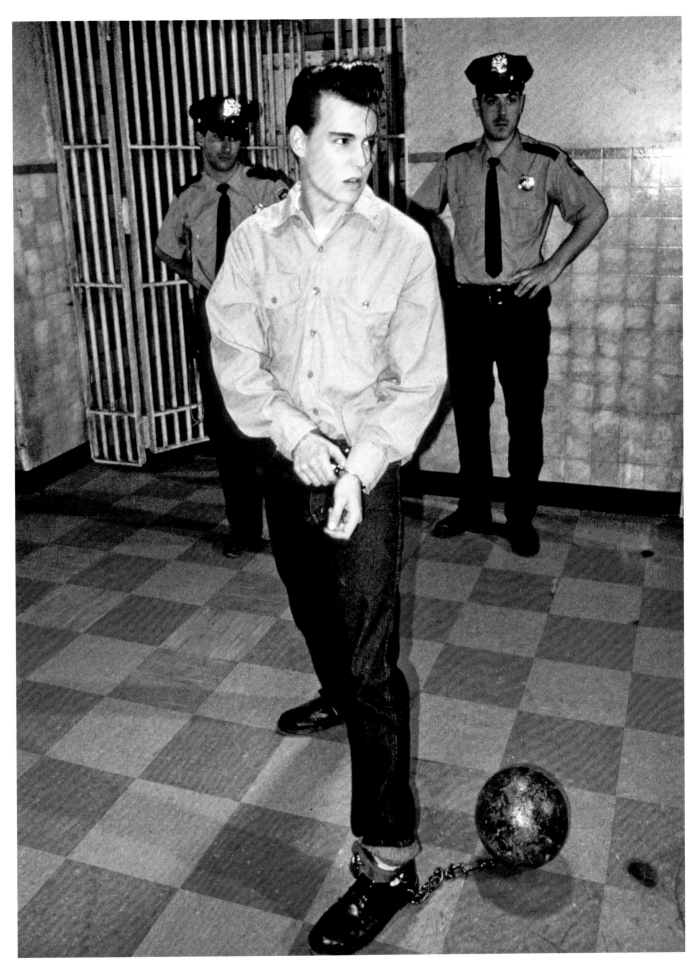

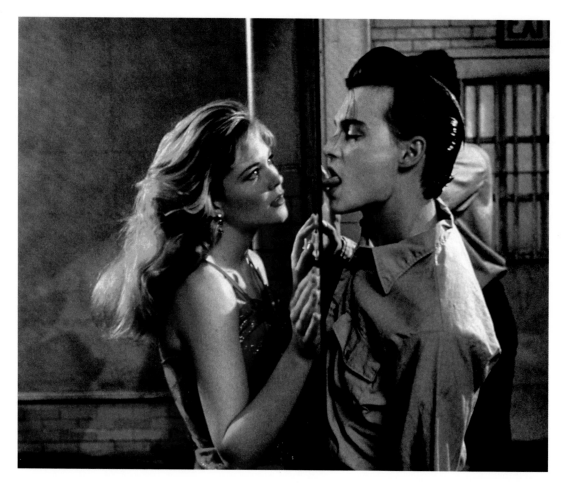

of a family (which he had been looking for with his music) has remained important throughout his career, as he needs to feel trusted and to evolve within a group sharing the same ideas and tastes. There are no parental models in the film: Cry-Baby is an orphan and the son of gangsters, while Allison's parents died in an accident. And so the young guy has recreated his own family, penniless, but united: grandmother Ramona (Susan Tyrrell), with her rotten teeth, is a receiver of stolen cars; uncle Belvedere (Iggy Pop); and a group of musicians, guys and girls, among them his sister Piment, overweight and pregnant, cheeky Wanda, and Mona, also called 'Hatchet Face'. It is the tribe that counts, with its music, its clothes, its attitudes, its vocabulary. When choosing his actors, Waters, who often works with the same people, begins by asking them whether they have been to prison. He likes bringing together improbable characters and creating unusual encounters between, here, a classic actor (Polly Bergen), an ex-TV star (Johnny Depp), a singer (Iggy Pop) and even an ex-porn star (Traci Lords). A genuine 'reintegration and rehabilitation work', as Iannis Katsahnias calls it. 'Waters does not exhibit monsters, he salvages characters who have too easily landed in the category of "rejects from society", offering them each a new role and a new image'.[25]

In the last shot of the film, the 'nice' look on Depp's face is interrupted. In tears, mouth askew, eyebrows raised and his hair in a mess, the actor has lost his virginity to Waters. He's now free to launch his career.

A career set free

The film premiered in April 1990 in the United States, but despite a good distribution it did not recover its costs. According to Waters, in America, 'the kids who didn't know that genre thought it was corny. They didn't get the joke. Young kids here never saw those Elvis movies'.[26] Some of Waters' supporters found it too 'nice', and criticized either the budget, which in their eyes was too substantial, or the mode of production. In *The Independent,* the reviewer deplored that Depp was not as filthy and degenerate as Divine, the director's favourite actress. 'The acting of the principals, Johnny Depp and Amy Locane, is assured enough. Waters may make Johnny Depp, currently a top teen idol in the States, crawl through sewers half-naked to escape from prison, but his underwear is only cosmetically smirched and the sequence is innocent of gloating', writes Robb.[27] However, the film was applauded at Cannes (where it was presented out-of-competition). Since the film was seen very little by teenage audiences anyway, Depp decided that he would continue to give priority to the films he liked, and declared in *Sky Magazine* in 1993, 'It's not really my goal to become that Tom Cruise

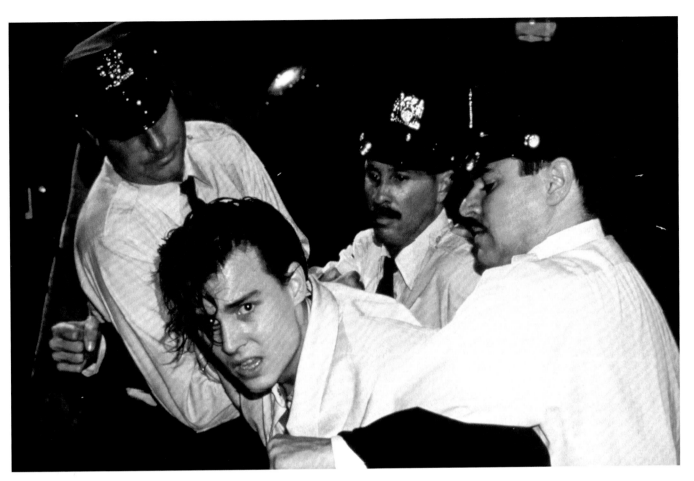

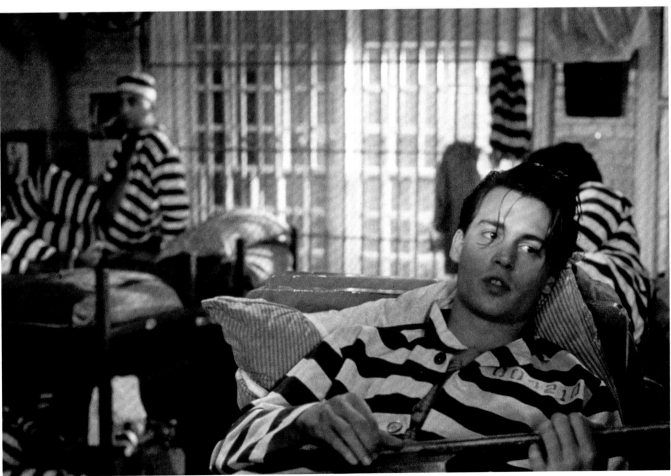

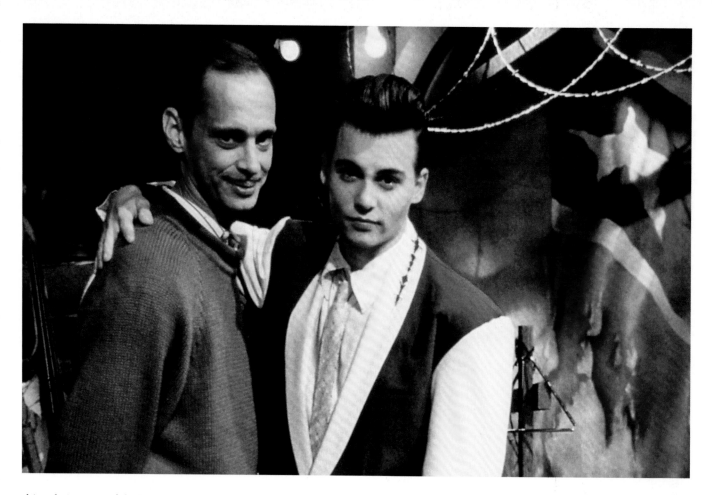

thing, being one of the biggest box-office stars in the world. But it's not like I'm allergic to commercial success either'.[28] In France, the film was seen as refreshing, humorous and very kitsch. *France-Soir* called it 'an amusing and pleasant sketch'.[29] It was too pleasant for *Les Échos*, for whom Waters seemed to have almost forgotten his worship of bad taste.[30] 'Johnny has finally found a role that suits him', said the review headline of *Ici Paris*[31], while *Le Quotidien de Paris* spoke of 'a mixed-race hunk with a bit of Native Indian blood'.[32] To *Le Monde*, Depp was a 'TV-series star with a beguiling charm and the irresistible pout of a pocket-size Brando'.[33]

Depp and Waters remained friends after the film. The director declared, confidently, 'He certainly has those handsome, smoldering good looks, but Johnny is gonna go way beyond being a teen idol. I think he's going to mature incredibly well, like Robert Mitchum. He could play a sophisticate or a suit, that whole look, or a redneck – all types. I'd love to work with him again and have him play an adult. I don't want him to play a kid again'.[34] Beyond this role, and throughout his career, Depp has tried hard to sully this image of the good-looking kid, but does not always succeed. In the *Los Angeles Times*, Chris Willman found the actor charming and bedraggled: 'Despite his handsome, all-American TV image, Depp in person is long-haired, loosely funky enough and unglamorous

to seem more a Keanu Reeves type than a James Dean type'.[35] To Waters, Johnny invented grunge. 'I don't remember a movie star with that look before him. Nobody looks better in rags'.[36] The director reckoned, 'It's the anti-star mentality. But I think Johnny is an *ultimate* movie star, and I mean that in a very positive way – I'm a firm believer in movie stars. That's how I wanted him to look in *Cry-Baby*, because he's playing a movie star – almost'.[37]

From the dead-end of *21 Jump Street* to liberating grunge there was just one more step: the encounter of a lifetime with an off-the-wall, sloppy and dishevelled director, Tim Burton.

John Waters and Johnny Depp on the set of the Jukebox Jamboree.

Opposite: The actor and Vanessa Paradis, his girlfriend at the time, at the premiere of *Once Upon a Time in Mexico* (2003) by Robert Rodriguez.

The success of the TV series *21 Jump Street* turned Depp into a teen idol overnight. Throughout his career the actor has felt under enormous pressure, both from the more serious press, who have always expected a lot from his contributions to quite challenging films, and from the tabloids, which have tried to take possession of his private life via his dazzling love affairs with Jennifer Grey, Winona Ryder, Kate Moss, or Vanessa Paradis. During the 1990s, the press disrupted Depp's everyday life, both as a private man and as an actor: 'I mean, all those films didn't do well at the box office. But I still had paparazzi chasing my tail, so it was the weirdest thing in the world. Everywhere you went you were on display. It was always some kind of strange attack on the senses; I was never able to embrace it. So self-medication [meaning drink and drugs] was just to be able to deal with it'.[a] Numerous incidents, at times quite hefty, with intrusive photographers have marked his career. The man who seeks to make himself invisible on screen, through his costumes, accessories, make-up, disguises and unconventional characters, never really succeeds in going unnoticed by the press. When asked to comment on this, Depp says he became an actor by coincidence, but that he has always hated being a celebrity, even though he knows it is part of the game. 'It's a very privileged opportunity I've been given, obviously. You know, the benefits are certainly very good. But there is a trade-off, as with anything. Somebody's always going to bring you the bill. The invoice comes'.[b] And the bill is his liberty. He admits to feeling more and more introverted as fame sucks the blood out of him, an actor who tries to step aside as the lights encircle him from all sides. The absolute paradox.

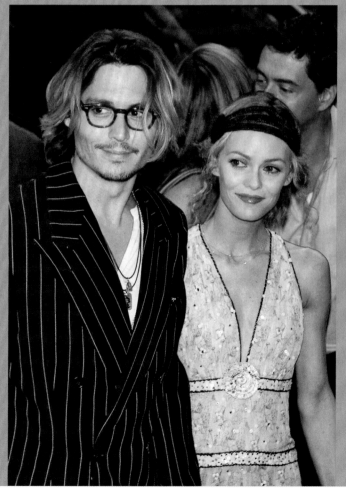

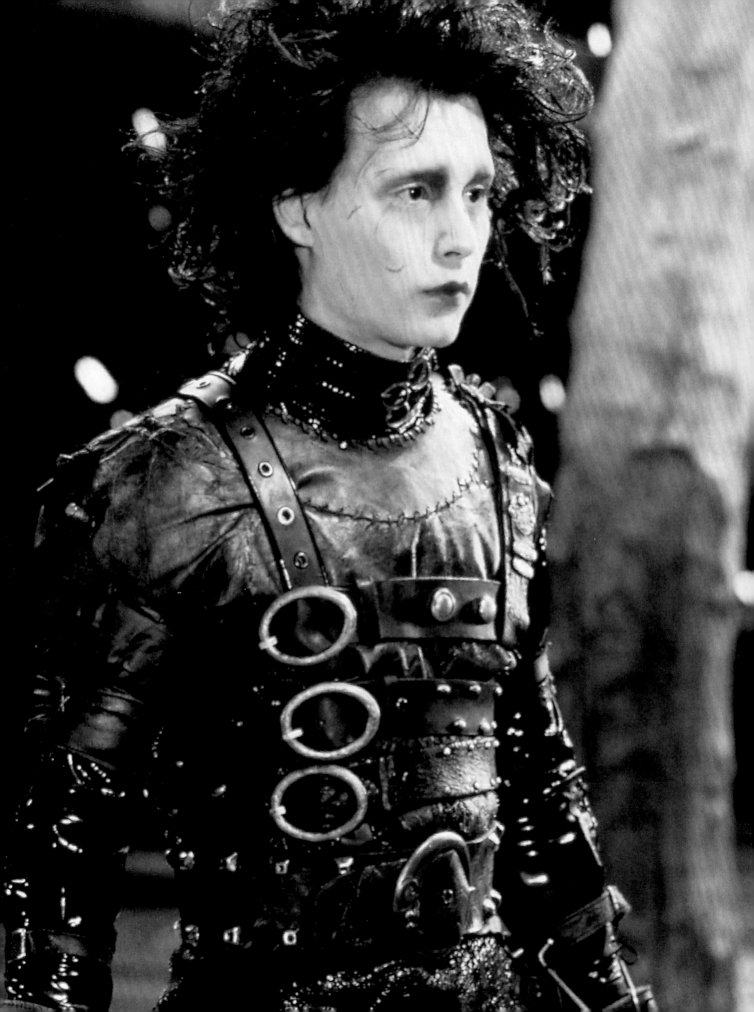

Edward Scissorhands

Edward Scissorhands (1990)
Tim Burton

'To me, it almost doesn't matter what Tim wants to film – I'll do it! I'm there. Because I trust him implicitly – his vision, his taste, his sense of humour, his heart and his brain'.[38] Johnny Depp, 1995

When Johnny Depp read the script for *Edward Scissorhands*, he was immediately taken with it. But in 1990, he had not had much acting experience. 'I felt so attached to this story that I was completely obsessed. I read every children's story, fairy tale, child's psychology book, *Gray's Anatomy*, anything, everything. And then, reality set in. I was TV boy. No director in his right mind would hire me to play this character. I had done nothing work-wise to show that I could handle this kind of role. How could I convince the director that I *was Edward*, that I knew him inside and out? In my eyes, it was impossible', he wrote in 1995, for the preface of Mark Salisbury's book on Tim Burton.[39]

His partner at the time, Winona Ryder, who had already made *Beetlejuice* (1988) with the director, arranged a meeting. Depp, nervous, smoking one cigarette after the other, came out of the interview 'jacked up on caffeine, chewing insanely on [his] coffee-spoon, like a wild, rabid dog'.[40] The two men had drunk four pots of coffee, talked about absolutely everything and – because of their shared insatiable curiosity and ideas on marginality – agreed. Burton was hypersensitive, with melancholy eyes, dishevelled hair and feverish hands. It was another Edward that Depp had in front of him. 'I now officially felt even worse about things because of the honest connection I felt we had had during the meeting', he added.[41]

As Bill Zehme recounted in *Rolling Stone*, the major film studio wanted Tom Cruise, the star from *Top Gun*, a 1986 box-office draw, who criticized Edward's character for its lack of masculinity and would only accept the role on the condition that his face was restored at the end.[42] Burton had to fight for Depp, especially as other stars – Tom Hanks, Robert Downey Jr – also wanted the role. But Depp continued to believe in, and work on, the character, convinced that he was Edward. Some weeks later, he learned that he had been cast. 'I became instantly religious, positive that some divine intervention had taken

place', the actor recalls. 'This role for me was not a career move [...]. This role was freedom. Freedom to create, experiment, learn and exorcize something in me. Rescued from the world of mass-product, bang-'em-out TV death, by this odd, brilliant young guy [...]. Resuscitated from my jaded views of "Hollyweird" and what it's like to not have any control of what you *really want* for yourself'.[43]

For his part, Burton had never seen *21 Jump Street* and had no preconceptions of the actor. He later revealed, 'I must have seen a picture of him somewhere. I like people's eyes a lot and, especially with a character like this who doesn't really speak, eyes are very important. We wanted him right from the beginning'.[44]

A Gothic character

Edward Scissorhands was vaguely inspired by a German children's book, *Der Struwwelpeter* (*Shockheaded Peter*), the story of a young boy banned from society for refusing to have his hair and nails cut. Tim Burton, who had carried this story with him since his teens, and who never stopped drawing the character in his sketchbook, had three imperatives for his film: scissors, a dogs' hairdresser and snow. Only the story needed writing, which was undertaken by Caroline Thompson. A genius inventor (Vincent Price) dies before completing his last work, a young boy called Edward. Not quite finished, the boy is equipped with enormous scissors by way of hands. Taken in by Peg Boggs (Dianne Wiest), he leaves his Gothic castle behind for an American suburb and falls in love with Kim (Winona Ryder), Peg's daughter. At first a curiosity, Edwards then becomes an attraction but he is unjustly accused of theft and banned from the neighbourhood. He inadvertently kills Jim, Kim's fiancé and goes back to live in his own world.

A *Pinocchio*-meets-*Beauty and the Beast* satire of WASP culture, *Edward Scissorhands* was also influenced by characters of *The Addams Family*, a show that was created at the end of the 1930s and centers upon the eccentric and macabre world of said family. As in *Cry-Baby*, *Edward Scissorhands* juxtaposes two contrasting aesthetics: American suburbia of the 1950s, pastel-coloured, with its brands like Avon cosmetics, symbol of female

For his first collaboration with Tim Burton, Depp chose to let his face do the talking.

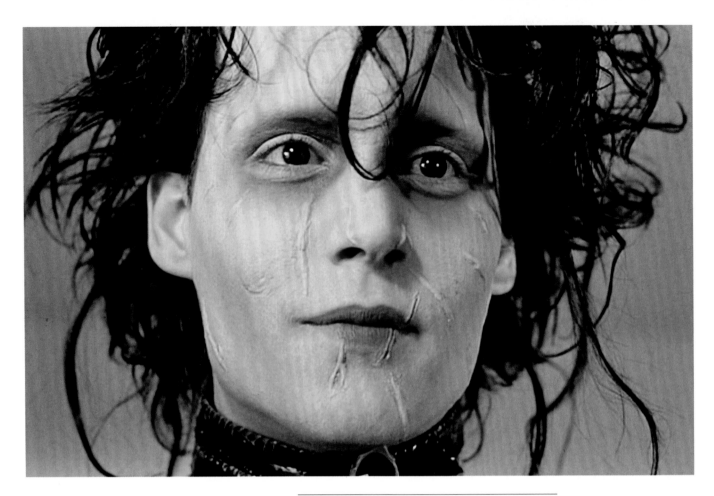

economic independence, and the Goth subculture of the 1980s, the darker, so-called post-punk.

It was the second time that Depp had carried a whole film on his shoulders, and it was no easy task, even though he, like Burton, was sympathetic to the music of the goth subculture, its theatricality and its 1970s style humour, and quite naturally slipped into Edward's costume, with its wig in the style of Robert Smith, The Cure's lead singer. The costume designer, Colleen Atwood, and her team did an incredible job on his skin and hair, and Stan Winston concocted two giant scissor-hands in plastic. The character's black costume, layered and built up from stuff accumulated over the years (collar straps, whipcords, spikes, leather, magnetic bands, mummy wraps), epitomizes the recycling culture of the 1990s. The hair, which Depp wanted to appear as artificial as possible, is dyed crow black and is as dishevelled as Burton's own mop. His complexion is pallid and pasty, blemished by fine scars and looks like old, brittle porcelain. His half-painted mouth, faded eyelashes and rounded eyes contribute to an eternally astonished expression evoking the face of a geisha.

Slightly unsure of himself, Depp quickly received support from his screen partners, who helped and encouraged him. And the actor was so happy being there that he endured, with some self-denial and a certain pride, the suffocating trappings under the blazing Florida sun.

How to play a monster?

Meeting Depp for the first time, Burton was not absolutely reassured: 'My worry was that, being relatively new to the business, he'd take Edward over the top and make him flamboyant', he revealed in 1991.[45] But the actor does the complete opposite. At the risk of appearing totally blank, empty, his approach was much more difficult, that is, letting his face 'speak' while remaining still.

Edward's initial appearance is fleeting: with his back to the audience, a long-haired being is staring through the window of the abandoned gothic manor overlooking the suburb. When Peg enters and discovers Edward, sitting cross-legged below the attic beams, the audience wonders how long he has been waiting. The director gives us a hint in the credits, where the name Johnny Depp is linked to a statue, a 'Lovecraftian' monster, with a patina of years of age. Edward seems to merge with the set, the dilapidated roof, the stone, the dust. He is ageless, an antediluvian creature suddenly bursting into the contemporary world. Incidentally, the manor park is filled with plant creations in the form of dinosaurs.

In this introductory scene, Depp has to master the challenge of conjuring a shadow coming alive. He bends forward, straightens up slowly, moves in circles round the light projected on to the floor as though performing

Above, and opposite: When Peg (Dianne Wiest) takes Edward under her wing, Depp has to master the challenge of playing a shadow that's coming alive.

Following pages: Edward arouses desire in a nymphomaniac neighbour (Kathy Baker).

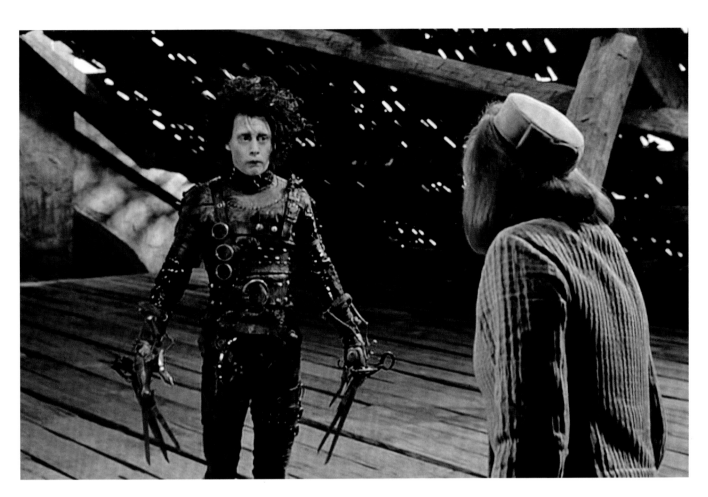

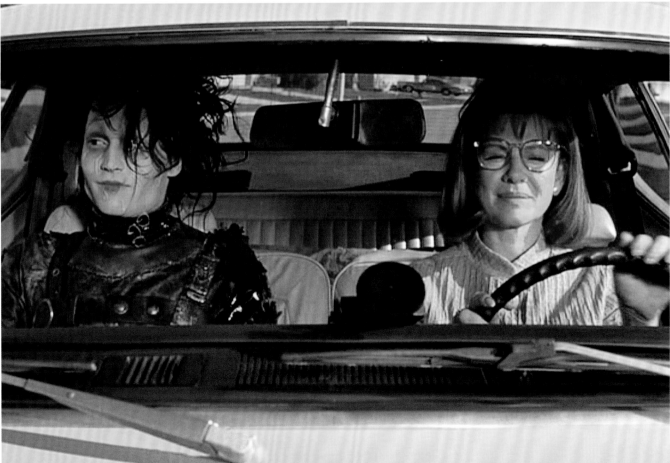

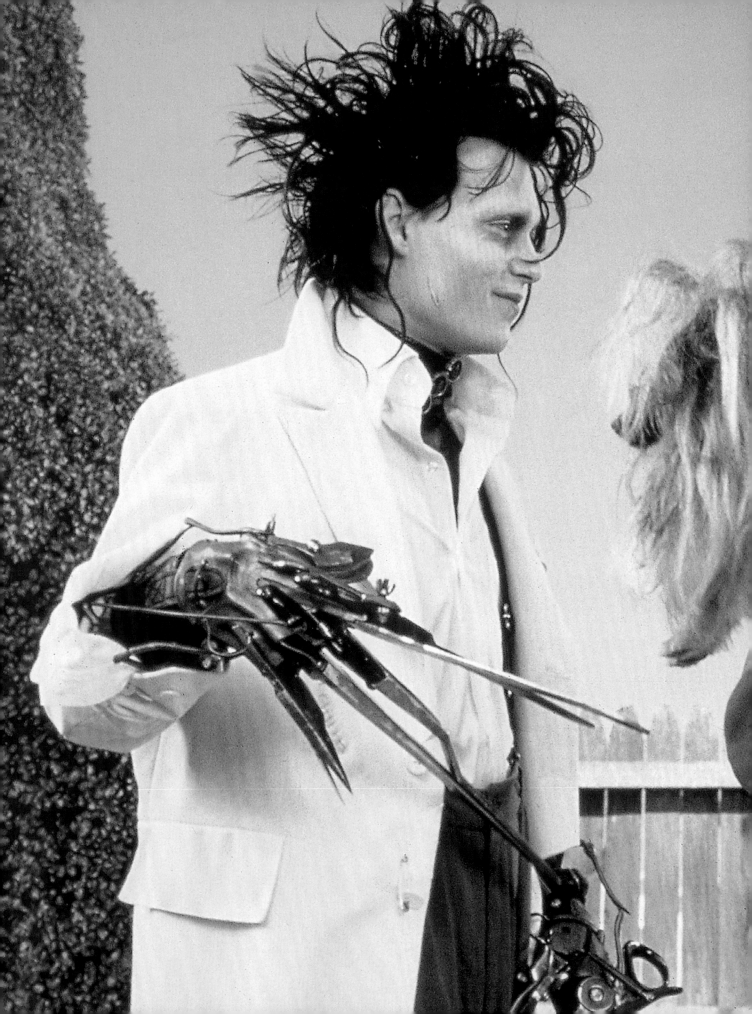

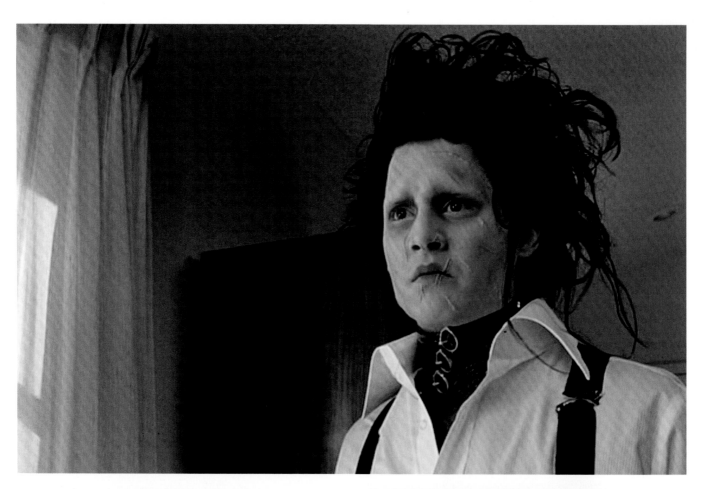

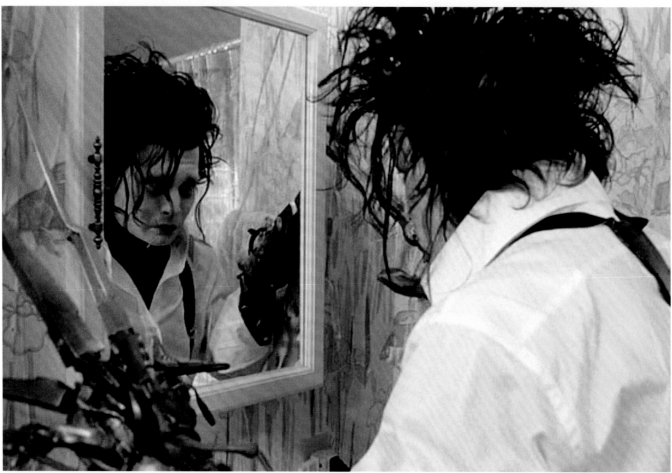

Opposite: Edward is divine
and human, pagan and
demon – a creature beset
by heartache.

Following pages: A stranger
to the world of men, Edward
returns to the castle where
he was born.

a dance movement. Then, arms crossed, he walks like a metronome toward Peg. It is through this slow motion that he becomes human. He extends his scissor-hands, pleading with her, just like Boris Karloff in *Frankenstein*. To make the character plausible, the director boosted the dread, helped by Danny Elfman's music, but the rest was up to Depp. His mechanical walk has its roots in the fantastical cinema of the 1930s, but he charges it with a rhythmic wavering and a quasi-antique presence, a *mélange* of stone and ice, solidity and fragility.

Depp plays an autistic 'scarface' who must learn to come out of himself. Just like Frankenstein's creature, Edward cannot speak, and the actor gives us a fantastic grimace. He pulls back his chin as though he is afraid of gulping. His first concise phrases ('Don't leave' and 'I haven't finished') are whispered in a tone above his usual timbre – the tone of a small boy whose voice has not yet broken. He does not articulate. Something is stuck in his throat, it seems, as if he is afraid of his own voice, afraid of what it might bring out. When he pronounces his name for the first time, it sounds like 'Ed Wood', the film Depp was to shoot some years later with Tim Burton. In order to emphasize the filiations between the two Edwards, Ed Wood's Hollywood producer mangles his name, calling him 'Mr. Ward'.

Between child and dog

Once he is outside, Edward's eyes light up. Fascinated by the utterly pure side of the character, Depp took inspiration from the newborn. 'I did look at babies, to get the way Edward gazes at things'.[46] He played a character without any filters and even took the initiative to omit certain dialogues. 'Because Edward is not human, and not a robot, I didn't think that he would talk a lot,' Depp explains. 'He would cut through everything, and have the most honest, pure answer with all the clarity in the world'.[47] Edward is 'like a young boy', Winona Ryder agrees. 'You don't feel sorry for him, he just plays it with the honesty of someone who doesn't know how to put on a face. You know how little kids can blurt out the truth? That's what he does'.[48]

Depp embodies a unique rhythm and permanently interacts with the world. Everything is a pretext for a reaction, for twitching his face. The actor told *Rolling Stone* that he based his performance on a dog showing unconditional love. 'It's like, if a dog is trying to please the master. It breaks something, you scold it, and it goes to the corner. But as soon as you call it, it comes right back. It forgets everything. There's this unconditional love. I thought Edward would be like that'.[49] Like a clumsy, slightly stupid dog, Edward emphasizes every new discovery with his body. He walks hesitantly, curious of everything,

sniffs, jumps whenever the phone rings and runs off, sheepishly, scampering. Depp even ventures into the burlesque territory as he slips on a pair of trousers and a shirt, attempts to pick up a spoon with his scissor-hands, drinks alcohol, and then goes to bed, with his scissors beside him on the sheet. And Edward is being tamed, ridiculed with his hairgrip, smeared in creams, smoothed down, pampered. He represents all things organic in a hygiene-obsessed society that reduces its animals to figurines, transforms its dogs into cuddly toys and whose consumers swear by gadgets and trinkets. It is when he refuses to be treated like a doll by Joyce, the nymphomaniac neighbour (Kathy Baker), that he becomes a pariah.

Creating with scissor-hands

As Edward's expressions are limited, Depp must take care to maintain the right tone. He uses his appendages like accessories and turns them into real tools for communicating his feelings. He puts his talents into learning plant and ice sculpture. Later he becomes a gardener, a chef, and a hairdresser, for dogs *and* women. The scissors become part of the everyday and serve as barbecue spits, tin openers, kitchen knives.

His prostheses even stand in for words: pointed downward, they express shame or embarrassment; folded neatly on the sheets, they become signs of appeasement. When raised, they show joy; when crossed, they indicate Edward's withdrawal into himself; sometimes, they quiver. One single blade moving conveys his impatience or annoyance. Caressing, they betray his sensuality. Depp's editing out of any excess emotion is done with a barber's precision. Just like Joyce's long fingernails, his scissors become erotic tools, and Depp's acting, as a result, appears sharpened, more entrenched.

When Kim goes back to her fiancé, Edward, prey to a new feeling of jealousy, expresses anger for the first time. This was a tall order for Depp, who was not allowed to say anything. He contents himself with furiously tearing first the curtain to shreds, and then, overcome by another bout of rage, his shirt, just like a rock star. His screaming comes from his scratching scissors. The creature turns into a creator when Edward plays a women's hairdresser. His face, appearing as a low-angle shot, is silhouetted against the clouds. He who lived high up will often be associated with the sky. With his white coat, he looks like a doctor, a mad scientist, at once a healer and a demiurge.

An adolescent's hybridity

Depp succeeds in bringing something extremely juvenile and, at the same time, wise to his acting. Much like an adolescent, Edward is not finished as such. Peg, by the way, corrects her husband

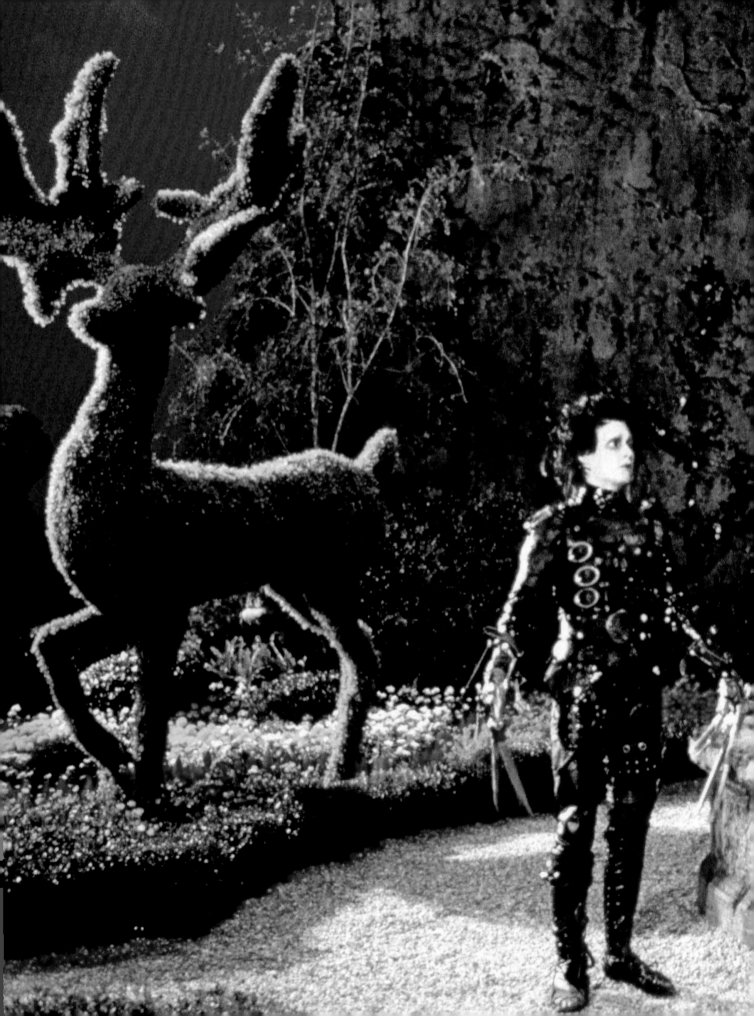

when he shortens Edward's name to Ed. 'Here the incompleteness goes from being aesthetic to becoming fictional, as an integral part of the character', Antoine de Baecque reminds us in a contemporaneous *Cahiers du cinéma*.[50] On this subject, Depp made the same remarks as Burton in *The Face*: 'I connected with it really well. I sort of already knew the character and what he represented. Edward seemed more of a feeling than a person. The metaphor of the scissors is about wanting to touch, but if you touch, you destroy. Nothing you do seems right. It's the feeling you get when you're growing up, very adolescent. I felt that way. I think everyone did'.[51]

Depp felt this schism all the more as he was being thoroughly smoothed with dyes and masks. Burton stated, 'So the themes of Edward, of image and perception, of somebody being perceived to be the opposite of what he is, was a theme he could relate to. The words "freakish" and "freak" have so many interpretations, and in a weird way he sort of relates to freaks because he's treated as one […]. You pick up a tabloid and he's portrayed as the brooding James Dean type or whatever way people want to label him as, but he's not […]. And he's probably been through a lot of that kind of stuff, so he understood that side of it. I think that a lot of the character is him. He has this kind of naive quality which as you get older gets tested and has holes poked into it. It's hard to maintain that, because you don't want to shield yourself from society and the rest of the world completely, but at the same time you'd like to maintain a certain kind of openness and feeling that you had earlier on in your life'.[52]

An adolescent perceives himself as a kind of monster. Ironically, Edward is associated with a pimple, for it is while inspecting her skin in the mirror that Kim discovers the young man in her bed. Edward protects himself behind his costume and his white clown mask, a shirt, trousers that are too big, braces, and oversized appendices in the form of long hair and gigantic nails, like a hybrid being, divine and human, pagan and demon, all at once. He does not have full control of his body and cuts himself regularly, when his emotions get the better of him. On set, Depp indeed had trouble controlling his blades from time to time and remaining fully aware of his gestures. He slipped back into being a clumsy teenager, in search of his armour, a second skin.

It's all in the eyes

Depp's acting was entirely concentrated in his gaze, and this performance required an enormous effort on his part. Much has been written about his borrowing from silent-movie actors. Distancing himself from the naturalistic performances by actors of his generation, he has frequently been compared to Buster Keaton, even though Keaton did not have the physique of the young Depp. What connects him to silent-movie actors is his placid demeanour while stuck inside his costume, and his moist gaze, his gliding, 'darting eyes'.[53] One can 'see' him think, which is a spectacle in itself. Depp also adopted the nimble approach of Chaplin, whom he openly quoted in *Benny and Joon* by Jeremiah S. Chechik in 1993. He watched the films of these two giants of the silent movie and took inspiration from Lillian Gish (her thin, purple-painted lips) and from Conrad Veidt (his sleepwalker allure and his eyes encircled with black khol), François Thomas wrote in *Positif*.[54] In his book about the actor, Fabien Gaffez sees in him a Lon Chaney in his ability to transform himself.[55]

But Depp's work with the sorrowful gaze is unique. Very few actors act out a silent despair with such intensity, as in the attic scene. 'I remember Johnny was able to do something that amazed me. I was very close to him one day, watching him doing the scene, and the next day we saw it on film, and almost without doing anything he was able to do something with his eyes that made them glassy,' remembers Burton. 'It was as if he was about to cry, like one of those Walter Keane paintings with the big eyes. I don't know how he did it. It wasn't something we did with the camera or the lighting, it was incredible and that kind of excitement – weird like little things, weird new images that surprise you – is very specific to film'.[56]

To the producer, Denise Di Novi, Depp embodied a mixture of vulnerability and strength: 'We were creating a new character and didn't want an actor that carried baggage with him. Johnny could do any movie he wants, yet he chooses to take risks on emotionally complex parts. The camera likes his cheekbones but it also likes what comes through in his eyes. He's deep, complex, intelligent, and sensitive. To me, that suggests he will fare very well'.[57] Edward learns about another form of pain as well. That is, the addiction to love: seeing Kim again with Jim, a new kind of sadness reveals itself in his eyes. When the character is unjustly accused, Depp acts like James Dean in *East of Eden* (Elia Kazan, 1955): Edward does not know how to express his sorrow and is incapable of talking. When he very nearly is lynched, he is dumbfounded. When Kim finally cuddles up to him, he is no longer frightened and instead protects her, with his almost paternal gaze fixed on her. Determined at last, as he fights with Kim's fiancé, he manages to close his eyelids. It is when one no longer sees his forever-wide-open doll's eyes that he becomes human.

If the actor expresses so much sensitivity, it is because he does not merely play a child or an adolescent, but a wise old man too. Burton raved about Depp's gaze: 'His eyes are incredible. They have the feeling of having been around for a long time, being older than his years'.[58] And Edward is indeed one of those rare characters,

When Edward is accused of stealing, Depp's performance is reminiscent of that of James Dean, unable to express his suffering, in *East of Eden* (1955) by Elia Kazan.

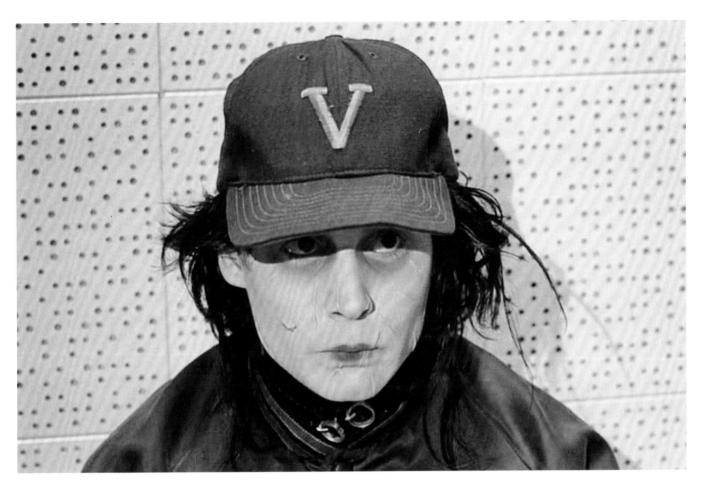

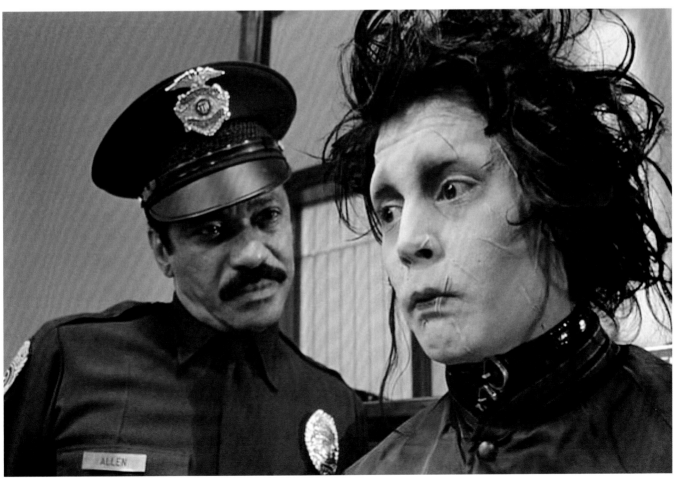

Johnny Depp and Tim Burton's partnership to date totals eight films, making their actor-director duo one of the most significant, not only in contemporary American cinema but also in the entire history of filmmaking. If it is difficult to tell who influences whom. There is no denying that they are on the same wavelength when it comes to bad taste in general (a fascination with quirky artworks and kitsch from the 1970s)[c] and B movies in particular, especially low-budget science-fiction and horror movies. Before meeting the director, Depp already shared (with John Waters) the guilty pleasures of American subculture, that is, Las Vegas, actress and singer Pia Zadora (nicknamed 'the worst artist of the century'), and books on serial killers. His conversations with Burton thus quickly revolved around old-hat singers like John Davidson. For *Charlie and the Chocolate Factory* they found inspiration

in a local TV programme from the 1960s and '70s. They frequently finish each other's sentences when it comes to evoking personalities as diverse as Errol Flynn, Peter Cushing, Casey Kasem, Ronald Reagan (one of the inspirations for *Ed Wood* in 1994) or the great 'freaks' of classic cinema, Peter Lorre, Bela Lugosi (legendary interpreter of Tod Browning's *Dracula* in 1931), Boris Karloff, or Lon Chaney. This improbable cultural breeding ground, their often kitsch imagination and child-like humour occasionally bring them to compete in zany behaviour on set. Feeling safe in this way, Depp regularly likes to surprise Burton with some improvising, and checks the effect of his off-the-wall brainwaves via the director's bodily reactions. From these non-verbal exchanges (a gesture, sigh, nod, facial expression of a sort, or laughter) the duo's best scenes evolve. When during a take one of them seeks

to provoke a reaction from the other, it is never clear who the puppeteer is. During the filming of *Ed Wood*, Depp was worried about overdoing it, being 'too cartoonesque', but Burton would push him along that path. On the other hand, when filming *Sleepy Hollow* (1999), the director had to stop his actor from wearing prosthetics for his incarnation of Ichabod Crane. The young Adonis-like seducer and Hollywood's gothic ugly duckling at times switch personalities, but create together very coherent works. As an example, their two Eds (*Edward Scissorhands* and *Ed Wood*) undoubtedly constitute their self-portraits. If Edward is an introvert who does not breathe a word, and Ed Wood an exuberant personality with a permanent smile, they are both 'freaky'. Edward is an imaginary freak, Ed Wood a real-life freak, a kind of vampire with black glasses in the blinding California sun. When Depp attempts to imitate Bela Lugosi's spellbinding hand gestures, it is as though he is trying to capture the method and talent of an actor he admires, but also the actual person who, off-camera, is pulling the strings. Burton and Depp are acrobats, dirty kids in a sandpit, fake twins at a fun fair, creatures and creators of their own charm, just as in a 'Hammer Horror'.

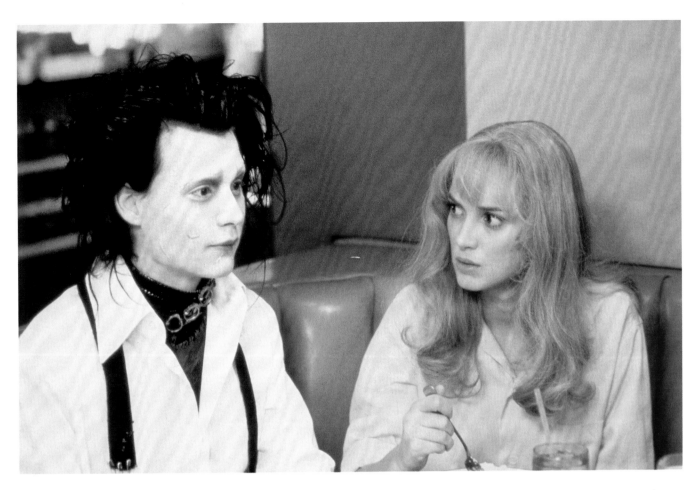

Opposite: Burton, Depp and Sarah Jessica Parker on the set of *Ed Wood* (1994).

Above: Edward has a crush on Kim (Winona Ryder). In the early '90s, Depp and Ryder formed an iconic couple that Burton described as a dark version of Spencer Tracy and Katharine Hepburn.

together with his creator and Kim, to have pupils that shine amid a totally extinguished world. Burton, who revered Vincent Price, had found in Depp an actor equally capable of using the power of his gaze.

Within the macabre tale, it is possible to change from one world to another. But one should not become absorbed by the other world. Difference enriches and nourishes the specific. That is why Edward must transform this chastisement (his hybridity) into strength. He returns to his world of shadows to create and unleash snow (the magic of creation) onto those – and they are few in number – who have the same sensitivity and ability as Kim to see him and listen to him.

Edward makes Johnny Depp

After *Edward Scissorhands* was released in 1990 in the United States, word quickly spread about it. The film was a success at the box office and received generally positive critique. Janet Maslin of the *New York Times* described Depp's character as 'a stunning creation',[59] and the actor was nominated for a Golden Globe Awards. Conversely, J. Hoberman wrote in *Village Voice*, 'Depp's eloquently sad eyes seem a factor of evident physical discomfort – hidden under a ton of make-up, hands encased inside an arsenal of implements out of a David Cronenberg film'.[60] In France, the audience found the actor intriguing.

Libération, called him a 'teenage mutant' and a 'smashing Johnny Cry-Baby Depp'.[61] The *Figaro* headline read, 'This sweet young man comes from afar' with 'his good-natured monster'.[62] For *L'Humanité*, the question was, 'Could *Edward Scissorhands* be a metaphor for Hollywood?'[63]

Depp applied himself so strongly to the character that, once filming was over, he missed this romantic, tragic creature. 'I hope this won't sound completely corny, but I loved playing Edward so much, because there is nothing cynical or jaded or impure about him, nothing mean about him. It's almost a letdown to look in the mirror and realize I'm not Edward. I really miss him,' he confided to the *New York Times*.[64]

The actor still had no idea whether his career would last thirty minutes or thirty years. Edward's impact on popular culture (the figure has been paid homage to in songs and quoted in series like *Family Guy*) gave him reason to wonder. The role acquired classical status and associated Depp with fantastical, fringe-type characters. In 2013, a fossilized lobster with very long claws, 500 million years old, was named *Kootenichela deppi* in honour of the actor!

This fable made Johnny Depp and transformed the media's and the fans' perception of him. The man who had been terrified of exposing himself, 'in that way, to a woman [he] love[d] more than anything in the world' (Winona Ryder, whom he had met six months earlier)[65]

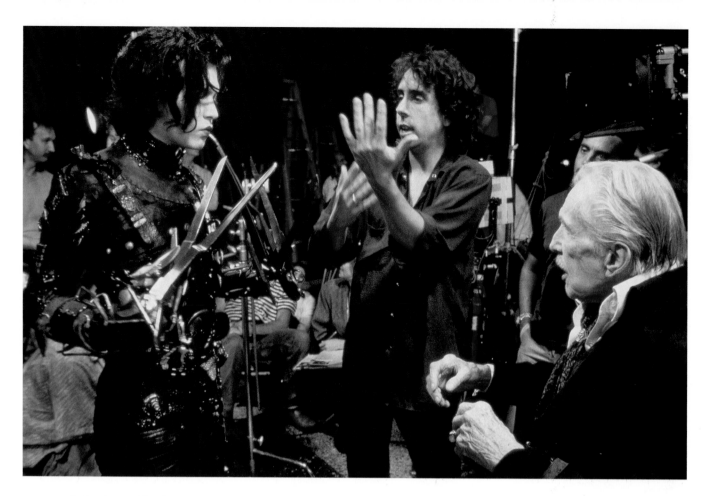

was now being hunted by the paparazzi. Indeed, the couple – 'a kind of evil version of Tracy and Hepburn', Burton called them[66] – had to fight the violence of fame, and did not survive.

Following the advice of John Waters and Vincent Price, Depp tried to preserve a certain form of freedom, maintaining his 'uprooted' existence. He had neither house nor car and preferred to walk everywhere (despite it being virtually impossible to live without a car in California). 'We used to call him the homeless millionaire', John Waters recounts.[67] Often very ironic, as in his interviews in *Rolling Stone*, he teased journalists, talking about everything from Houdini, Jesus and Al Capone to his tattoos, his hair, his nightmares, his profound fear of clowns (a theme he later developed when playing the Mad Hatter in Tim Burton's *Alice in Wonderland*) and his passion for old books, including his at times very costly passion for first editions of his favourite authors.[68] He dreamt of buying Bela Lugosi's or Errol Flynn's house, but wanted to take his time and not choose roles in terms of what they may bring him. Nor was cinema his only preoccupation: 'I'd love to have kids. I'm rapidly approaching thirty. I want to put down roots, have kids, dogs, pigs. When I'm fifty or sixty, I want to have all gold teeth, a big fat belly, a big thick beard. I'm working on my belly'. He rolled up his shirt

to reveal not even the beginnings of a gut. 'Maybe I should drink a few beers or something. Once I get to a certain age, I want to be this big, fat, ugly American', he said to *The Face* in 1991.[69]

Even though Depp's next film did not transform him into a caricature, it is still America that he portrayed, in both a sunny and twilit manner, in collaboration with an exiled European filmmaker.

Above: Burton, who revered Vincent Price (seated, right), found in Depp an actor equally capable of using the power of his gaze.

Opposite: Eschewing the naturalistic interpretation of actors of his generation, Depp has frequently been compared to Buster Keaton, with whom he shares a placid demeanour and 'darting eyes'.

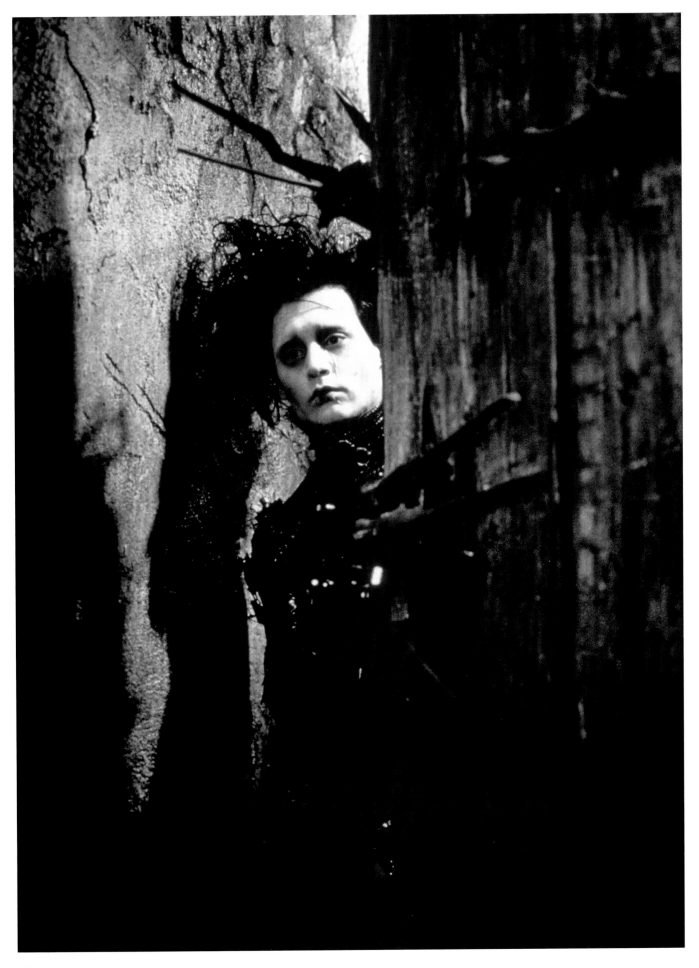

3

Axel Blackmar

Arizona Dream (1994)
Emir Kusturica

'Some directors feel so strong a need to discuss every scene in detail that they end up killing all the mystery, all the freedom. Emir, on the contrary, leaves the board blank. You can throw yourself at it, without thinking, and see what comes out of it. If it works, fine, if it doesn't, do it again. I believe, as an actor, it's important to surprise yourself'.[70]
Johnny Depp, 1993

After *Edward Scissorhands*, Depp wanted to do films that looked like him. He had changed since *21 Jump Street*, reinvented himself, and the success of Tim Burton's film allowed him to imagine a non-conventional career. Emir Kusturica, living in New York, was looking for a young actor for a new project, the entire action of which takes place in the United States. Depp, deeply moved by *Time of the Gypsies* (1988), the director's then most recent film, believed he could experiment further with a European filmmaker who was not already shaped by Hollywood.

Kusturica wanted to adapt *The Arrowtooth Waltz*, a script by one of his students at Columbia University, David Atkins. The core storyline is an initiatory journey, a rite of passage: Axel Blackmar, a young New Yorker, is summoned by his uncle to meet him in Arizona, where he falls in love with an older woman. Kusturica makes it into a parable of the disenchanted American dream. He infuses the film with his fantasy universe and adds a prologue and an epilogue set in Alaska, with an Inuit fisherman, a young girl suffering from depression and a monomaniacal actor waiting for success.

An encounter of two different sensitivities

From their first meeting at the Beverly Wilshire Hotel in Los Angeles, Kusturica and Depp kept their distance. The former, taciturn, didn't master the English language very well, and the latter didn't really understand the man he was dealing with. But Kusturica was impressed by the actor's attitude and approach. In an interview by Jean-Pierre Lavoignat for *Studio Magazine* he explained, 'My first reflex was to resist my impulse. Perhaps because I feared he represented something I really don't like, Hollywood! I had not seen his TV series, but I had seen *Edward*

Scissorhands, and despite the make-up, he clearly showed – in his eyes, his gaze – an energy, a very positive energy. And then, when meeting him a second time, I discovered the human being. I was truly impressed by his personality […]. He has a huge sensitivity, but here, that's not what they want, they don't need it, they're not interested. He has enormous potential, a very wide range'.[71]

Kusturica realized that Depp had 'got something' when he heard him play the guitar. 'That is more important than how good an actor he is. Who cares? Everyone could be an actor', he proclaimed.[72] This sensitivity nourishes the role from within. The director saw Depp as one of the biggest talents of the moment: 'In America I've stopped meeting people with secrets. They just become part of the CNN global system. He has *secrets*, and secrets are the main sign of human existence. It's beautiful to have a guy who has not been eaten by TV civilization, who is still human in spite of it'.[73]

The two men, who shared a love of Kerouac and Dostoyevsky, quickly became friends and played music together. Kusturica had found his Axel. He chose, as his partners, Jerry Lewis (the old uncle, a car dealer), Faye Dunaway (Elaine, the older woman), Lili Taylor (her stepdaughter Grace) and Vincent Gallo (the obsessive Paul Blackmar, whose pseudonym, Paul Léger, stands for 'born actor' in French, according to him).

The director liked to take his time, and the filming, which began in 1991, was never-ending. Kusturica was going through a difficult period and at times remained sitting under a tree for hours, searching for inspiration. His homeland, Yugoslavia, was being torn apart by civil war and his dying father passed away two weeks after the shooting had ended. A nervous breakdown forced him to stop everything for three months. But the team remained totally committed and the actors waited for him to recover. Depp even declined other projects. These painful periods inspired the woeful tone of a film whose initial four hours was edited down to almost half in its final version.

A character between two worlds

Following the prologue in Alaska, and a red balloon linking the dream to reality, Depp appears, reclining in the back of a pick-up truck,

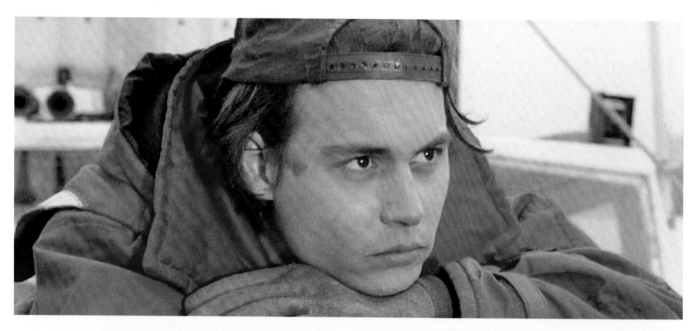

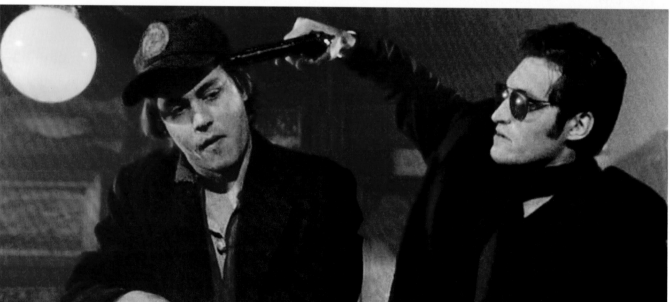

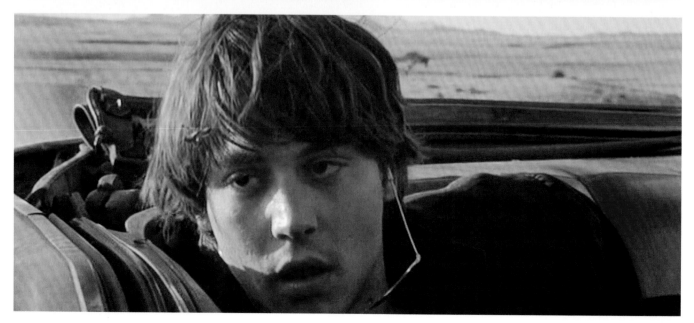

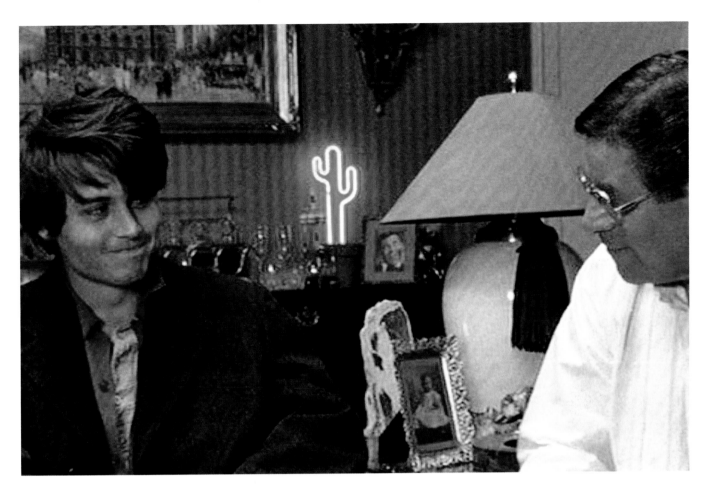

amid ropes and fishing nets, his face hidden underneath a cap. When the balloon bursts, the dream is over and it is time to wake up. The introduction to the film's hero, presented as a vagrant of a sort, a social reject from America, is strange, to say the least. But Axel does not seem that unhappy. He emerges, smiling. And then we hear his enticing voice talking of America, a voice that immediately sets up a distance between the spoken and the real, as though the character is withdrawing from himself.

In a single shot Depp breaks free. He gets up and zigzags between the boats crisscrossing New York harbour. From this very first scene, the actor rids himself of Edward Scissorhands' rigid costume. This was his first film shot outside, and he looks radiant! The camera dances around him and moves close to his face, as a friend.

Depp saw Axel as a kind of Holden Caulfield, the hero of Salinger's *The Catcher in the Rye*, only more positive,[74] a character to whom he related, having himself left school very young and moved from place to place with his family. But Axel is no runaway teenager. He is a twenty-three-year-old man with a melancholic, dirty face, the older brother of Chaplin's Kid of a sort, with his back-to-front cap and his oversized coat. He is a solitary fisherman who loves New York because 'you can watch without being seen'.

Just as in the dream of the prologue, Axel identifies with a fish, a dissymmetrical halibut whose eyes migrate as it grows. Depp indeed borrows its expressionless mien, its dumbstruck, open-mouthed look and its vacant stare, estranged from the world. Like Kusturica, who, when arriving in Prague, had felt like a 'small solitary fish swimming round the empty streets of a Baroque city, […] a mute fish incapable of doing even the most fundamental things for his livelihood',[75] Axel does not see anything. And then, he is carried around like some puppet and follows his cousin Paul to Arizona.

Depp immediately establishes both a distance from and a bond with Vincent Gallo in the New York bar scenes. When the two actors look one another up and down and repeat over and over again the same sentences, like Scorsesian actors (a style of acting that Kusturica admired and the disappearance of which he deplored), we soon understand that something holds them apart. Axel has a moonlike face, Paul a very angular chin. He wears a black, quite austere jacket and dark glasses. And he imitates the poses and accents of his favourite stars. Axel prefers loose-fitting clothes and sports a nonchalant look, with tousled hair and a bin bag as suitcase.

Playing up and playing down imitation

Depp knew how to create a real chemistry with his fellow actors, notably with Jerry Lewis, with whom the question of imitation arose.

On the set, all ideas were welcome and now and then the characters merged with their actors. For the Alaska scene, Depp, who conscientiously learned his phrases in Inupik, was advised by Lewis to just invent as he went along. 'My first day of shooting, I'll never forget, with Jerry Lewis, this legend, I was trying to be as creative as he was with this made-up language, to try to make it sounds the same […]. It's Jerry Lewis! It's easier for you, Jerry!' Depp recalled,[76] terrified from day one on the set by this legendary comedian, whose creative mind he admired.

When Axel wakes up in Arizona, to the ethereal music of Goran Bregovic, with his shades sliding off, eyes half closed and his mouth askew, Depp is already venturing onto the terrain of his older master. To become worthy of his uncle Leo, his childhood hero, Axel will do everything to become a salesman: wear a tailored suit, a bow tie, hair like a choirboy. Paul even teaches him to pronounce the word 'Hello' in a sexy manner. Like Lewis, Depp plays with his mouth, his pout, works on the accent, the tone, makes his face elastic and flexible. He ends up looking like a pretty toy (and he does indeed become Elaine's sex toy). And yet, when Leo suggests a way for him to earn money, he is not interested. 'Although I loved his eau de Cologne, I'd never be like him', he lets us know. But Grace warns him, as soon as she sees him in his uncle's garage: 'In spite of you, you become your parents'. So, how does one free oneself from one's background? What exactly is an actor, an idol? How do you learn from your peers, from your fathers, and most importantly, how do you distance yourself from them all?

When Axel and Leo watch a home movie, we learn that the young boy, orphaned at the age of six and raised by his uncle, has drifted between two countries, Mexico and the United States, before ending up in New York. Depp watches this movie, as he will later watch Bela Lugosi's final rushes in *Ed Wood*, with a pained expression. Not only does he see Leo, but Lewis too, a titan, one of the last of his kind, whose cohort from bygone days no longer exists. Leo's America, the America of Cadillacs and the golden age of Hollywood, has become tattered. Nobody wants those bulky, flashy cars that have faced competition from foreign, much more functional models.

It is the America of icons, the America of Jerry Lewis, and Faye Dunaway, the 1960s and '70s star who will always be Bonnie Parker for the actors of her generation, that Depp is soon to become part of, by dint of an ironic blink of an eye, improvised by Vincent Gallo (this take was kept in the final cut), and whose character will not allow a young girl to kiss him in the cinema.

PAUL: No, I'm not kidding. We can make love but
 don't touch my face or my hair.
GIRL: Are all actors like that?

PAUL: All the great actors are. Do you think
 anybody touches Brando's face?
GIRL: No.
PAUL: Or Pacino's?
GIRL: No.
PAUL: Do they touch De Niro's face?
GIRL: No.
PAUL: Or fucking touch Johnny Depp's face?
GIRL: No.
PAUL: No one's gonna touch Paul Léger's face,
 okay?

An actor in suspension …

Few actors can match Johnny Depp when it comes to creating moments of suspension. As in *Edward Scissorhands*, everything is an excuse for observing something: the rotating fan, Elaine's legs, Paul chatting up the girl at the movies, Elaine's drawn-out arguing, the peculiar Grace who plays with her tortoises. Depp does not need to do much. His face, still child-like despite his twenty-nine years of age, lends itself beautifully to the camera. With his punkish, spiky hair, as if he has just got out of bed, a napkin tied round his neck, and open mouth, he grabs hold of his spoon in the way a child would and sees the others stirring, bemused and amused. 'If you want to see Johnny Depp's greatest moments in film, look at the scenes where he has no dialogue. He's the most brilliant listener in a movie', Vincent Gallo proclaimed.[77] Probably influenced by his work as a musician, Depp knows how to hold back.

In the talent-show scene, when Paul Léger repeats a cult moment from Alfred Hitchcock's *North by Northwest* (1959) before a jury of astonished Texans who liken him to a robot, Axel seems fascinated and sceptical at the same time. What Kusturica admires in Hitchcock is the rhythms, the framing, the tension, the precision and the art of sequencing,[78] the very antithesis of his own filmmaking, which is more risky, more improvised. Paul Léger is the incarnation of an obsessive actor, an absolute mimicker, the type who never finds his own style. By reproducing the golden-age icon Cary Grant's gestures down to the finest detail and removing them from their context, he comes close to caricature. Depp, dumbfounded, appears by contrast very light – *léger* – in this scene, as if acting is simple, and difficulties wash over him and it is possible to be funny without doing anything, in two shots. It is him, and not Paul Léger, who has Grant's *sang-froid*, his refined gestures and comical talent. Murray Pomerance, in his book on Johnny Depp, notes that in his observational technique he also resembles Grant, rather than Montgomery Clift, who played more on introspection.[79] But he looks like a studious schoolboy too, feeling his way. His inner questionings are also those of an actor in the making.

To be worthy of his uncle, his childhood hero, Axel does everything he can to imitate him and becomes a car dealer, although the money doesn't interest him.

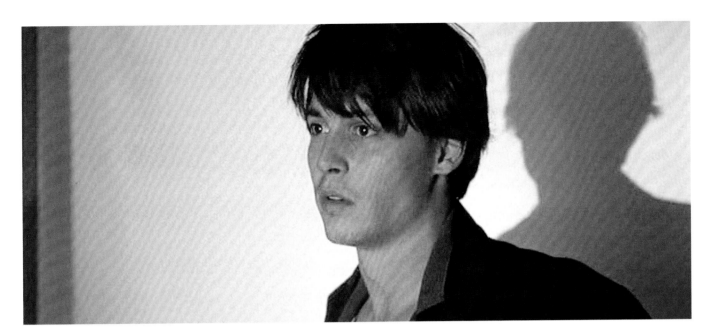

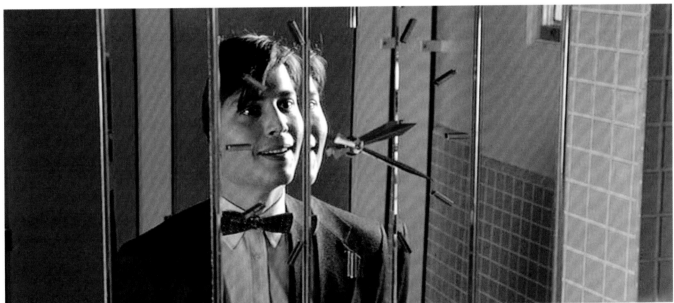

... and on a winning streak

Representing a new generation of actors, Depp distanced himself from the classic tradition. He was more mannered, more cautious. In 1991, the American male had changed. He did not ooze virility and in that sense came close to Jerry Lewis, who had often played 'eternal child' characters. In the first meal scene in which he competes with Paul in trying to seduce Elaine, he observes, sighs, runs a finger under his nose and sprinkles milk on his cousin's face. 'He's young, he's a kid', says the latter while wiping his face. Some time later, it is Grace, jealous because of the night Axel has spent with Elaine, who throws a glass of milk in his face. But the young man could not care less and carries on eating his cereal, his face soaked. He even takes another helping. Depp is well aware of his charm. The impudence of youth.

Acting for a European director indisputably enabled him to free himself of American standards. He worked at length on the dialogue scenes with Kusturica, who, as Christophe d'Yvoire noted, 'gets rid of any ready-made intonations and modifies his facial expressions. He doggedly rejects clichés so as to construct his own world, almost syllable by syllable'.[80] All the while giving a wide margin of freedom to Depp, who, for example, brought a piglet onto the set for an improvised scene with Jerry Lewis.[81] Just for

the fun of it, and because he saw his character as a young cockerel, Depp offered to mimic a hen. He put on Elaine's white skirt and cackled his way through a long, screwball sequence. Depp joined the director's universe, whose bestiary he was able to partake in, with animal spirit, mud, sweat and feathers.

He appeared to be ceaselessly trying to deconstruct his Caulfield, so as to act with more lightness, and not take his handsomeness too seriously. In order to become an actor, one needs grace – and to not be Paul Léger. One must somehow offload the solemnity from the creation, make oneself lighter, Depp and Kusturica seem to be saying in one of the film's opening scenes, in which Axel throws peanuts at the filmmaker, who cameos briefly on the screen. Axel makes fun of everything, dances, bashes into things, fools about and then hurts himself, sniffs and fights like a puppy-dog with Paul, in the dust. After making love, he smokes not one but three cigarettes, all at once. He plays truant with Elaine in an isolated ranch in the American countryside where time seems to have stopped. They both wear clothes that are far too big, inappropriate and retrogressive: him, pyjamas, blankets or boxer shorts; her, a long, white Western skirt. The trunks in the attic are filled with treasures, with machines to be made, dreams to be reinvented. In this promiscuity, their bodies search for and find each other.

Above: Axel grabs hold of his spoon in the way a child would and watches the bickering around him with a bemused expression.

Right: Ed Wood in a straight skirt, one of many experimentations with the feminizing of Depp's body.

Following pages: Axel, an Icarus mechanic, takes Elaine (Faye Dunawaye) for a drive in his flying machine.

Depp and disguise

Johnny Depp has carved out roles not only in the realm between childhood and adulthood but also in that between masculine and feminine. 'God, how can you act so casual when you're dressed like that?' Dolores Fuller (Sarah Jessica Parker) shouts at Ed Wood (Johnny Depp) when she sees him for the first time in a skirt and angora jumper. Depp continued to make use of this quasi-feminization of his body, first experienced in *Edward Scissorhands* – through the costume, the 'beauty' creams, the gait – during his entire career.

He developped a real taste for distortion and disguise, and acted with disconcerting spontaneity, not least when wearing a glamorous dress *à la* Rita Hayworth and a blond wig in *Ed Wood*. Also in *Arizona Dream*, in which he tried on women's hats, for, unlike certain actors of a previous generation, De Niro for example, proud of their manliness, Depp loved to play heterosexual characters who cultivate an ambiguous side within them. In *Don Juan DeMarco* by Jeremy Leven (1994), he ended up in a sultanate, where he was forced to dress as a woman

and wear a veil. He played a drag queen in *Before Night Falls* by Julian Schnabel (2000) and ambled around, overly made up, swaying his hips *à la* Marilyn Monroe. For Burton, he played the precious and frightened detective Ichabod Crane in *Sleepy Hollow*, the eccentric asexual Willy Wonka in *Charlie and the Chocolate Factory* and the Mad Hatter in *Alice in Wonderland*, tackling strong female characters. Yet another way to cover his tracks and 'disappear'.

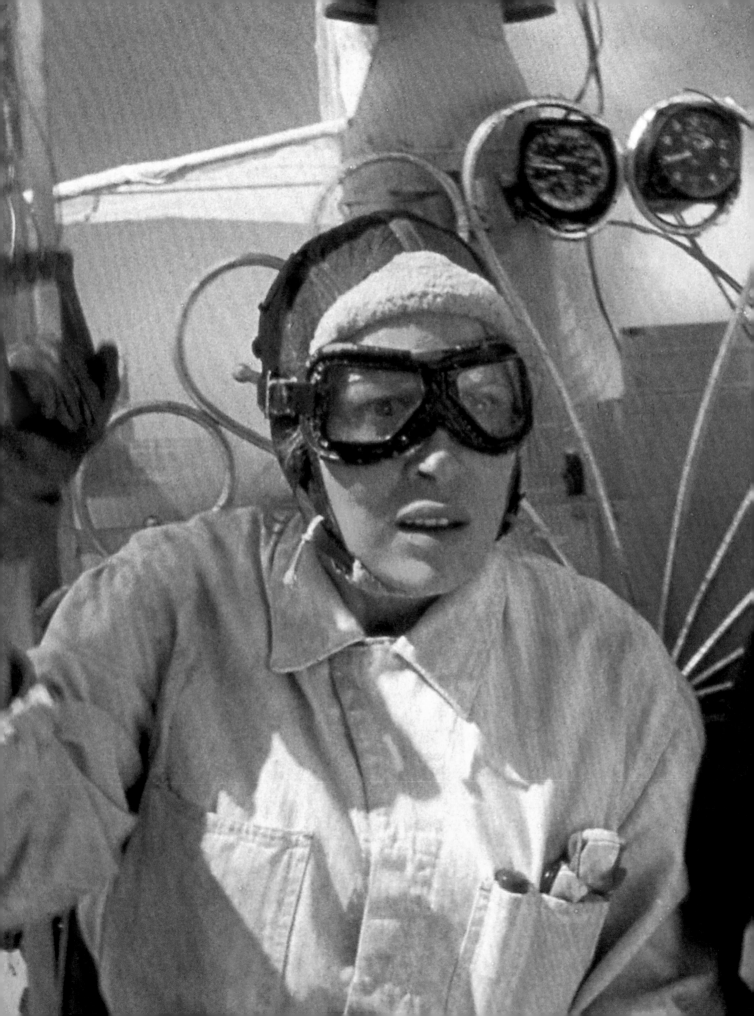

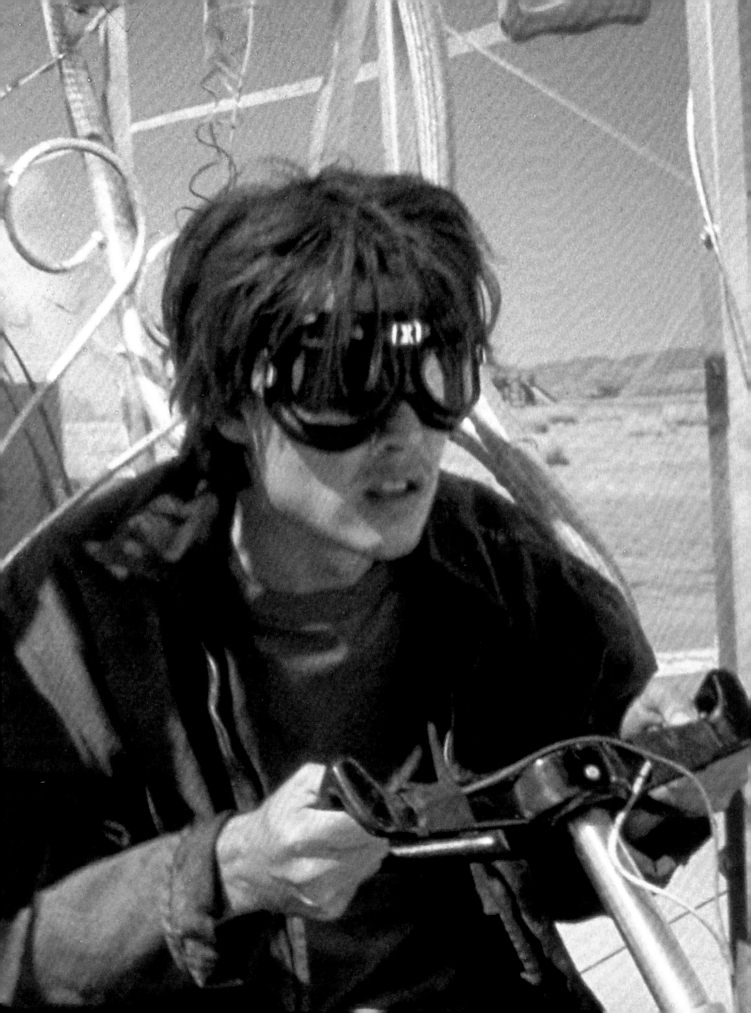

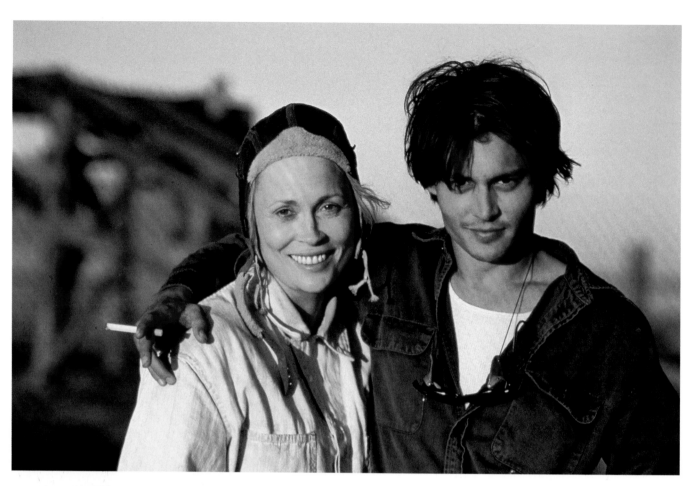

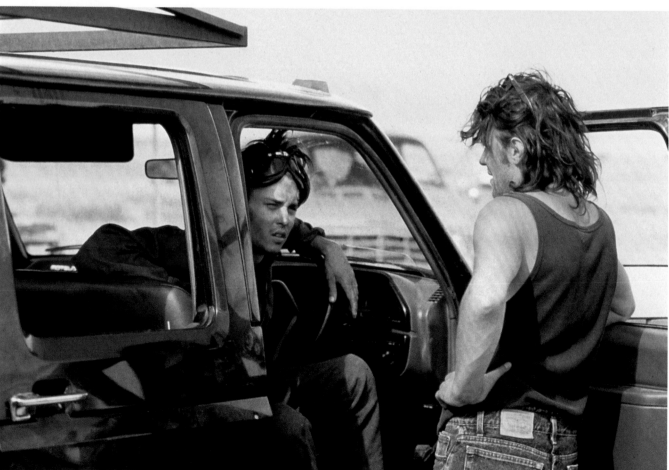

Top: On the set, Depp encouraged the other actors, not least Faye Dunaway who, at the age of fifty, had to play a much younger woman.

Bottom: The actor and his director enjoyed a close collaboration. Depp plays Axel, but also Emir, the exiled gypsy, torn between two continents.

Following the example of Kusturica, whose aim is to 'raise people, literally, to make them take off',[82] Depp is an inventor of flying machines, an Icarus mechanic. Contrary to Roger Thornhill in *North by Northwest*, Depp wants to fly, build, at the risk of coming to grief. He wants to get his hands dirty, to uproot himself, and take root at the same time.

'It took a lot of courage [from Kusturica and the producer Claudie Ossard] to go into a project like this', Depp later admitted.[83] He avoided mentioning his own audacity, but surely saw himself as an inventor of old-fashioned, rattling machines, on the brink of crashing, and he must have thought twice before accepting the role. Indeed, finding the right freedom of tone and completely letting go was not always easy. All the actors stayed in character during the filming, he revealed.[84] Depp himself injected a lot of energy into the set and helped the other actors get into their roles, not least Faye Dunaway, quite fragile at the time, who, at the age of fifty, had to play young women and who, just like her character on screen, became jealous of Lili Taylor when the script was altered along the way. On finding out that she would like to trampoline, Depp travelled miles to find her one. 'We set up the trampoline in the middle of the desert, and in less than a second she became a twelve year-old girl again', the actor recounted.[85] Also, Vincent Gallo noted that his relationship with Depp evolved during the filming, and that he felt excluded from the close bond that existed between Depp and Kusturica. As it turned out, the former played Axel but also Emir, the exiled gypsy, torn between two continents. For Depp, the actor, this was an impossible mimicry, which was to become his hallmark: being there without being there, in exile from himself.

Between wrench and melancholy

Depp's subtly tanned complexion, illuminated by Vilko Filac (who worked with him again on *The Brave*) beautifully captures the Arizona glow, its nocturnal heat and velvety dawns. The white-as-the-moon actor from *Edward Scissorhands* radiates like the sun through his lens. He is the very image of heart-wrenching love. Seldom since has he been seen smiling and laughing as naturally as he does here.

But it was also one of the rare occasions for showing his many aquatic faces, bathed in tears, sweat, milk or rain, surprisingly, and contrary to the more sensible characters he has since portrayed. Depp does not seem at ease when having to cry, which he goes about bashfully, like a little boy, in the scenes of first Leo's, then Grace's death. And yet, he loves acting melancholia, and when asked about this, Depp claimed that he is 'neither sad nor lonely, but finds these qualities easy to tap into'. He has a great understanding of the vulnerability of people; an empathy with solitude and the daily heartbreak of ordinary life.[86]

A far cry from the smooth beauty of Tom Hanson, his character in *21 Jump Street*, Depp's face, here linked to the earth, darkens throughout the whole film. With his hair and clothes falling about him, he gradually changes from a young schoolboy observing the world to being a cub, the tip of its nose slightly greasy, and that bares its teeth in front of Paul. The melancholia of this 'wild stallion' (in Elaine's words), grubby like a teenager, is rapidly set ablaze when he plays Russian roulette with Grace. Audiences have retained the romantic image of Depp pointing a revolver at his throat, as it sums up the melancholy pessimism of a film that incarnates the disorientated youth of the 1990s. Although seemingly not very comfortable with the revolver, he does in this scene show some anger (of which the first signs appeared in *Cry-Baby*), something new in his acting, profound, chthonian, more savage, more sexual, overflowing. His breathing is mastered to a T and given yet again the perfect rhythm. He knows how to build up the tension.

After Leo's death and Grace's suicide, in a very non-Hollywoodian ending (the tree burns, the family roots are destroyed), Axel returns to his uncle, in an abandoned house, quite simply happy to be alive. Depp's voice-over, delivered as a poem, circles, drifts and envelops the audience like a breath of wind, warming them a last time.

Depp: a cult figure in Europe

Released in France on 6 January 1993, the film was shortened by 20 minutes when screened in the United States, starting on 9 September 1994 (it was distributed in its original version in January 1995 in a small number of cinemas). Poorly attended, *Arizona Dream* astounded its American critics but became a cult movie in France. 'Wildly off-the-wall reverie', wrote the *New York Times*,[87] '*Arizona Dream* is the quintessential Nuart movie', said the *Los Angeles Times*.[88] The *Chicago Sun-Times* found it 'a dazzling, daring slice of cockamamie tragicomic Americana envisioned with magic realism by a major, distinctive European filmmaker [...] goofier than hell'.[89] After this equally intense and painful experience, Kusturica, Lili Taylor and Johnny Depp contemplated filming a modern version of *Crime and Punishment*, in Brooklyn, but the project never came to fruition. *Arizona Dream* won the Silver Bear at the Berlin International Film Festival and the Audience Award at the Warsaw International Film Festival.

Again, a far cry from the stereotypical macho hero – Arnold Schwarzenegger is, incidentally, mentioned at the beginning of *Arizona Dream* –

Depp's imaginative spontaneity seems very refreshing. Susan Morgan, in *Harper's Bazaar*, hailed the characters played by Depp: 'After a decade dominated by bullies, political and cinematic, Depp's off-kilter heroes provide a delightful antidote to the automaton brutes, vengeful suburbanites, and noble defenders of public truth that so many male movie stars seem determined to play these days. His characters don't wield automatic weapons or sneaky agendas, nor are they models of admirable behavior; they wrestle with misunderstanding and thwarted desire'.[90]

In the teen magazines, read by Depp's fans, the film was described as surrealist, complex and bizarre. But they found the actor very brave. 'The former pin-up looks ready to play grafters, sociopaths, doomed romantics, sexy flotsam, saints', Stephen Rebello wrote in *Sky Magazine*.[91] Still, the media seemed more interested in his romance with Winona Ryder and in his unusual outfits (he has frequently been awarded the prize for the 'worst-dressed male celebrity') and Depp had to constantly dodge the issue. From his private life, though, nothing or nearly nothing filtered through. He hid behind his treasured directors, John Waters, Tim Burton and Emir Kusturica. During interviews, the naturally shy actor revealed his passion for Tod Browning and for his collection of dead insects, and quoted underground directors like Neal Jimenez, at the risk of creating an eccentric image of himself. But although he might have a sharp tongue and a short fuse, he was not the bad boy that the media was enjoying presenting him as. Vincent Gallo, who honoured his acting, found this street urchin or hipster façade the least interesting aspect of Depp. 'If only he would allow himself to be who he really is, somebody who's traumatized and trapped by his childhood and emotional life, then he would be interesting, a great person, a great talent. He is one of the funniest, most talented, likeable, sweet, authentic people I've ever met'.[92]

In 1990, Depp was not 'bankable' like Tom Cruise, for example. In *Studio Magazine* he was very quickly branded a 'Hollywood rebel' alongside a generation of young actors like River Phoenix, Keanu Reeves, Gary Oldman and Brad Pitt. *Arizona Dream* was received with enthusiasm, although some criticized the film for not really finding the means for its outrageousness, with the characters drifting, without knowing quite what to do with their freedom. The *Canard enchaîné* found that the film 'flounders around in its own craziness, but never takes off'.[93] 'Johnny Depp struggles to give more than a hollow impression of this Axel, a McGuffin as overelaborate as it is laboured', Joël Magny wrote in *Cahiers du cinéma*.[94] But the actor's charm and energy resonated with some: 'I believe it is the vitality of American filmmaking […]

that has produced this type of actor', *Les Lettres françaises* said.[95] Depp, who hates seeing his films again, could with *Arizona Dream* look at himself without blushing. He was now ready to plot his own course.

On this unmarked path along which he had set out, the actor was going to encounter death, the death of a poetic character lost in the American space, that of a disunited nation, forever inscribed on his face and in his body.

Audiences have retained the romantic image of Axel pointing a revolver at his throat, a symbol of the disorientated youth of the 1990s.

4 | William Blake

Dead Man (1995)
Jim Jarmusch

'I did *Dead Man* so that I could work
with Jim Jarmusch. He's a director whom I trust,
a friend and a genius'.[96]
Johnny Depp, 1995

In 1994, Johnny Depp was at the peak of his
career. He had recently shot *Benny and Joon*,
Gilbert Grape and *Ed Wood* and by virtue
of these choices continued to attract attention
from independent filmmakers such as Jim
Jarmusch, with whom he committed himself
to one of the most ambitious and beautiful films
of his filmography. *Dead Man* is an iconoclastic,
metaphysical and poetic western. With
a $9 million budget it was the director's most
expensive film. Jarmusch liked the atmosphere
verging on the fantastical in little-known
westerns such as *Blood on the Moon* (1948)
by Robert Wise. The film studio accepted his
insistence on using the radiant black-and-white
photography of his chief cameraman, Robby
Müller, to make a temporal difference, a return
to cinema's early days, and to recreate the
atmosphere of the 1940 and '50s black-and-
white movies with an oriental resonance,
in the vein of Ozu, Mizoguchi and Kurosawa.

When writing the lead role, Jarmusch had
Johnny Depp in mind, whom he knew and
to whom he had presented the storyline a year
prior to writing the script. The actor once
again took on a title role, that of William Blake,
a young man from Cleveland who has lost
everything and goes by train to Machine, a town
in the Wild West of the United States, where
he has been promised a job as an accountant.
The story unfolds during a pivotal period:
the American government is encouraging the
massacre of bison so as to decimate the Native
American population. But time is against Blake.
When he arrives at John Dickinson's (Robert
Mitchum) factory, his position has already
been filled. Alone at the end of the world, he
spends the night with a young woman, Thel
(Mili Avital), whose lover he kills in self-defence.
Wounded in the heart during the fracas and left
for dead, he is nursed by Nobody (Gary Farmer),
an educated Native American who mistakes
him for the eponymous English poet. While
Dickinson sends three bounty hunters after him,
Blake continues his journey West with Nobody.

Several stars – John Hurt, Gabriel Byrne and Iggy
Pop – make cameo appearances in the film.

Depp, the driving force of the film

Because of his demanding roles, Depp was
most probably considered to be an intellectual
actor by some directors. And yet, it was
the actor's more instinctive side that attracted
Jarmusch. 'Just like myself, he's a ditherer.
He can never decide which restaurant to go to
[…]. He's incapable of concentrating on anything.
But as soon as he starts acting, his concentration
is extraordinarily powerful', the director
recounted.[97] 'He is just as capable of improvising
as of keeping unscrupulously close to the already
planned'.[98] 'He is very intuitive […]. It's kind of
contradictory because he's incredibly intelligent
and smart, but he will react from his heart
and not from his head. For me, really good actors
don't act, they react; they become a character
and they're put in a situation that their character's
in and react to it'.[99]

Right from the prologue, Depp motivates the
whole spirit of the film. Pale, with longish hair,
small round glasses, a black hat, matching jacket
and trousers, a cravat and a pocket watch, Blake
sniffles discretely and straightens up in his seat,
as though the actor himself is settling in to his
role. Judging by Depp's oblique glance at the oil
lamp dangling from the ceiling, his somewhat
haughty pout and evading look in his eyes, it is
already clear that this man is feeling out of place.

Depp has fully assimilated Jarmusch's
characteristic slowness, his intrinsic pulse. In the
next shot, he is no longer wearing his hat and has
fallen asleep in a very uncomfortable position.
The road is clearly never-ending. Later, with
downcast eyes, Blake is entertaining himself with
a pack of cards. A woman smiles at him, but he
does not respond. Through the blinds, he glimpses
an abandoned carriage. Instead of the thick
forest there is now a rocky landscape, scattered
with bushes. Unabashed, the character snoozes.
The compartment has filled up with moustached
fur trappers, armed with guns. Only one woman
is present. Ill at ease, as though tarnished by the
onlookers' gaze, Blake sinks deeper into his seat,
pulls the brim of his hat further down over
his brow and falls asleep.

Depp, as William Blake,
was ideally suited for
the intrinsic slowness
of Jim Jarmusch's films.

He sleeps so as not to see the people around him and not meet the others' gaze. His fleeting eye movements contrast with the wide shots on the locomotive's thundering axles. Behind him a fur trapper has fallen asleep leaning against his gun. Now only a handful of travellers occupy the compartment. Woken up by a snore, Blake turns round, looks again through the window, hardly perturbed by the change of scenery and the three torn tepees in the middle of the prairie. In *Go West* (1925), Buster Keaton relied on his own innovations to illustrate the notion of time passing. Depp here uses his accessories: a pack of cards, the hat pushed back, the review he flicks through with a circumspect look, the quick glance at his pocket watch, the suitcase, resting on his knees, behind which he is taking refuge.

The closer he gets to the Wild West, the further he moves away from literature. 'I wouldn't trust no words written down on no piece of paper', the engine driver warns him when Blake shows him his job offer. The young man is sad; he has lost something precious. When at the end of the sequence the fur trappers shoot at the bison, Blake, gripping his suitcase, jumps violently, transfixed by the sound that propels him into the film.

Another innocent role

Viewing the Wild West, Blake is immediately shocked. Muddy roads, free-running pigs, horses urinating in the street, bison-hide commerce, battered faces, freshly made coffins. One can almost smell the dreadful pong from the tanneries. It is no longer possible to appear evasive, the character must demonstrate that he is affected. Machine is the end of the line, for everybody. Filmed in an old mill in Virginia City, the place seems forever haunted, with its ghosts, snow-covered hills and freezing cold.

Here, Depp again plays a lost, candid person, a sad clown in a surreal universe in which anything can happen, an innocent James Stewart type (as in John Ford's *The Man Who Shot Liberty Valance*, 1962). John Badham, who filmed the actor in *Nick of Time* immediately after *Dead Man*, saw an obvious filiation with this sacred Hollywood freak: 'Who's the Jimmy Stewart of the '90s? Nice, unassuming, unpretentious? Johnny has a basic sweetness to him. He's a classic movie actor, like the true greats – Paul Newman, Gary Cooper, even Steve McQueen. Minimalist in approach, but extremely honest. Johnny is that kind of actor. He has this great ability to be in a scene where he may do nothing, yet establishes his presence on the screen'.[100] 'Portraying a provincial guy lost in the modern world is in fact what launched the careers of both James Stewart and Gary Cooper', Luc Moullet reminds us in his book, *Politique des acteurs*.[101] But both actors were of course much taller than him. And even though

Depp has James Stewart's facial expression, as when he opens his mouth wide, or remains silent, he is very rarely brought in to play the average American. 'And where did you get that goddam clown suit? Cleveland?', exclaims Dickinson upon catching sight of him. The workers in Machine mock his Sunday-best allure and Depp knows better than anyone how to show stilted indignation. In the arrival scene at the factory, one is also reminded of Anthony Perkins' finesse in *The Trial* (1962) by Orson Welles. During the filming, Depp admits: 'I hope that this is the last of these innocents I play!'[102] But of other actors of his generation, only he can convey fragility in this way, with his boyish physique and his gestures shot through with subtle delicacy. And that is precisely his manner when, strolling about in Machine, he elegantly jumps over a puddle of water.

Despite being small, Depp has a great presence, which contrasts with John Hurt's grimy complexion and Robert Mitchum's gravelly accent. 'Depp's face possesses a beauty usually reserved for apostles and saints and silent-movie stars. Draped over perfect bone structure, his impossibly pale skin is without a line or crease – this despite thirty-one years, too many cigarettes, other interesting substances and frequent extreme acts of human expression', Holly Millea wrote in the British edition of *Premiere* at the release of the film.[103] His voice is clear cut, without any accent, that is, an accent from the better-off neighbourhoods. And indeed Depp is not sure where this accent comes from. He recalls losing his original Kentucky accent years earlier and admitted in *Newsday* to not always being comfortable when having to place it.[104]

The encounter with Robert Mitchum (for whom this turned out to be his last screen role) was all the more disconcerting, partly because the two actors' share Native American origins, but also because it highlighted the profound difference between Depp and classic actors of a moral fibre like Mitchum. 'The incongruous appearance of Robert Mitchum in this sequence ultimately highlights, and reflects on, the presence of Johnny Depp in a western', Francisco Ferreira noted.[105]

A face as a blank canvas

Rejected by Dickinson, Blake, the city-dweller of the East, gets lost in the factory maze, but eventually finds his way out before he wanders off into the streets of Machine. He has no job, no money, hardly enough to pay for the small bottle of whisky that he softly handles, turning it again and again. With this gesture, Depp exposes the bottle's insignificant size and thus explains to what extent Blake is a reduced character. Like Dirk Bogarde

Right from the prologue, in the train taking Blake westward, Depp's rather haughty pout and evasive eyes make it clear that his character feels out of place.

Following pages: In the forest, Blake meets a group of trappers, one of whom, Salvatore Jenko (Iggy Pop), dresses as a woman.

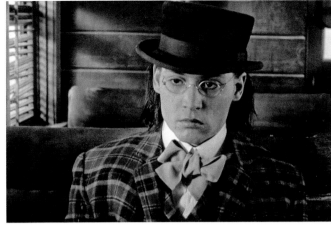

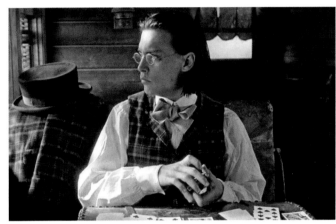
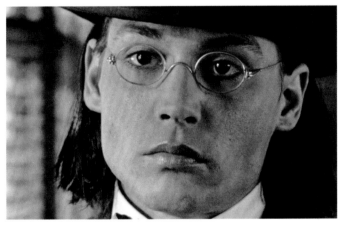
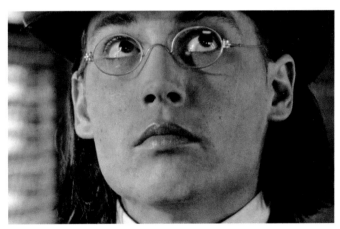
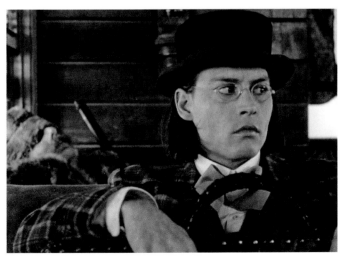
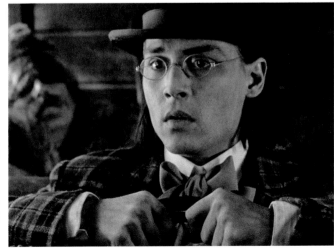

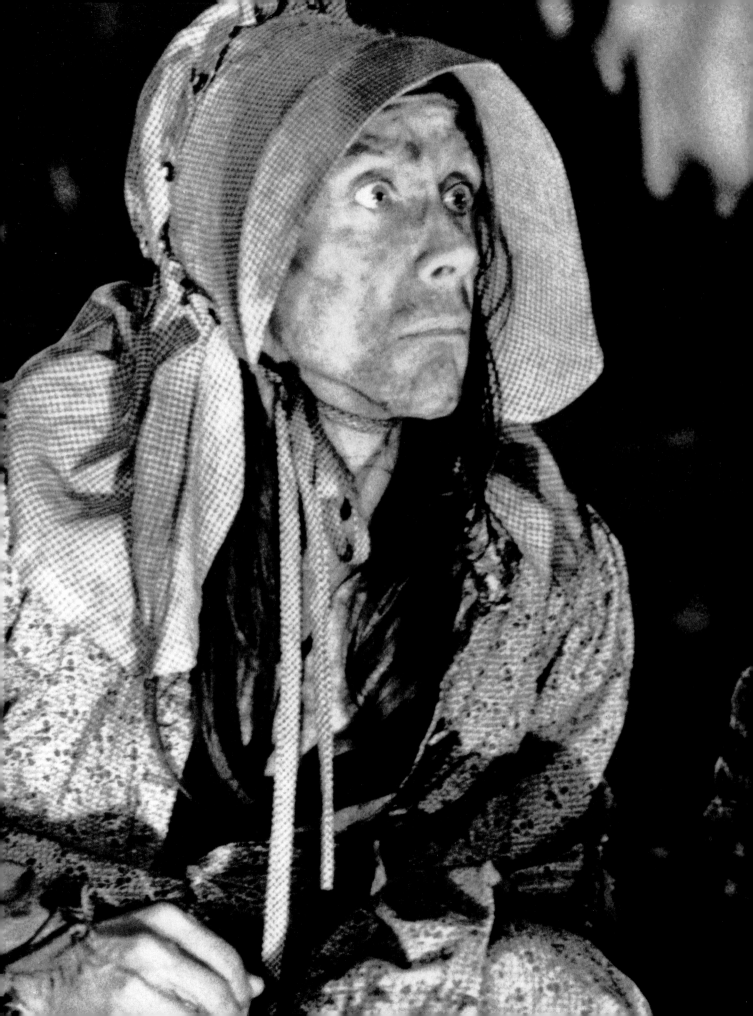

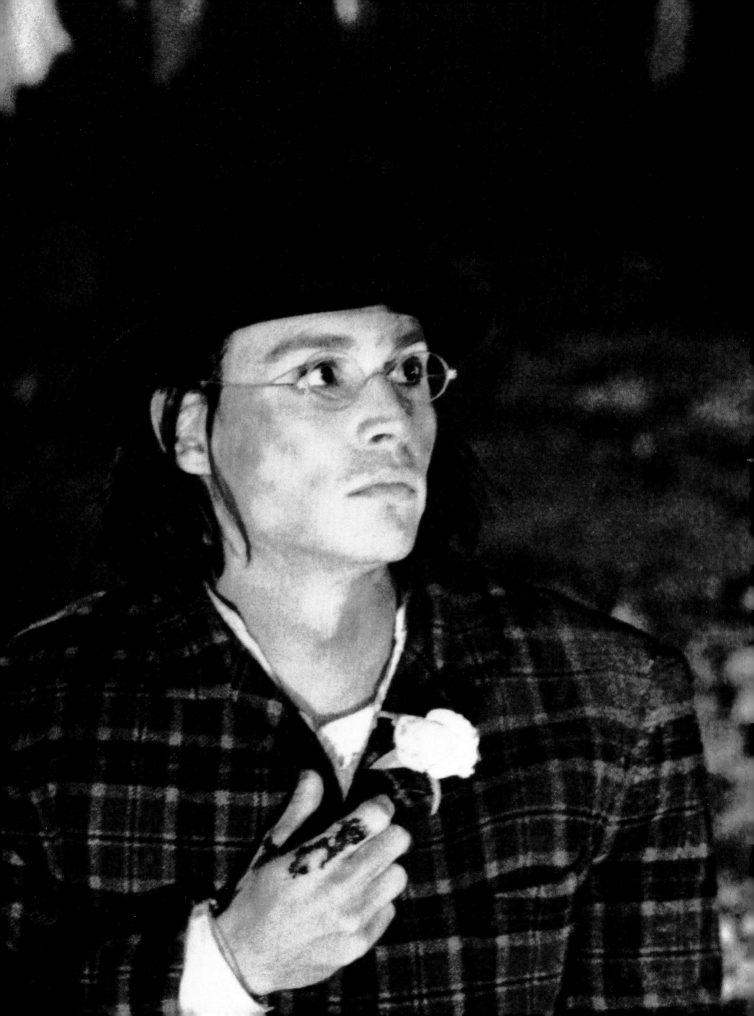

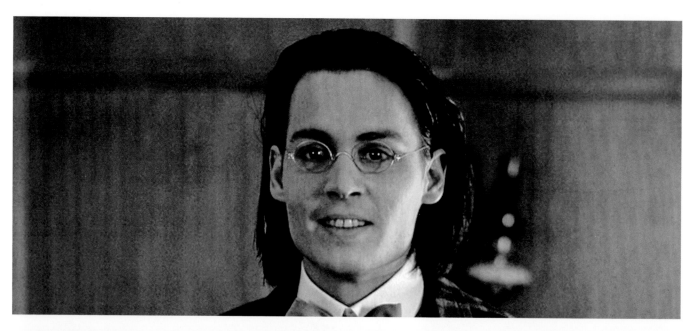

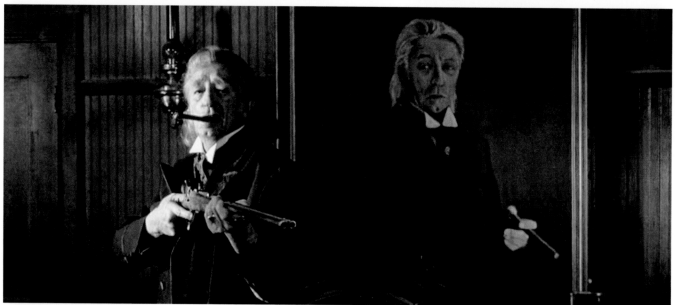

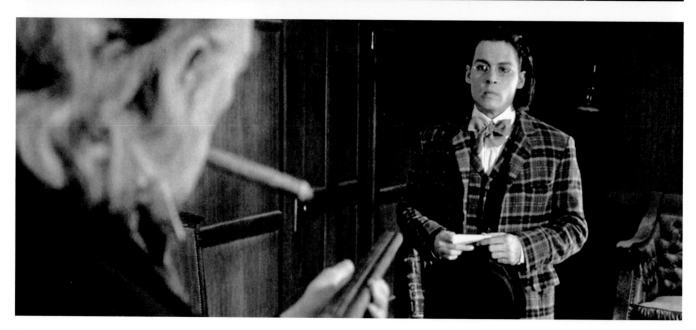

Opposite: Arriving at Machine, where he has been promised a job, Blake learns that the position has been filled. His interview with the factory boss, John Dickinson (Robert Mitchum), is rather unsettling.

Right: Alone at the end of the world, Blake spends the night with a young woman, Thel (Mili Avital), whose lover, Charlie Dickinson (Gabriel Byrne), he is forced to kill.

Following pages: During a vision quest, Nobody (Gary Farmer), an educated Native American who mistakes him for the eponymous English poet, sees a skull on Blake's face.

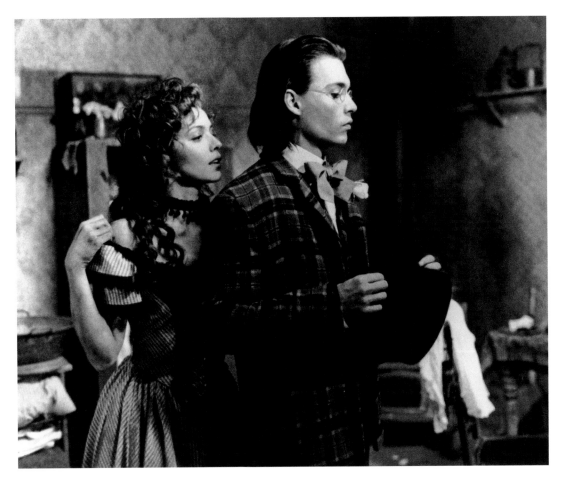

in *Death in Venice* (Luchino Visconti, 1971), he is heading toward his own decline as he enters Thel's lair, a naive and despairing look in his eyes. After a brief intimate moment, Blake, shiny-eyed like a doll and half-smiling, has only one wish: to disappear. When the young woman's fiancé, Charlie (Gabriel Byrne), finds them in bed together, Depp hides among the sheets, just as he will in *Sleepy Hollow*. One senses that he enjoys slightly 'overplaying' the scary side of the situation. Blake ends up mortally wounding Charlie, who in turn aims at Blake's heart.

From the moment he is back in the forest, dying and in his underwear, everybody wants to touch him, put him back in his clothes, rename him. Blake is 'like a blank piece of paper that everyone wants to write all over', Jarmusch declared.[106] 'He has this fresh and pure appearance, this paleness that makes one want to cover him in graffiti'.[107] And Blake is affected by it all. Nobody draws two zigzag 'flashes' on his cheeks and the fur trappers caress his 'girly hair', thus highlighting the incongruity of his delicate features in this virile universe. The young man enters into their game as he smears his face in blood from a fawn, a gesture improvised by the actor. Rain then moistens his face, liquefies it until it nearly dissolves into the landscape, and brings death to him. Made-up painted faces and broken glasses have indeed become distinctive features of the actor

and were notably picked up again in Roman Polanski's *The Ninth Gate*.

Chased by bounty hunters, Blake is driven to commit lawless acts: he kills trappers, marshals and a bigoted missionary (Alfred Molina). It is because Nobody gives him the name that Bill Blake becomes William Blake. He is just a passer-by, carrying somebody else's name. He is also a hero who does not learn from life. 'He's branded an outlaw totally against his character, and he's told he's this great poet, and he doesn't even know what this crazy Indian is talking about', Jarmusch explained. 'When Nobody leaves him alone after taking peyote, Blake is left to go on his own vision quest briefly, whether he knows it or not, because he's fasting – not because he wants to but because he doesn't know how to eat out there'.[108]

The character becomes someone through performing his poetry with blood. The only time he uses a pen is when he puts his signature to his 'wanted notice', before slamming it hard into the missionary's hand. 'He's not an outlaw, violent-type guy, but he gets made into a wanted, hunted criminal. And Johnny has that too, in that he has the ability to let others project things onto him. And it happens to him in his real life as well – movie star, bad boy – whatever they project onto Johnny seems, to me, so far off from who he really is'.[109]

In Dana Shapiro's words, this role strikes 'a parallel with the young guy from Kentucky

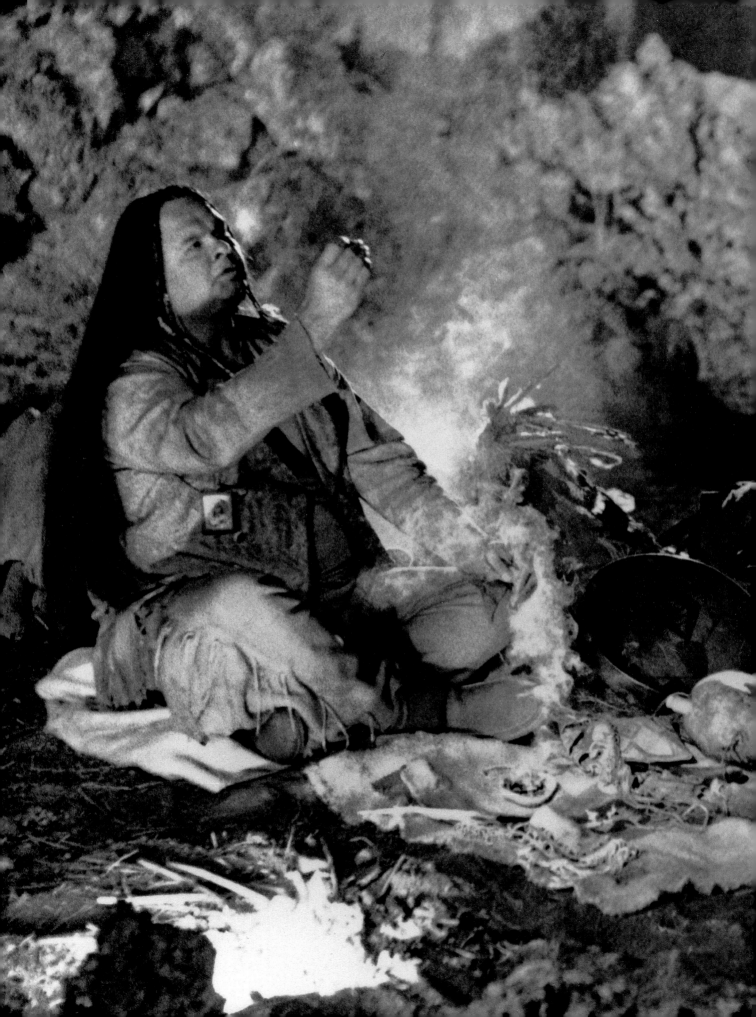

who has come to Los Angeles to land a recording contract and who's ended up adorning the front covers of all the teen magazines, having become a youth idol, despite himself'.[110]

A disappearing actor

For Jarmusch, the linear scenario of the film 'unravels gradually',[111] and Depp seems to follow the same trajectory. Pretending for two hours to be a lethargic fish that suffocates, without overacting, and maintaining a certain irony, is a challenge. The actor demonstrates genuine humbleness when letting his partners express themselves on the screen.

The duo he forms with Gary Farmer, a virtually unknown Native American, is emblematic for this notion of 'disappearance'. Nobody is, literally, 'no one', Outis as in the Homeric Odysseus, the theatrical mask, the stereotype. He is neither a star nor a celebrated poet, but he alone knows about poetry and speaks several languages (English, Blackfoot, Cree, Makah), none of which are translated, deliberately. Blake does not understand Nobody's language. The quotes from *The Marriage of Heaven and Hell* sound out deliberately as Indian proverbs. For the white American's conquest of the West is unmoved by poetry.

Gary Farmer, whose face is round like Johnny Depp's, engages in a mimetic play as he steels Depp's sunglasses ('Perhaps you see much better

without them', he says to him). He mimics Depp's stilted movements of the mouth, the image of the White Man's disdain, and in his way eclipses him. Nobody is a guide, a Virgil leading Dante out of Hell. He practically steals the picture from Depp, who, from being his own persona must become a person in his own right.

Acting as reverberation

When Depp confidently steps forward, with a veil before his eyes and, almost facing the camera, shoots at the two Marshals, just as in Edwin S. Porter's *The Great Train Robbery* (1903), one imagines he is going to apply another, more violent tactic. And yet, the actor manages to preserve his delicate character and kills with very sparse means, simply lifting one eyebrow. His acting appears to indicate an eternal return. Like a machine, he again becomes this character who never ceases to doze and wake up, doze and wake up. He repeats what he has already said, and his voice, still very soft, at times almost inaudible, gives the film its musicality. When he recites 'Auguries of Innocence' by William Blake ('Some are born to endless night'), he marks a pause, as though his echoing voice is fading into nothingness. Edward Scissorhands is not Depp's only incomplete character: Axel searched for infinity in Alaska, and William Blake seems to be perpetually reborn.

Above: Lying down close to a fawn killed by a hunter, Blake gets closer to nature the further west he travels.

Opposite: Wounded during the fracas with Charlie Dickinson, Blake is nursed by Nobody.

➡ Excerpt from *Dead Man*

NOBODY
What name were you given
at birth, stupid white man?

WILLIAM BLAKE
Blake. William Blake.

NOBODY
Is this a lie? Or a white man's
trick?

WILLIAM BLAKE
No, I'm William Blake.

NOBODY
Then you are a dead man.

WILLIAM BLAKE
I'm sorry. I d – I don't
understand.

NOBODY
Is your name really
William Blake?

WILLIAM BLAKE
Yes.

NOBODY
*Every night
and every morn,
Some to misery are born.*

*Every morn
and every night,
Some are born
to sweet delight.
Some are born
to sweet delight.
Some are born
to endless night.*

WILLIAM BLAKE
I really don't understand.

NOBODY
But I understand,
William Blake.
You were a poet and a painter.
And now, you are a killer
of white men.
You must rest now,
William Blake.
*Some are born
to sweet delight.
Some are born
to endless night.*

71

Depp, being the film's musical driving force, is capable through his acting of dictating a certain type of orchestration. He progresses at the pace of the harmonium, the out-of-tune piano and the electric guitar. The use of reverb and of a single family of instruments enhances the feeling of profound solitude, as though the rock music, which collides with the world of westerns, has come from far, far away, from the bowels of the earth. This mineral music, echoing in the wind, drives the actor through the film. It punctuates his heartbeat, highlights his lethargy, the monotony of his walking, the infernal circularity of his life. As an invisible character, it speaks for Blake, accompanies him to his death.

To Jarmusch, Blake was 'a vessel carrying us through the film'.[112] Each scene is composed independently of the others, so that the actors avoid referring back to the preceding one. Thus the film is conceived as a poem, with blank spaces between the sequences, similar to stanzas.

A graphic face

What is so striking is that Depp, imprisoned in his narrow, chequered costume, all trussed up, appears to exist entirely through his face. We do not see his body. The way he knits his eyebrows, the actor's true signature, concentrates his acting's expressiveness into one sensitive spot. His eyes

spin without him moving his head, just as in a cartoon. Besides, he seldom smiles, and his only cheerful moments are intended for Thel or Nobody.

During the peyote ceremony, when Nobody sees a skull instead of Blake's face, the chief cameraman frames Depp close-up, old style, bringing out the actor's pale, androgynous face in chiaroscuro, under his black hair. The background is blurred, and his face looks as though embalmed, detached from the body, resembling a medallion. He could be perceived as a vanitas from the seventeenth century, showing us his ephemeral beauty and the fragility of existence. This skull-face also evokes Mexican art with its frequent representations of death as well as the experimentations of the Surrealists, often under the effect of hallucinogens.

Through the use of different tones of grey and contrasting textures, Robby Müller elicits several truly ghostlike expressions with bulging eyes, worthy of some of the pioneers of photography and of ethnologists like Edward S. Curtis (Jarmusch and his chief cameraman drew inspiration for the costumes, sculptures and canoes from Curtis's film *In the Land of Head Hunters*, dating from 1914). Jarmusch most likely chose Depp because his face, at once European, American and Cherokee, seemed haunted by the memory of his ancestors and the Native American genocide. Depp is 'one

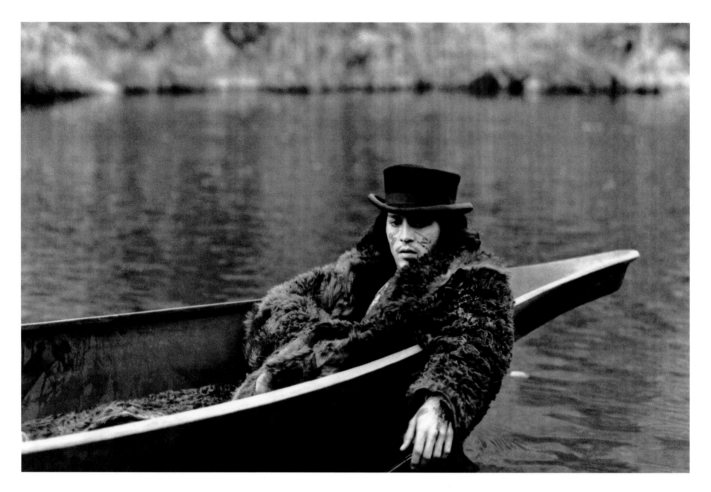

of the most haunted beautiful actors in American movies – a presence whose brooding quietness and mystery suggest Buster Keaton', Jonathan Rosenbaum summed up.[113]

Cut off from its head, Blake's body becomes more vegetal, more mineral as the film progresses. The further west he travels, the more the character looks like the surrounding nature, as though going backward in history. He reverts from the industrial era back to the primeval waters. When Nobody leaves him behind in the forest, Blake continues his metamorphosis alone as he looks at the giant sequoias, sacred like cathedrals, lingering at their shredding bark, shot close up, with its points and microscopic projections reminiscent of Henri Michaux's mescaline drawings (quoted in the film). With his coat, curly-haired like the moss on the trees, he appears to be experiencing an animistic moment. After the murder of the missionary, while Nobody, on horseback, gets ready to leave, Depp, looking small next to him, climbs up onto a small stone, then squats down, as though he, all alone on his island, is going to change into stone himself. Death itself regains its dignity, lost on this devastated earth, which perverts all rules. It regains its natural rhythm and Blake follows the sun's daily course. He is not really a character any longer but a work of art.

This incredibly graphic and hybrid facet of the actor is crystallized into one single shot (which again was chosen for the film's poster): Blake, hit a second time in the heart, proceeds in a canoe with Nobody to the village of the Makahs. The character is an itinerant contradiction, a condensed image of America, with his Native American hair and face paint, his white-man-from-the-East hat, his fur-hunter coat typical of the Wild West and his revolver.

Playing dead

Upon arrival in the remote village, Blake, who is still drifting in and out of his torpor, relaxes his body as if he was relieving himself of a burden. He passes out, like someone whose perception is increased tenfold by drugs. The Makahs have to carry him, helping him to walk, in an extraordinary scene. Depp does indeed frequently play a character on the verge of falling, and the lethargic body is a recurring theme in his films: sleeping (*Arizona Dream*), blackouts (*Sleepy Hollow, The Ninth Gate*), falling (*Pirates of the Caribbean*), narcolepsy (*Fear and Loathing in Las Vegas, From Hell*).

The sequence is conceived as an echo to Blake's arrival in Machine. He can no longer walk straight and has trouble moving forward. Nor is he alone any more but accompanied, supported even, but what he sees around him is a mirror image of the world. The rhythm of Depp's acting influences the editing, and not the other way

Above: Wounded a second time in the heart, Blake is evacuated by canoe.

Opposite: Nobody prepares his friend for his final journey. Depp's face betrays slightly oriental contours in these last shots.

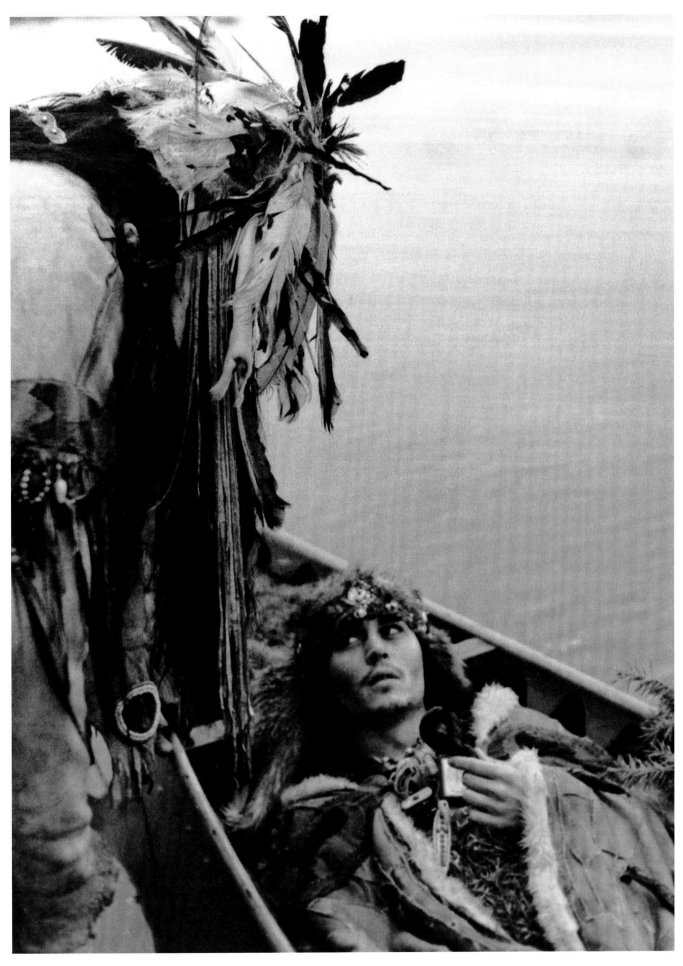

around. In the peyote ceremony, his fluttering
eyelid dictates the fading into black. Here,
a simple glance gives rise to the shot of the sewing
machine, the superimposed Native American
faces, and dictates the saturated sounds.

Blake, in a weak, exhausted voice, admits
to Nobody that he does not understand his culture,
and that he does not smoke. He thus merges with
eternity, having failed to grasp that in the Native
American culture, smoking or burning plants
is what triggers visions. But here Depp's voice
is somewhat different, tainted with irony. Blake
seems to join Nobody's allusive game at last.
And the actor's dead body is finally embalmed
for the ultimate journey, adorned with garlands,
headgear, a coat embroidered with a whale,
and some cedar branches. His face, betraying
slightly oriental contours in these last shots,
attempts a last awakening before the eyelids close.

Depp changes register

Presented in competition at Cannes at the same
time as *Ed Wood, Dead Man* inexplicably
returned home empty-handed. The American
press, generally sceptical, missed out on the
masterpiece, finding Depp 'sad and lost',[114]
and the film too long, with its 'allegorical
pretensions'.[115] Biographies of the actor,
for that matter, very rarely mention the film.
Even the French press was not always gentle
with this 'wonderful comedian dressed
as a hippy clergyman',[116] lost in 'a web
of pseudo-philosophical lines',[117] and talked
of 'a bunch of actors puzzled by their own
presence on screen'.[118] Despite its poor
American box-office returns, some critics,
such as Jonathan Rosenbaum, however,
very quickly understood that this was one
of the major films of the 1990s.[119] *Dead Man*
won a number of prizes, and today figures
on college and film school syllabuses.

In 1995, Depp worked on many projects.
As he was being accused of playing only eccentric
roles, he decided it was now time for something
different, that is, to interpret a 'Mister Everybody'.
When *Dead Man* was released, the American
press was more interested in his roles in *Nick
of Time*, a popular thriller, anchored in reality,
in *Don Juan DeMarco* (Jeremy Leven, 1994),
in which he acted alongside Marlon Brando,
and in *Donnie Brasco* (Mike Newell, 1997),
in which he played an ex-FBI agent. But after
Waters, Burton and Kusturica, his encounter
with Jarmusch demonstrated the extent to which
Depp needed to work in partnership with others
in preparation for his roles. These supportive
collaborations had provided him with wings
for a new leap into the unknown: the actor trying
his hand at directing.

Johnny Depp on the set
of *Dead Man*, in a shot that
was cut from the film.

Raphael

The Brave (1997)
Johnny Depp

'Sure there will be people who won't like it, or who won't understand the humour I've put into it, but at least it will be a film that's like me'.[120]
Johnny Depp, 1997

The Brave is the story of Raphael, an illiterate Native American who agrees, for the sum of $50,000, to die in a snuff movie in order to save his family from poverty. The scenario did the rounds of various production companies for several years before landing in Depp's hands. 'I immediately hated the adaptation of Gregory McDonald's novel of the same name. It was full of clichés, a sort of Christ-like allegory that was a long funeral march without the slightest bit of humour', he explained.[121] But the central idea fascinated him: was it possible to sacrifice one's life out of love, for those you love?

Depp had already directed a few film clips for friends, made a twelve-minute-long documentary, *Stuff*, in 1993, and an anti-drugs short film, *Banter*, in 1994. He felt that the right time had come to direct a feature film and asked to rewrite the scenario with his brother Daniel, a writer, imbuing it with his own, darker vision. The actor, who had predominantly acted in independent movies, had a flawless celebrity profile. But the project was risky, especially as the film studio refused to finance it and would only give Depp the final cut on condition that he take the main role.

A gruelling shooting

As a first experience, the pressure was enormous. In particular, the scenario seems unaccomplished. Raphael lives in a shantytown, has an alcohol problem and has already been in prison. The film does not dwell upon snuff movies as such, but narrates as a countdown the last week of a man who has agreed to be executed without having talked to his wife Rita (Elpidia Carrillo) or his children. Although the original idea is strong, many other elements still beg questions. Not at any point does Raphael ask whether his family perhaps would prefer him poor but alive. The majority of the characters are equally left open to interpretation.

Like Blake in *Dead Man*, Raphael is already dead when the film begins. He has run out of alternatives, he has given up (in the original scenario he fought harder). To those who criticized Raphael for not taking up arms to defend himself, Depp retorted in *Interview Magazine*, 'But, in a way, going into a snuff movie is like going into battle for this guy, because of his upbringing. He doesn't have a real education, he's done a couple of years in prison, he can't get a job because of that, and as a Native American and Mexican, he's been exposed to the kind of racism that really does exist in this country. He wants to provide for his family but he can't, so it's a really extreme situation – and a very heavy subject to deal with'.[122] The actor-director wanted his character to be an anti-American postmodern hero, a very difficult idea to convey.

Furthermore, seventy per cent of what was shot did not occur in the script, since Depp, on the basis of his own experience, encouraged his actors to improvise. But being in charge of everything, he very soon realized that directing and acting were two different things. Despite being in good company, with Vilko Filac as cameraman and Iggy Pop as composer, and despite asking Emir Kusturica and Jim Jarmusch for advice, the shooting proved, by his own admission, rather testing. 'To be a director, you have to be in complete control of the set, complete control of the surroundings, and very aware of what's going on, on the set. It's insanity! To be an actor, you have to be, in a sense, out of control', he admitted to *Studio Magazine*.[123] But what he found most difficult was having to watch the film's rushes, he who hated seeing himself on screen. For two weeks, he suffered a mental block about this exercise. 'Everyone was asking me a lot of questions at the same time, and I had a lot of trouble clearly explaining what I wanted', he recalled.[124] Despite all these difficulties, Depp threw himself into the film, not only physically and emotionally but financially too. '*The Brave* was the most difficult thing I've ever done and I was an idiot to attempt it. It's way too much work for one person. You get up before anybody else and you go to bed later than anybody and when you are asleep you are dreaming about it. I don't know that I'll ever catch up on the sleep I lost', he admitted at the release of the film.[125]

The shoot took place at Ridgecrest, between Los Angeles and Death Valley. 'The hottest seven

Raphael, an illiterate Native American who agrees to be paid to die in a snuff movie in order to save his family from poverty, hints at the future Jack Sparrow.

weeks of my life', he remembered. Floyd 'Red Crow' Westerman, who plays his father in the film, explains: 'At first I thought Johnny was taking on more than he could handle with *The Brave*. I've only seen one other guy who directed and acted in the same film. That was Kevin Costner in *Dances with Wolves,* but I've seen Kevin break a couple of times and tear after someone and get mad. I haven't seen that in Johnny. He goes beyond getting angry. He likes off-centre, artsy roles as an actor, and he's that way in his personality, too'.[126]

Profile portrait of an actor

The relatively successful opening scene is interesting in that it shows Johnny Depp's vision of himself. The actor appears, alone, after a long tracking shot across a shantytown in the desert, and seems in this way to fuse his body and soul into the garbage. He then climbs inside a caravan and gazes at his sleeping children. *The Brave*, which the director wanted to be 'as a very organic drawing, as honest as possible',[127] brings to mind his documentary, *Stuff*, a long sequence filmed as a tracking shot in a slum covered in graffiti, and intended as the image of the sordid life of the musician John Frusciante during his heroin addiction.

Raphael is Jack Sparrow – before Depp played the pirate – with longish hair (a constant feature with Depp), a bandana tied over his forehead, a shirt half open over his hairless and tattooed chest, worn-out jeans, olive skin, and a certain rocker allure. Depp is no longer the naive, slightly effeminate accountant from *Dead Man*, nor the translucent Edward Scissorhands. His face, frequently shot close-up, captures the light as it did in *Arizona Dream*. Here, the actor appears more muscular, more as a man of the soil. The boots give him a heavier gait. We see more of his body than in *Dead Man*.

But having to direct himself seems to have made him uncomfortable. It is obvious when, in one of the film's very first shots, he is sitting in front of the dilapidated depot, puffing nervously on a cigarette. His gaze is elusive, he is biting his thumb, as though frightened by finding himself in command. The camera clings to his eyes, but also to his body, his fits and starts, his hesitations. He is filmed in chiaroscuro, as he climbs the stairs of the depot, until his face is completely hidden, below a setting sun. Modest and shy, he is reduced to a shadow when making love to Rita in the desert.

The fascinating Brando

Depp benefitted from a significant advantage in his film, namely the unexpected participation of Marlon Brando whom he met when shooting *Don Juan DeMarco* and who had always been his idol. What he admired with Brando, beyond his acting, was the man himself, his detachment and his way of thinking. And he indeed had written the role of McCarthy, the snuff-movie producer, for Brando, though without having dared to ask him. When Brando called him up on the shoot to ask whether things were working out all right and whether he had got someone to play McCarthy, Depp answered in the negative. 'Fine! I'll do it', said Brando. For Depp to have his 'guardian angel' in the film he was directing was like a gift from heaven.[128]

A mysterious character, McCarthy appears for only ten minutes at the beginning of the film, in a wheelchair, with grey, thinning hair and a small Texan cravat, in the gloomy depot where the snuff movies are supposed to be filmed. Nothing more is revealed of him, nor of his handicap (an experience gone wrong?). He reappears at the very end of the film, in a single shot. Depp first and foremost shoots Brando's shadow, in the way a child would film a dinosaur. Raised, nearly always framed within a low-angle shot, or seen from the back, opposite Raphael, Brando seems to have intimidated the young director. In fact, Depp shares only one scene with him at the very end of the money-exchange sequence, when they clink glasses. It is as if he wanted Brando to appear alone in the shot, as if he was afraid of showing himself on the same level as him. This scene brings all the young director's humbleness to light.

McCarthy talks to Raphael about the pain and ecstasy of death, comparing it to our birth. 'The great strength of this performance resides in the actor's "act", Brando reciting his lines as though he himself were suffering and letting the moment of ecstasy show on his face', Jean-Louis Leutrat wrote.[129] Next to him, Depp, monosyllabic, tries to absorb his words and smallest gestures, in order to seize something from his art. The scene is strange, for the two actors say very little; the young director appears to be forcing the words and the tears from his mentor. Brando and Depp share in their work an attitude or approach of 'trial and error', of real and false hesitations, a desire to speak of the forgotten people's America and to make a unique, full-length feature film (as for Brando, *One-Eyed Jacks*). 'What we have here is just a little bit of shadow play', Brando groans. Comparing snuff movies and violence as part of the acting profession might have engendered a vertiginous *mise en abyme*, but Depp does not explore that avenue. Instead, he hints at prostitution, after having confessed his Faustian pact to a priest, whom he asks to keep an eye on his family – a comparison he in fact already made in 1992, declaring that '[t]he problem with this profession is that either you're a whore, or too picky'.[130]

A final hesitation before meeting the producer of the snuff movie (Marlon Brando). Next to his favourite actor, Depp tries to absorb his words and smallest gestures, to seize something from his art.

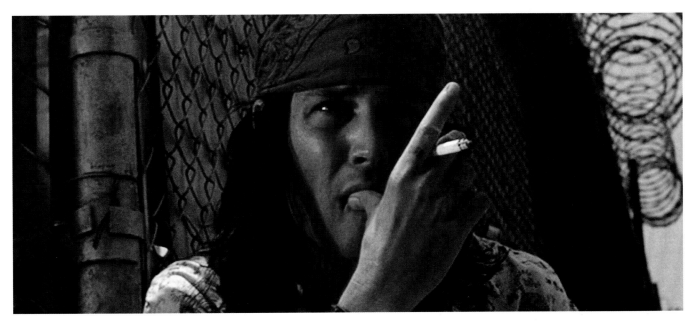

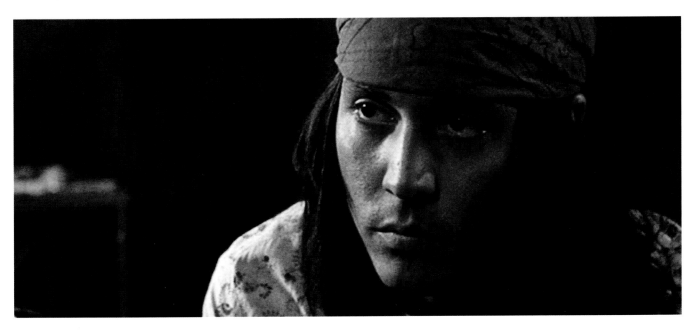

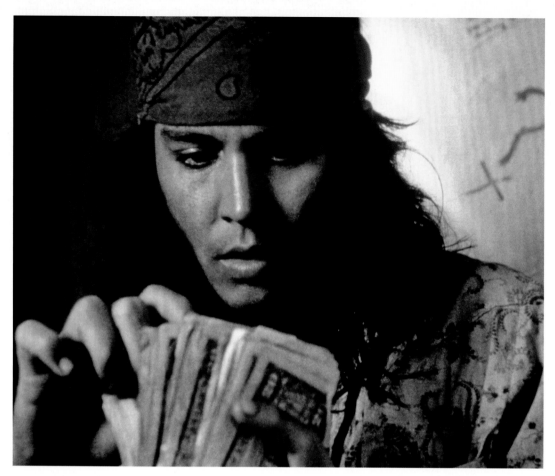

Left: An incredulous Raphael
counts the advance he has
just received and, possibly,
the few remaining days he has
left to live.

Opposite: Terry Gilliam
and Depp on the set
of the unfinished *The Man
Who Killed Don Quixote*.

Following pages:
The actor-director on the set
of the carnaval sequence.

A director under influence

As a director, Depp was influenced by
the filmmakers he had worked with: John Waters,
Tim Burton, Emir Kusturica, Jim Jarmusch.
When Raphael goes to the nearest town and sees,
through the window of the bus, the whites
putting up houses and destroying the landscape,
one thinks of the prologue to *Dead Man*.
When Larry, the bizarre snuff-movie backer,
follows him to ask for his accounts and then
threatens his family, shouting, 'I'm gonna find
them. And then I'm gonna kill 'em. And then
I'm gonna fuck 'em. And then I'm gonna eat 'em,'
he reminds us of Cole Wilson, the barbarian
bounty hunter from *Dead Man*.

Likewise, the shadow of *Arizona Dream* hovers
over *The Brave*, through the camera work of Vilko
Filac (with whom Depp maintained a relationship
of trust) and because the part of the scenario
that interested him the most – the character's
remaining time before his execution – allowed
him to move close to Kusturica's phantasmagoria.
Depp was attempting to say, as in *The Time
of Your Life* by William Saroyan, a poem
he had loved since he was twenty,[131] that, first and
foremost, one must live and make the most of life.
This is why Raphael spends some of his advance
given to him by the backer (making his wife
believe that he has earned the money by honest
means) on a feast for the entire shantytown.

He salvages what is left of a rusty funfair,
with clunky lights, a kind of *pendant* to Faye
Dunaway's flying machine, and slips in a gigantic
television showing Cocteau's *Orphée*, lighting,
balloons, a swimming pool and a spit. A character
wanders through the fête talking French to a pig.
One senses Depp's pressing desire to drown
the austerity in the festive chaos, so as to avoid
the too 'heavy' side of the scenario and create
a powerful discrepancy, in the vein of Kusturica
and Jarmusch. But, despite this grotesque upside-
down world in which the moments intended
to be happy are imbued with great sadness, Depp
struggles to make this long requiem shine.

The actor wanted to film a human bestiary,
most likely to set up a contrast to his own beauty,
and to recreate some kind of equilibrium, but
he filmed the members of Raphael's community,
his wife and his children without making them
look grim. The critics indeed criticized him for
having filmed beauty amid slum, magnifying
the faces, and systematically contrasting them
with the degenerate white community, drunken
and lost. Raphael's community live in the middle
of scrap metal, in a world of recycling, reminiscent
of a post-apocalyptic film. But their everyday life
is shown only crudely and a number of ideas beg
to be developed. For example, the oil rig scanning
the ground, or old Lou, who uses his backward
son (bringing to mind Arnie from *Gilbert Grape*)
like some human hamster in a giant wheel.

Missed opportunities

Johnny Depp has for a long time dreamt of incarnating historical characters like Rasputin, Howard Hughes and even Liberace, and his career abounds with unaccomplished projects. For personal reasons and timing issues (as for *The Diving Bell and the Butterfly* by Julian Schnabel in 2007), the actor turned down roles finally offered to William Baldwin in *Backdraft* by Ron Howard (1991), Brad Pitt in *Thelma and Louise* by Ridley Scott (1991) and *Legends of the Fall* by Edward Zwick (1994), Christian Slater in *Robin Hood* by Kevin Reynolds (1991), Patrick Swayze in *Point Break* by Kathryn Bigelow (1991), Keanu Reeves in *Dracula* by Francis Ford Coppola (1992) and *Speed* by Jan de Bont (1994), and Tom Cruise in *Interview with the Vampire* by Neil Jordan (1994). This decision to turn down so many romantic male lead roles during the first half of his career is telling of Depp's state of mind. Among other roles for which he was shortlisted, the following should be mentioned: Tim Roth's in *Pulp Fiction* by Quentin Tarantino (1994), Eric Bana's in *Hulk* by Ang Lee (2003) and Josh Brolin's in *American Gangster* by Ridley Scott (2007). The main missed opportunity remains perhaps *The Man Who Killed Don Quixote* by Terry Gilliam (2000) which, at the time of writing, remains unfinished and was the subject of the documentary *Lost in La Mancha* (2002). In this film, Depp, with long, white hair, incarnates Toni Grisoni, Don Quixote's acolyte. Gilliam created the character with Depp in mind, who saw it as 'a kind of human polecat for whom he took inspiration in someone he knew: a fascinating, strange, and anything but sympathetic travel agent'.[d] A number of scenes were shot (one of which showed a hysterical Depp battling with a fish), but the filming was abandoned due to a series of setbacks. The whole experience left the actor depressed.

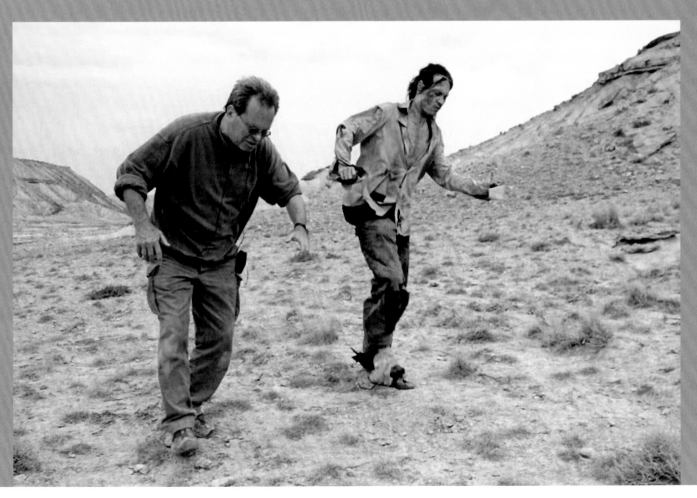

Pending words

To Depp, *The Brave* (a title Native Americans give to a person who has shown great courage) meant dignity and spirituality. 'The Native- and Mexican Americans have always been the downtrodden in our society, through successive governments. They are even called "illegal aliens". They are exploited and then discarded. And in spite of everything the Native American manages to hold his head high', he explained to *Le Figaro*.[132] The backer in fact gives Raphael an alias, Tonto, the icon of Native American culture, whom Depp would play fifteen years later. But the actor remains more or less elusive throughout the film. It is never clarified whether he is Native American or Mexican or whether he embodies both cultures. His wife talks to him, and prays with their children, in Spanish. Only his father wishes to invoke the spirits, so that he can revive the ties to that part of his Native American culture. Contrary to actors of a previous generation, Robert De Niro and Al Pacino, for example, clearly identified as Italian Americans, Depp is most likely reflecting on the heterogeneity of his own origins and likes to play American immigrants, European or rootless characters in their own country (*Arizona Dream, Dead Man*).

In the original script, McCarthy talked to Raphael of Native American ceremonies, like the sun dance. But the final scene becomes much more austere than originally intended: when Raphael meets the producer for the first time, the expression 'snuff movie' is not mentioned. Nothing is shown. He asks very few questions and takes the money. Also intended was a different ending, in which Raphael tried to negotiate a larger fee during a new confrontation, and ended up killing McCarthy. But Brando stayed only two days on the shoot. In addition, a clause in his contract stipulated that he should never take part in any scene showing torture or killing of Native Americans, Christopher Heard points out in his book about Depp.[133] Therefore the director was not able to complete his film as envisaged. The end was rewritten and left open- ended: Raphael goes to the depot, and the metal gate closes. The film ends with an image of McCarthy sitting in his chair. One believes that Raphael has been killed, but it is also possible to imagine that he will commit a murder, seeing that, ten minutes earlier, he has torn off an ear and savagely strangled Luis, the shantytown dealer who threatened Raphael's wife. Although he is very capable of quickly flaring up, Depp never shows any De Niro or Brando-esque bestiality. Everything is conceivable, everything remains in the unsaid, and hence the film seems timid despite this violent, central scene. Even Iggy Pop's participation, consisting of an acoustic guitar solo, seems a peculiar choice in this context, as it is tinged with too much sentimentality.

Above: Raphael prays with his daugther (Nicole Mancera) in the family caravan.

Opposite: Having killed the dealer who was threatening his wife, the young man washes himself in the river and dries himself on the bank.

Following pages: Raphael and his son (Cody Lightning) in a rare moment of bonding.

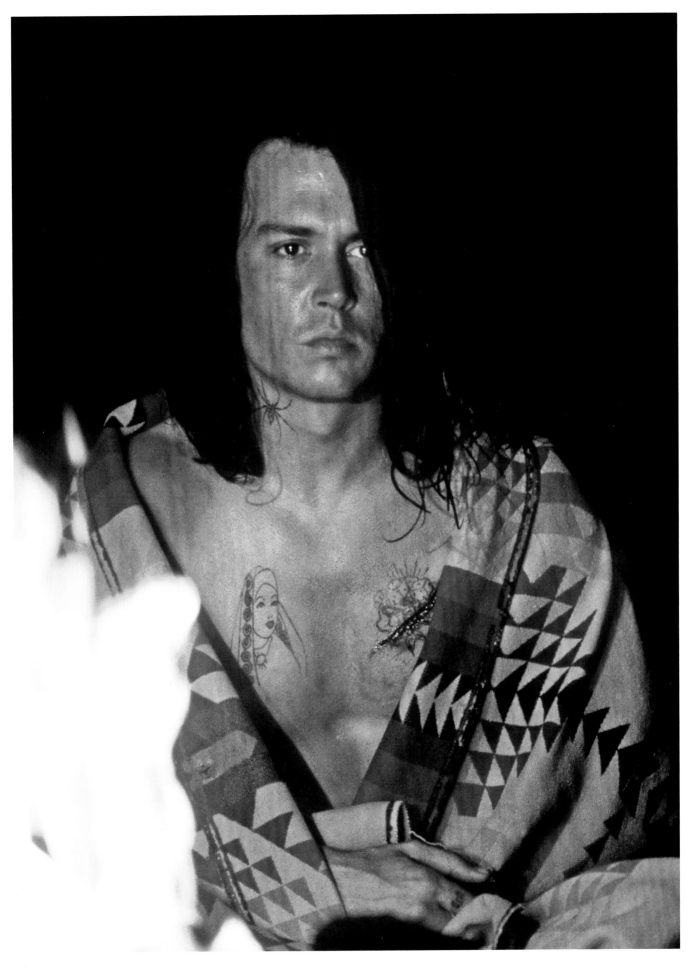

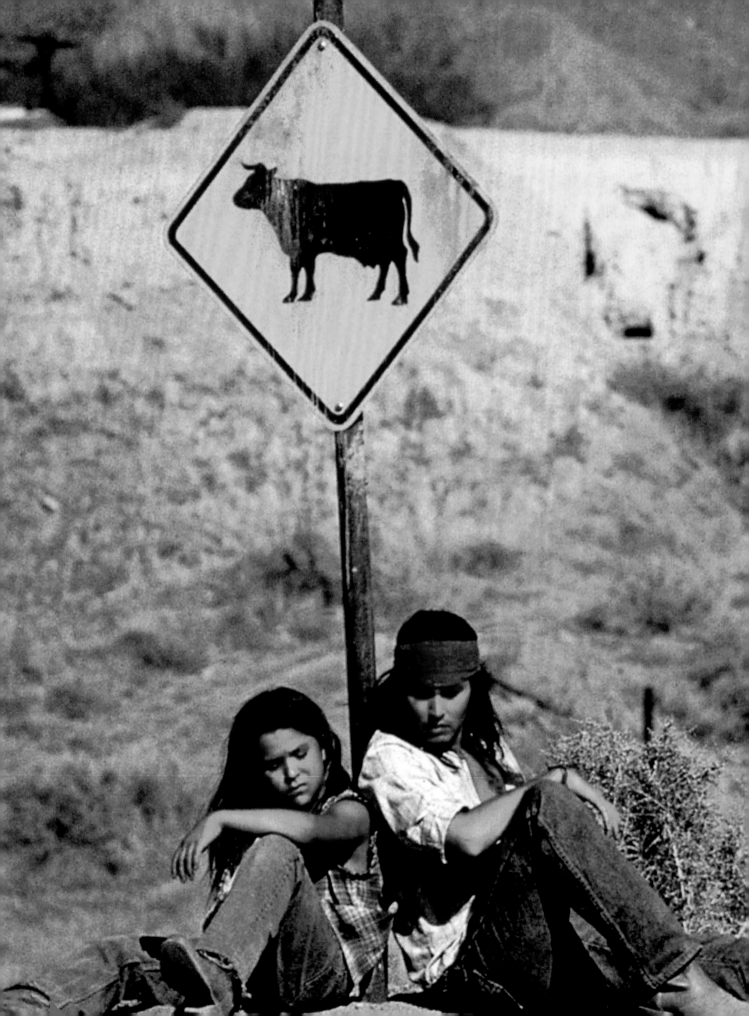

If Depp as director is everywhere on the set, Depp as actor seems elsewhere. For someone wanting to sacrifice himself, Raphael remains expressionless throughout the film. He frequently appears frowning, sullen, with his hair, shoulders and hands hanging limp. Everything about him seems constantly on the verge of slumping. But if one were to retain a totemic image of Depp, it should perhaps be exactly this one, the hurt actor, with his obscure face and his worried gaze, which contradicts – and completes – the clown-like image of *Ed Wood*, *Pirates of the Caribbean*, or *Charlie and the Chocolate Factory*.

The Brave is a slow film which, despite its warmth, sets up a distance. At times, Depp even seems absent from his own film, a stranger to his own family, whom he observes from afar (as in *Gilbert Grape*) and ends up abandoning. Even though he establishes a relationship with his son, Raphael seems more like an elder brother than a father (similar to the one he interpreted in *Benny and Joon*). That is also why Depp is dear to a director like Tim Burton, who deals with family structures.

In the film, Raphael walks a lot, as though Depp is seeking to compensate for his film's lack of rhythm. He makes a string of blunders and creates kitsch moments. As he walks through the village and greets a woman by raising his hand, although she is right in front of him, he gives the impression of a director out looking for locations, a foreigner to the community that he is supposed to belong to. Some viewers indeed criticized the length of the film and the character's silence, even deploring that the voice-over did not elucidate the young man's thoughts, especially as Raphael (who is not illiterate, as in the original script) is writing in a notebook throughout the film, just like Depp, who liked to draw and jot down his thoughts. No one knows his mind, neither his family nor the audience. The idea is beautiful, but it very quickly becomes frustrating on screen. This sparseness in terms of method and words again recalls Gilbert Grape and his withheld rage. 'The only true reason I wanted to direct *The Brave* was that I was too inarticulate to tell another director what I wanted, you know. What I wanted it to look like, or be like, or what the pace should be like, or what it should feel like, you know. Just because I couldn't express that, you know', Depp revealed.[134] In 1999, he made a connection between this muteness and his chaotic childhood, explaining, 'We grew up every day with the sense that something was about to blow'.[135] '"The sense that something is about to blow" is a pretty accurate description of his performances in both films. With Johnny, the words are just the ice floe on the river', Peter Hedges, the author and screenwriter of *What's Eating Gilbert Grape*, says. 'Underneath you have this incredibly complex, complicated stuff going on'.[136]

Hence Depp filmed himself as the silhouette of a man, hurt and sacrificed, and retains certain Christian images, notably when he plays the water-carrier, with his arms forming a cross, or when Larry stabs his hand. In the scene where he bids farewell to his family, he hides his face behind his bandaged hands, tears in his eyes, but one does not see him cry. He is beyond emotions, feelings. It is the others who are crying for him.

A taste of incompleteness

Depp did a rushed job on the editing in order to present the film at Cannes in May 1997. *The Brave* was screened in the morning, in an atmosphere of mixed feelings and under poor conditions (the film was stopped due to technical problems). By the next day, the press was taking it to pieces. A surprised Depp declared, 'The reviews of *The Brave* were written before the reviewers even saw the movie'.[137] American newspapers such as *Variety* and *Hollywood Reporter* claimed to have heard catcalls and insults, and denounced the film's 'arty pretensions'.[138] The distributors were frightened, and Depp objected to the film's release in the United States. Instead, *The Brave* was released directly on DVD and was neither added to the *Movie & Video Guide* list nor shown on TV for a whole decade.[139] Terry Gilliam posited, 'If there is a weakness in the film, it is these two sides of Johnny that haven't quite found a middle ground, how you put it together. Because there are scenes in the movie that are like Kusturica's stuff; they're fabulous, outrageous. And then the other part of the film is incredibly dark and real'.[140] In Dana Shapiro's opinion, the film was not ready to be shown.[141]

Irrespective of the blunders in the script, the temporal context was perhaps not in the actor's favour. After a lull during the previous decade, the 1990s saw a resurgence of films dealing with Native American culture. This was the time of *Dances with Wolves* (Kevin Costner, 1990), *Thunderheart* (Michael Apted, 1992) and *The Last of the Mohicans* (Michael Mann, 1992), mainstream films showing the dispossession of the Native Americans, and denigrated by the critics for presenting the Native Americans as noble servicemen and essentially mysterious beings, more often than not played by white stars. Depp's first foray into the art of directing thus ended as 'unfinished business'. Exhausted by the experience, he declared that he was giving up directing, at least when it meant being on both sides of the camera. *The Brave* marked a transition period for the actor, who put his filmmaking desires on hold.

Once again, a role, a writer and a filmmaker were going to enchant him, not to rejoin a straight path but to digress even further from it, not to play 'close by' but to travel 'far off', always westward, and beyond.

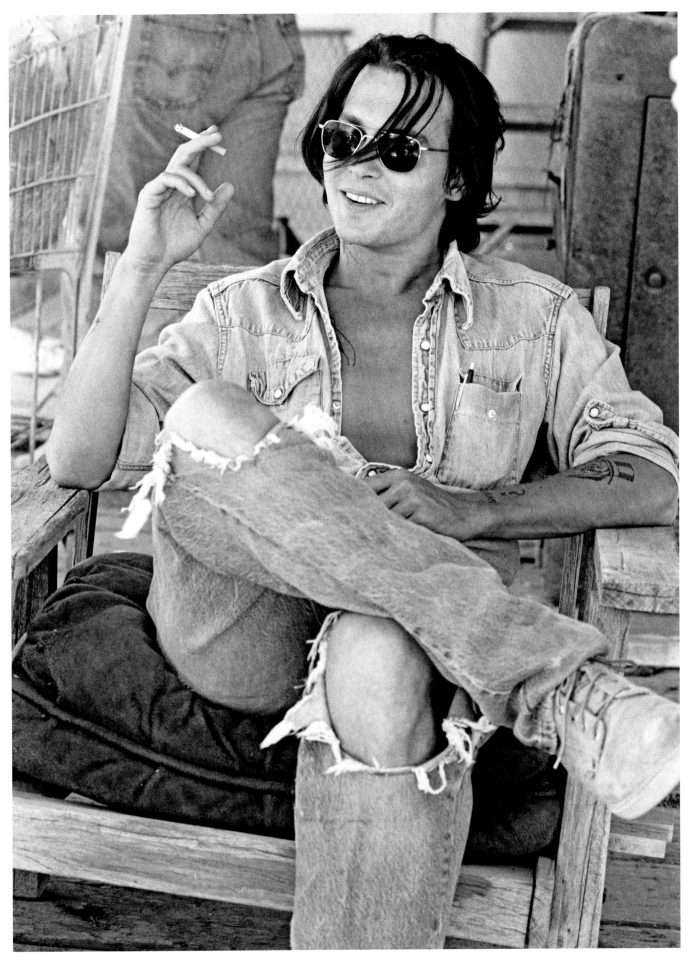

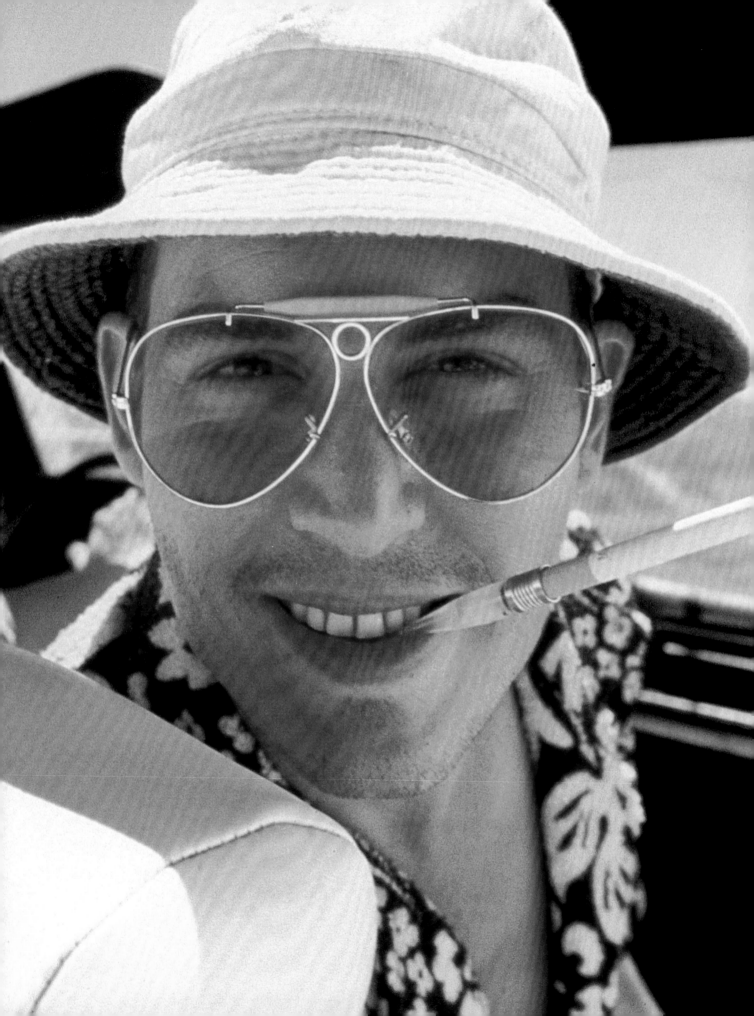

Raoul Duke

Fear and Loathing in Las Vegas (1998)
Terry Gilliam

'Hunter is indelible! He is like a disease you've got. He slips under your skin, takes root into your blood and your pores. Hunter impregnates you. He haunts you. His rhythm, the way he speaks, his language are very interesting. And it's hard to get rid of it after mixing with him for a time'.[142] Johnny Depp, 1998

'I've been obsessed with outlaws all my life', Depp admitted.[143] The writer Hunter S. Thompson definitely belongs in that category, with his nonconformist approach, his battle against Nixon and for peace in Vietnam and his involvement in Native American issues. The film adaptation of his novel *Fear and Loathing in Las Vegas* had been in the planning stage since the book came out in 1971, but it was looking complicated. In the book, Raoul Duke (Thompson's alter ego) practises Gonzo journalism (a freeform style of writing induced by drug taking) during a weekend in Las Vegas with his sidekick, the lawyer Oscar Zeta Acosta (Gonzo). The two men, who are supposed to cover a motorcycle race and a police conference, all while completely high, take all sorts of drugs for two days straight and trash their hotel room before returning to Los Angeles. 'I wrote the book as an experiment, trying to teach myself how to write cinematically, but I forgot the interior monologues and the hallucinations!' Thompson recalled in *Rolling Stone* magazine.[144] How could those be portrayed on screen? How could that kind of drug-induced delirium be visually conveyed?

Lengthy preparation

In 1996, things started to come together. There was talk of Alex Cox (*Sid and Nancy*, 1986) as director. Keanu Reeves and John Cusack were put forward for the leading role and Benicio Del Toro for that of Gonzo. But Thompson took the initiative and called Depp, whom he had met a year earlier, when the actor was filming for *Donnie Brasco*: 'What do you think about playing me?'[145] Depp could not believe his ears and felt it was imperative to have the writer's blessing: 'I said to him: "If I even remotely do an accurate portrayal, you'll probably hate me for the rest of your life"'. Thompson, remembering the conversation, remarks, 'Actors take themselves too seriously. Is he saying I'm a monster? Does he mean I'm going to see myself stripped naked? He worries too much [...] He couldn't possibly do an accurate job. He's too short'.[146] In any event, the writer and the director had some major creative differences, so Alex Cox was replaced by Terry Gilliam, with whom Depp was very keen to work.

The project was back on track, filming in the Nevada desert and with a budget of $18.5 million. Thompson had seen Depp in *Cry-Baby* and was immediately struck by the intelligence, black humour and instinctive enthusiasm of this 'suave little brute'.[147] In order to be worthy of this honour, Depp wanted to spend time with the writer. 'I told him that I'd probably become a fucking pain in the ass, because I'd be asking him a lot of questions and taping the conversations and writing things down, and it'd be like I was a fucking parole officer', says the actor.[148] For four months, he observed Thompson closely like a bird of prey, spent days with him to study his mannerisms, his habits, his expressions. 'It's weird with Hunter – it's more sort of watching the way he thinks. You can see the wheels turning, and you can see an idea coming. That was really the key for me – cause he's thinking constantly. He's very, very quick, and there are no lulls', explains Depp. The actor rehearsed in front of Thompson, who did not hold back from correcting him, pulling him up on things; really pushing him to his limits: 'Punctuate that! You've really got to hit that!'[149]

Working on the character's wardrobe involved honest and direct communication between the two men. Thompson was worried about the film falling into caricature. Depp constantly had to remind him that he could never be perfect, but that his job was to portray Thompson as accurately as he possibly could. Depp's one and only fear was that Thompson would hate the film.

Genuine physical transformation

The script was written in two weeks and the film shot in six. Gilliam, who likes the idea of working fast, explains that: 'I imposed a *blitzkrieg* style!'[150] He wanted to make a great film, but also 'one of the most hated movies of all time'.[151] A nightmare, something truly disturbing.

Depp as Raoul Duke, Gonzo journalist Hunter S. Thompson's *alter ego*.

Left: Terry Gilliam (standing), who wanted to make 'one of the most hated movies of all time', liked Depp's unpredictability.

Opposite: The writer and his typewriter, which he carries as if it were an accordion, upon his arrival in Las Vegas.

And the thing he liked about Depp was his unpredictability.

The actor himself admits that the very peculiar intonation of his voice happened almost by chance, through a blunder on his part. Depp was nervous during the rehearsals; he loaded up on red wine, and forgot he was chewing a piece of gum until he started reading.[152] He therefore managed to find a nasal, husky and cheekily confident voice, similar to Thompson's (although the latter has a slightly more serious voice). However, it is his physical appearance that underwent the most dramatic transformation. Depp actually got hold of the clothes that Thompson wore in the 1970s, which 'hadn't been washed in thirty years'.[153] Yellow floral shirt, huge tinted glasses, oversized watch, awful sun hat, gaudy multicoloured jacket, shorts, and trainers with white socks pulled-up high. Even Thompson had forgotten that it was possible to have such bad taste. But the star of the show is the hair: the bald pate, which Depp does not reveal straight away and is a shock to the viewer when he does (during the scene where he thinks he is seeing alligators in the bar). His flowing, almost womanly locks so cherished by previous directors, had up until then been slicked down, dyed, dirtied, but never shaved. After trying out various different wigs, Depp faced the inevitable: he would have to shave his head to recreate Thompson's baldness. And it was the writer himself who

took care of it for him. Terry Gilliam explained: 'A lot of actors refuse going all the way in giving up their good looks […] Not so with Johnny. It took a while to get him to shave his head, but he knew that this was unavoidable and he was going to do it. And it wasn't just that he shaves his head, but then he has a little toupee with seventeen sad little hairs on it. So it's even SADDER baldness! […] He loses himself totally, and I think he's escaping from Johnny Depp a lot'.[154]

Thompson therefore manages to achieve the impossible: making Depp look ugly. And we immediately hate the outcome, for there is a kind of almost aristocratic beauty about Depp that is more in keeping with the role of Ichabod Crane in *Sleepy Hollow* than with the role of Raoul Duke.

Depp and Thompson absorb one another

According to Depp, Duke is 97 per cent Thompson in terms of his appearance. The actor soaked up the role like a sponge, confessing it was 'a horrible way to approach a human being'.[155] Gilliam said that Depp used a process of 'osmosis'.[156] The whole film is a process of absorption and regurgitation. Duke and Gonzo consume everything they come across, to the point of nausea: ether, mescaline, acid, cocaine, tequila, Budweiser. The film was rated R (under-17s require a parent or adult guardian to be present in order to view the film).

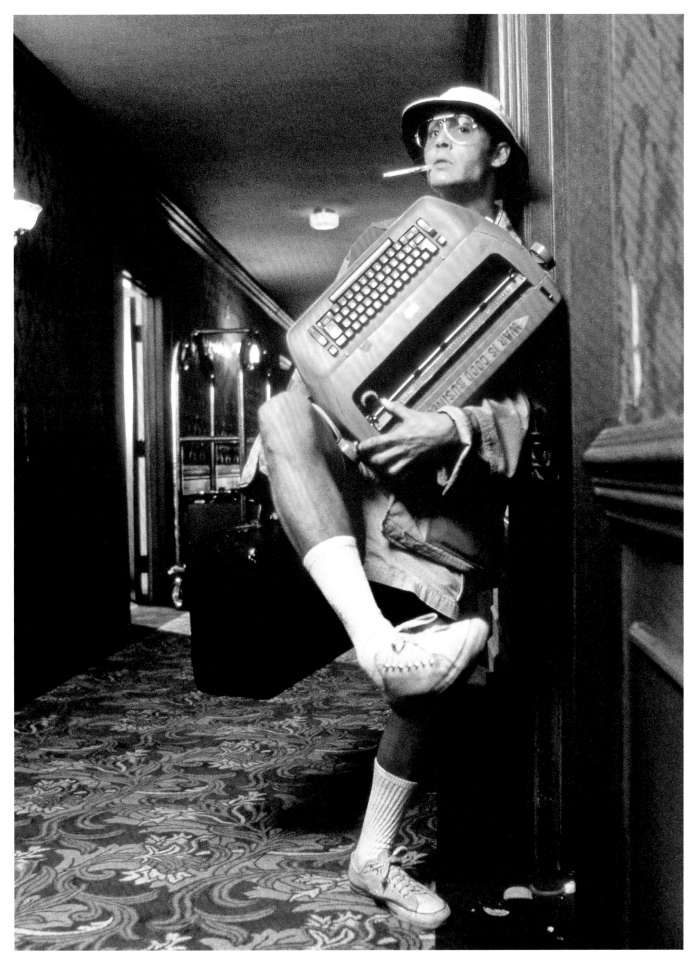

Depp also closely studied Thompson's style of driving, from the slightest crunching of the tyres to the way he parked. He used other objects belonging to the writer: his Chevy convertible, and the music evoked in the book, with the sounds of the Rolling Stones, Buffalo Springfield and Janis Joplin alongside The Lennon Sisters, Perry Como and Debbie Reynolds. 'Johnny was like some kind of vampire. Each time he'd come back with more of Hunter's clothes and things. He was stealing Hunter's soul, really, secretly', recalls Terry Gilliam.[157] Thompson was not there during filming, but he was constantly on the phone with the actor. Gilliam, meanwhile, was forced to keep his distance in order to find his place. Depp, who is not a fan of 'becoming' a character, later admitted that he had spent too much time with the author.[158] He melted into him. Thompson, in turn, sucked his blood.

An epileptic role

The gamble for Terry Gilliam was how to visually translate the ferocity of Thompson's words and hallucinations; how to adapt the unadaptable. He wanted to convey the psychological state of the characters (paranoia, terror, disorientation) and recreate the effects of each drug on their phrasing and intonation, at the risk of confusing moviegoers. Indeed, he starts the film by giving them an earful. Depp explained in *Première* that he had followed the advice of Marlon Brando, using an earpiece to sync his acting to the sound of his voice-over. 'Rather than having someone behind the camera reading the text to me, it was better I had my own rhythm in the ear'.[159] To record Duke's voice-over, the central theme of the film, Gilliam was inspired by Martin Sheen in *Apocalypse Now* (Francis F. Coppola, 1979). 'It was like going upriver,' he says. 'We were off to war!'[160] Depp stepped into line: muttering to himself in a military fashion.

The problem is that Duke and Gonzo are on a constant drugs binge. Gilliam knows that the issue is risky, but he can count on Depp's absolute mania to really nail this role. How can an actor play a character that is permanently high? The role of Duke is a far cry from any of Depp's previous roles, and, having learned from Tim Burton, who pushed him to lay it on thick in *Ed Wood*, he was scared of overdoing it. From the opening scene, with his fraught driving, his hands clutching the top of the steering wheel and his head sunken down into his shoulders, we can see that the actor wants to smash his image. The new Depp bursts into the film. His phrasing is faster; his flow uninterrupted. He jerks his head in tiny nervous movements, like a bird, his pupils dilated. Fully tripping, plagued by hallucinations, he pulls the car over and starts swiping in the air at imaginary bats. This is the first time that Depp has ever moved his body so jerkily, with so many

tics, and he acquires a real strength (something he was not fully able to do in *Cry-Baby*). Like a disjointed puppet, he crabs his way forward, arms and legs out of sync, then grabs a fly swatter from the trunk of the car and busts a gut as he tries to kill the critters. The camera does not need to move: his reeling gait alone makes us feel seasick.

Even though the press have always highlighted the strangeness of his roles, there is nonetheless always something reassuring and familiar about the actor's screen presence. His voice is gentle and steady. 'Depp is the quiet center of the story', writes Elizabeth McCracken.[161] But there is nothing in the slightest bit calm or reassuring about Raoul Duke. The image of the bald, twitching actor is a visual assault to the viewer.

Depp usually listens to music (mainly rock) during filming to pep up his role.[162] In this film, he still plays an autistic role, but he must externalize his emotions and infuse the character with a sort of epileptic rhythm, playing on alternating very different facial expressions, brutal outbursts and moments of apathy, silent incantations and the forced smile we see in *Ed Wood*. With his pupils rolling and his stare fixed, he does not shy away from becoming cartoon-like. When he pretends to hit Gonzo frantically with his fly swatter before becoming wild-eyed once again, his voice is by turns rasping, distorted and slurred.

The insect repertoire

Drug-taking is supposed to transform the actors into wild animals. For Depp, this turned out to be an insect. The way he slumps down behind the car when he has taken psychoactive drugs, or the way he clutches his plane ticket when he arrives in Las Vegas, these actions are already spider-like. With his body curled over on itself, his gangly arms and bowed legs, Duke always seems like he is about to start crawling. When he starts hallucinating at the hotel again, he falls to his knees and again his hand enters the frame, creeping finger by finger. Then Duke becomes crab-like once more, his hands dancing again. Sometimes we see a similarity with the incantatory hands of Ed Wood. His whole body seems to sing, and he carries his typewriter as if it were an accordion.

When Duke goes to cover the motorcycle race in the desert, with his glasses, sun hat and a scarf covering his entire face to protect him from the sand (not unlike in James Whale's *The Invisible Man*, 1933), the transformation seems to be complete. Depp disappears. Later, Gonzo wants to engrave a small 'Z' on his partner's forehead, like one of the characters in *Dead Man*. The spider legs are also those of the writer: Duke bashes away at his typewriter with mal-coordinated movements, one key after the other with his fingers curling. Under the effects

Plagued by hallucinations, Duke swats at imaginary bats. On their way to Vegas, he and Gonzo (Benicio Del Toro), his lawyer, pick up a young hitch-hiker (Tobey Maguire).

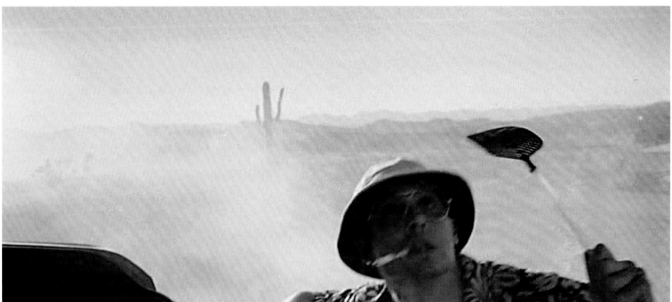

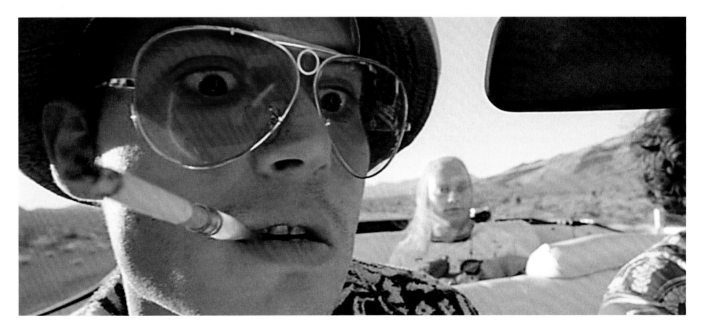

of drugs, he becomes a woodlouse, like Gregor Samsa in *The Metamorphosis*. This spiderlike appearance is counterbalanced by Benicio Del Toro, who gained twenty kilograms for the role; his beastly physical presence is in stark contrast to the dryness of Depp, who is like a skinny maggot.

The way he acts being high also has something military about it. He has a constantly hunted look about him, as if he is in a state of extreme vigilance. In the hotel room, Duke hides behind the bar, afraid that he is under attack. His eyes, far from being glassy, have an extra lucid look about them. He does not hug the walls, rather he uses the space as much as he can and moves forward under cover, hunched over like a soldier in the thick mud of the trenches. Depp is war incarnate.

An accessories-actor

Another striking element is Depp's hands, which are magnified by the enormous watch and Gilliam's framing. The actor's hands usually hang down beside his body (*Edward Scissorhands, Dead Man)*. He fiddles; he is always handling or holding something (a beer can, a pen, a fly swatter). Perhaps it is because he is a heavy smoker: 'For me, it is very important to know what my character is going to look like. Just like, in life, I can't imagine myself without a cigarette in my hand, I need to know the habits and mannerisms of my characters'.[163] But these are also musician's hands; hands that like to be free. In the restaurant scene in Los Angeles, his fingers do a little dance before picking up the phone, as if he is playing the piano in thin air. He even punctuates Gonzo's words with his hands.

As in his previous films, Depp is an accessories-actor; more so than any other actor. His accessories seem to be an extension of his body, as in *Edward Scissorhands*. He wears several different styles of hats and glasses. After their final nightmarish night, Duke wakes to find himself completely trussed up: a microphone attached to his face with tape, the legs and tail of a plastic dinosaur strapped to his behind. Here, it is the actor's body itself that imposes limits. Depp is constantly adding accessories to it: a cigarette holder (which helps him to maintain his nasal voice), a megaphone, a revolver or a canister of tear gas.

Just another freak in the Freak Kingdom

Depp is playing a monster, but his physical transformation is brutal. He puts his acting to the test and wants to live the experience to the limits, the real subject of the film. The more drugs Duke takes, the further Depp pushes himself. His baldness is already a step toward becoming monstrous. The actor moves toward the fantastic, in response to the role of Ewan McGregor in Danny Boyle's *Trainspotting,* which came out two years earlier. For Depp, however, there was no weight loss, no search for realism. When Duke and Gonzo hole themselves up in their hotel room for one last mescaline binge, Duke's face becomes more and more hideous, his lips white, his eyes like cat's pupils, his face red and sweating. Gilliam uses wide angles and extreme close-ups to distort his face. He and Nicola Pecorini, the cinematographer, also used sheets of clear plastic to create distortion effects. Depp pushes his character to the limit, to the edge of plausibility. He is neither man nor beast. The actor creates a mutant, a different face, a kind of hapax in his filmography.

The film is about American society at a time when everyone took everything at face value. Opting for an outdated fantastical creature (Gonzo transmogrifies into a demon) seemed to be the only way of conveying the violence of drug consumption. As for the real monsters, Duke and Gonzo cross paths with more than one of them during their weekend drugs binge. And it is not the lost souls (Christina Ricci as the drugged-up lolita, or Tobey Maguire as the hitch-hiker), the tattooed waitress or the chambermaid that they terrorize, but the ones who are America's worst, the fauna that haunt Vegas, the Nixon voters, portrayed as stupid, vain and hysterical. At the police conference on the topic of drugs, a short film on the dangers of narcotics shows an identikit picture of a junkie (similar to Duke's face). For Kent Jones, '*Fear and Loathing in Las Vegas* recalls a time of extreme polarization, a time when people, whether high or not, saw themselves as monsters from different galaxies'.[164] Thompson writes about the death of the 1960s and the illusory side of the acid culture. Martin Luther King and Robert Kennedy had been assassinated; 1971 was a year of transition, toward a decade that was to be known as the hangover years. In the film, Gilliam arranges a meeting between Duke and Thompson in a bar in 1965, in San Francisco. *Fear and Loathing in Las Vegas*, which was like a veritable vomit on America, does not skimp on the violent cut-tos of puke in the movie (Gonzo throws his guts up all over his shining car), nor on the kitsch. And despite the trashed hotel room (pornographic images pinned up all over the walls, food spread about everywhere), the book is a calmer version of what actually happened that weekend.[165]

However, unlike the wild, terrifying Gonzo, Duke is not dangerous. When, exhausted from their weekend of excess, the two men retire to one of the bars a little way outside Las Vegas, and Gonzo terrorizes the waitress before stealing a pie from her, Duke follows him out, carrying his unfinished meal, then returns to leave his plate on the counter. This polite little gesture is typical of Depp.

Even in *Benny and Joon,* in which he played a clown, he was attentive. Depp's characters are never really inherently evil. He always maintains

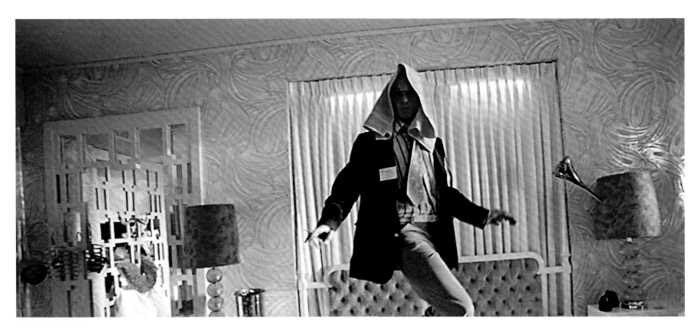

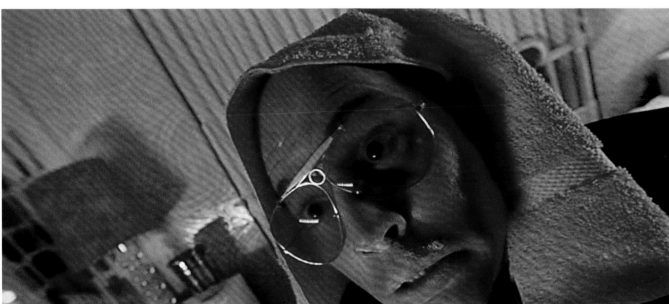

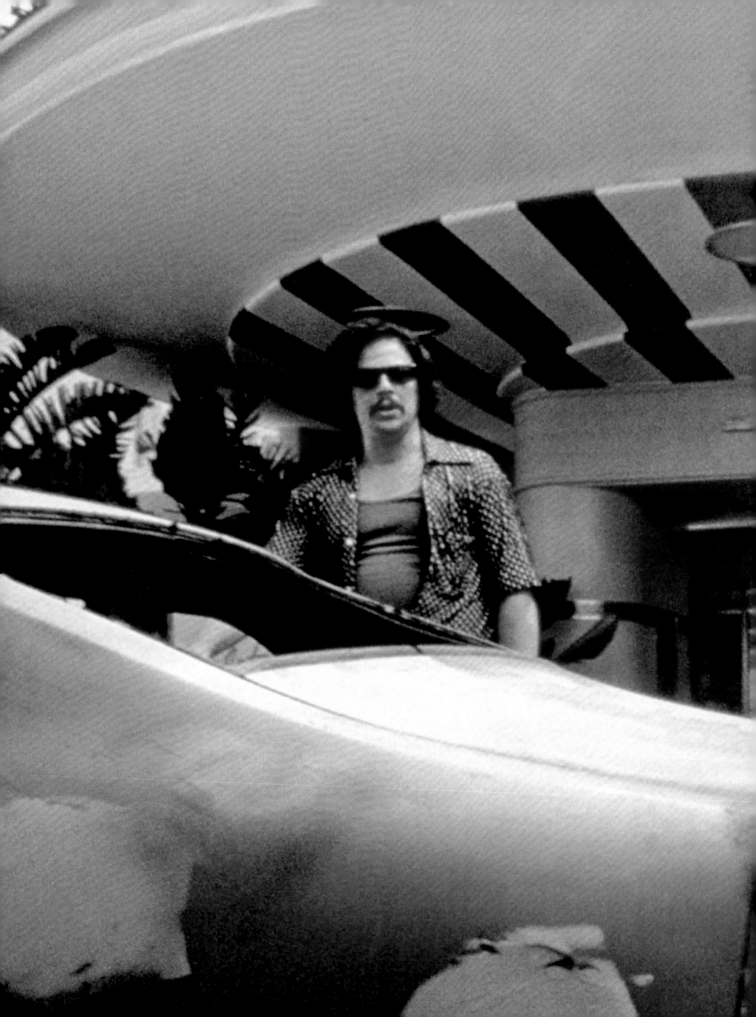

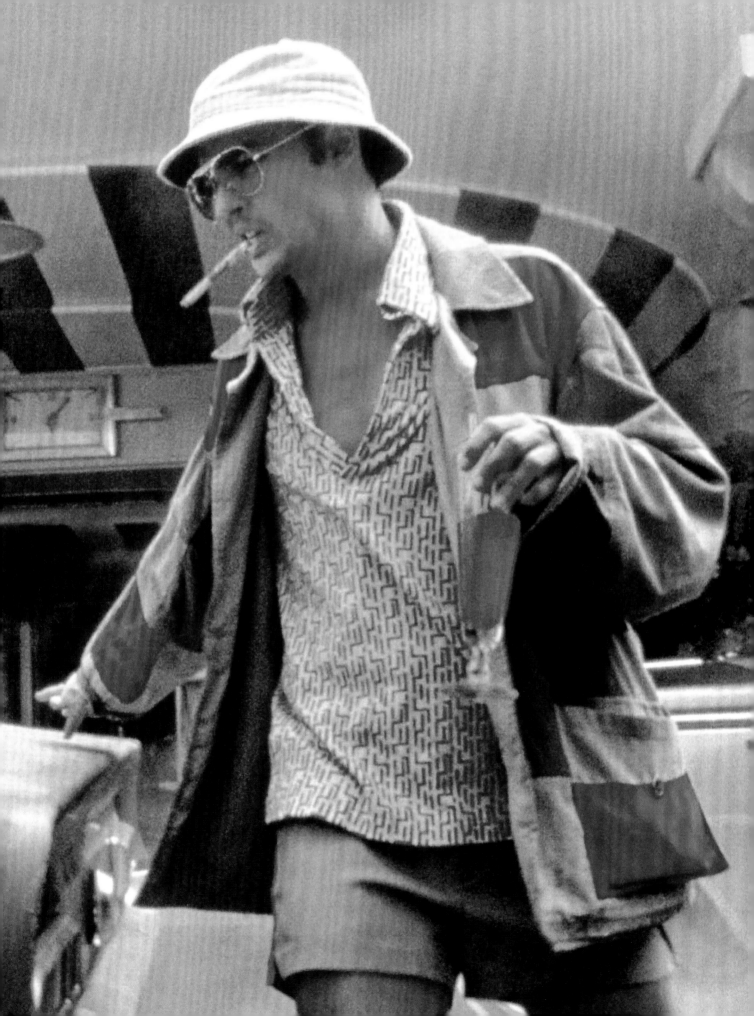

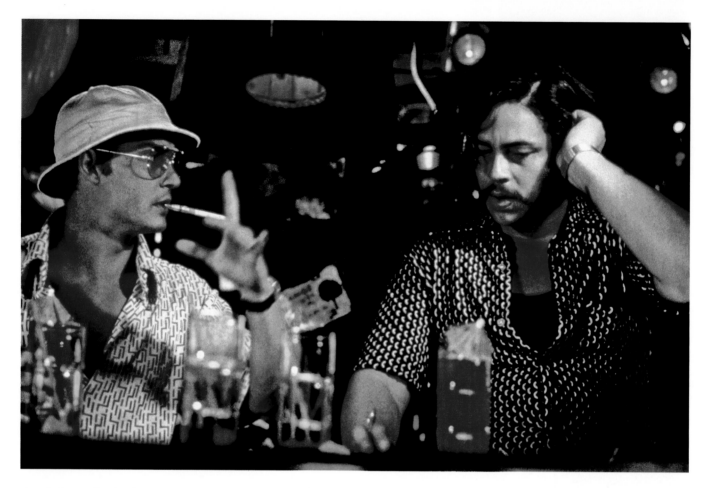

that delicate edge, by frowning, even in the middle of a devastated hotel room, the way Chaplin used to do.

With the weekend over, Duke has only one option: to go back to the conformity of those he calls the real monsters. 'There was only one road back to L.A.: US Interstate 15, just a flat-out high-speed burn through Baker and Barstow and Berdoo, then on to the Hollywood Freeway straight into frantic oblivion: safety, obscurity, just another freak in the Freak Kingdom', we hear the voice-over say. In the final scene, Depp becomes Ed Wood in one shot, reconstructing his wide, vacant grin, in the style of Lon Chaney. In this role, in which Depp really thumbed his nose at the conventional Hollywood role, he shows that he needed to experiment, even at the risk of veering permanently off course.

The role that set Depp free

Depp, who has dreams of going abroad and buying his own island like Brando did, loves the politically incorrect aspect of the film, and it is undeniable that *Fear and Loathing in Las Vegas* strengthened his reputation as an actor. In 1998, he is thirty-five, with a lot of experience behind him, and he feels disconcerted by the younger generations who have 'this nonconformist approach, but they're exactly like their buddy, who's exactly like some other guy, who's exactly like another guy, because this other guy saw it on MTV'.[166]

Thompson praised Depp's performance. But the film gets a frosty reception when it is presented at Cannes, and receives generally negative reviews from the critics. The film should have been shocking, but it was boring. There were some reservations about Depp's role as well. People found it grotesque,[167] and more disturbing than funny.[168] 'Johnny Depp has been a gifted and inventive actor […]. Here he's given a character with no nuances, a man whose only variable is the current degree he's out of it […]. Depp, who doesn't look unlike the young Hunter S. Thompson but can't communicate the genius beneath the madness', reports the *Chicago Sun-Times*.[169] As with *Ed Wood*, he was reproached for creating a caricature rather than a character. The *New York Times* said that 'Depp's largely nonverbal role seems more like a pantomime than a three-dimensional portrait'.[170]

However, he also surprised critics, and the collaboration with Gilliam was evidence of this. 'Johnny Depp feeds, like nobody else before him, the cartoon aspect of his movies', Laurent Rigoulet writes in *Libération*.[171] The casting of the film is something miraculous, 'made possible by a most intrepid young actor, unafraid to pass through the rhythms and colours of the most risky of cinematic landscapes, sacrificing any semblance of vanity that might have been

Above: During their stay, Duke and Gonzo consume everything they come across, to the point of nausea: ether, mescaline, acid, cocaine, tequila, Budweiser.

Opposite: Depp agreed to shave his head for the film. 'But then he ha[d] a little toupee with seventeen sad little hairs on it. So it's even sadder!', the director gleefully recalled.

→ 'A Pair of Deviant
Bookends'
Excerpt from Johnny
Depp's tribute to
Hunter S. Thompson
(in *Rolling Stone*,
24 March 2005)

'His generosity was astounding. Never once did he try to wriggle away from my never-ending barrage of questions. He was always exceptionally patient and very giving. He was totally open regarding the details of his exploits and personal experiences, even the more intimate particulars of his past. The more time together, the more intense the bond. The connection was profound and becoming more so. I used to tease him that we were becoming a perversely twisted version of Edgar Bergen and Charlie McCarthy, which really made him uncomfortable. I had, by this point, purloined an impressive amount of his clothing from the Vegas period and adopted the same mode of dress: the aviator shades, a bush hat, short pants, athletic socks, Converse sneakers, cigarette holder clenched tightly between the teeth. We'd saunter out

of the house to take a drive in the car like freakish twins. So, for good or ill, there we were, a pair of deviant bookends on the prowl. Truly, the man should be sainted for putting up with my continual scratching away at the layers of his life. He stuck it out like a champion and couldn't have been a better friend [...]. There are endless other moments and experiences that I was fortunate enough to have gone through with Hunter, far too many to write about at this time. I cherish the seconds and milliseconds I shared with him. I was well aware that it was all going to happen only once in a lifetime. These were fantastic experiences. Some of the best moments of my life were happening to me and, luckily, I knew it. Speaking as a fan: You owe it to yourselves to not be cheated, or short-changed, by believing merely the myth.

Read the work. Read his books. Understand that his road and his methods were his and only his. He was in no way irresponsible when it came to his writing. He lived it, breathed it – twenty-four hours a day. There are those of you who, based on Hunter's journeys and the mad stories that surround his life and memory, might think that because of his lifestyle, the excess and the wild rantings, he was simply some hedonistic lunatic, or as he always put it, "an elderly dope fiend". I promise you, he was not. He was a Southern gentleman, all chivalry and charm. He was a hilarious and rascally little boy. A truth seeker. He was a hypersensitive medium who channeled the underlying currents of truth, concealed in veils of silken lies that we have become accustomed to swallowing. Hunter was a genius who revolutionized writing in the same way that Marlon Brando had done with acting, as significant, essential and valuable as Dylan, Kerouac and the Stones. He was, without question, the most loyal and present friend I have ever had the honor of knowing. I am privileged to have belonged to the small fraternity of people in his life who were allowed to see more than most. He was elegance personified. I miss him. I missed him when he was alive. But, dear Doctor, I will see you again.'

Opposite: The real Hunter S. Thompson's unorthodox way of aiming at the target.

Right: Depp got hold of the clothes that the writer wore in the 1970s: a gaudy jacket, yellow floral shirt, huge tinted glasses, an awful sun hat and a cigarette-holder.

expected from another movie star', Kent Jones says.[172] And, despite his modest film career thus far in the United States, he went on to be offered numerous roles.

Depp came away empty but transformed by this role: a role which he claims made him more extrovert: 'It's a curse for a part of me, which is kind of comfortable being slightly shy and away from people. But on the other side, it's nice to have that sort of thrust. It's like a drug, I guess, like some horrible addictive drug – once you've felt it in the bone marrow, you don't want to let it go, because it's a great tool. Dealing with people'.[173] But Thompson's habits and posture would stay with him for a long time. Bill Murray gave him some words of advice: 'Be careful or you'll find yourself ten years from now still doing him […] Make sure your next role is some drastically different guy'.[174] Depp took his word for it, and after filming was finished he went to Paris to film *The Ninth Gate*. But he struggled to bring his personal touch to the role, finding Roman Polanski too inflexible as a director. The actor likes metamorphosis too much. 'If I could morph my face for the night it would be one of the greatest gifts I'd ever be given', he told *The Guardian* in 2000.[175] He then worked with Tim Burton on *Sleepy Hollow* and continued to develop a taste for exaggeration and stylization that would stay with him. A new, unexpected metamorphosis led him into the only American territory that he had not yet explored: the world of Disney.

105

7 Jack Sparrow

Pirates of the Caribbean:
The Curse of the Black Pearl (2003)
Gore Verbinski

'I can get obsessed by a part quite easily. When I get to the stage where I know the character that good that it becomes a second nature, I just have to snap my fingers and it will be there'.[176]
Johnny Depp, 2003

The film adaptation of *Pirates of the Caribbean*, a Disney attraction dating from 1963, had been planned for some time. In 1999, Depp was living in Paris, far away from Hollywood. Producer Jerry Bruckheimer made the trip over there to talk him into playing the pirate Jack Sparrow, because 'Johnny's known for creating his own character'.[177] Everything about it seemed worlds away from Depp's usual choices: a Disney production, associated with the name of Bruckheimer, a huge budget, a more commercial than artistic outlook, as well as big earnings to be made. On paper it looked like the last thing he would do. The actor was shocked that they had even thought of him for the part. He accepted, however, explaining that he wanted to make a film that was accessible to children. Deep down, he really wanted to play a pirate.

An unexpected franchise

Pirates of the Caribbean was inspired by great epics like *Treasure Island* by Robert Louis Stevenson. In the first movie, *The Curse of the Black Pearl* (2003), the governor's daughter Elizabeth (Keira Knightley), falls in love with Will Turner (Orlando Bloom), a boy she had saved from the sea. She has no idea that Will is the son of a pirate who disappeared, or that the medallion around his neck is the missing piece of Aztec treasure that must lift the curse over the crew of Hector Barbossa's (Geoffrey Rush) ship, The Black Pearl. For stealing the cursed gold, Barbossa and his men are condemned to wander the waves as the living dead. With the help of Captain Jack Sparrow, who wants to get his ship back following a mutiny, Elizabeth and Will set out in pursuit of the mythical ghost pirates.

Pirates of the Caribbean was not originally supposed to be a franchise, but after the success of the first film, Disney planned a trilogy full of new characters and creatures. Depp insisted on giving his fellow actors space, so that *Pirates* did jnot become a Jack Sparrow one-man show.

In fact, in the sequels, there was no longer a leading role but numerous secondary roles. In *Dead Man's Chest* (2006), the crew of the Black Pearl expands. Elizabeth casts off her fancy dresses and joins the mêlée, Will's confidence grows, and we discover his father, Bootstrap Bill (Stellan Skarsgård), who is half-man, half-sea beast. Meanwhile, Jack must break the infernawl pact binding him to Davy Jones (Bill Nighy), the captain of the the *Flying Dutchman*. In *At World's End* (2007), the crew tries to gather the Nine Pirate Lords together to stop the East India Trading Company from taking control of the seas, and they set out to rescue Jack, who has been trapped by the Kraken (a giant squid-like sea monster). In *On Stranger Tides* (2011), directed this time by Rob Marshall, Jack faces Blackbeard (Ian McShane) and comes across an old acquaintance, Angelica (Penélope Cruz). A fifth instalment is scheduled for 2017.

Depp's own brand of pirate

The character of Jack Sparrow does not have much of a history behind him. In the Disney attraction, he is the archetypal pirate with a reddish beard, armed with a sword and pistol; a rogue with a booming laugh and a parrot on his shoulder. Depp therefore had a lot of freedom to make the character his own. He watched all the pirate films he could lay his hands on and read a vast quantity of books on the subject, including *Under the Black Flag* by David Cordingly, intent on creating something totally new. From the works of Bernard Moitessier, Depp learned that the objective of any sailor is to reach the horizon. That was his guiding principle throughout the film, and led him to create the final line of the film, 'Now, give me that horizon'.[178] The first thing that struck him was the extreme heat endured by those at sea. He recalled the illustrations of Howard Pyle, showing pirates sweltering beneath the blazing sun on white sandy beaches. This gave him the idea for the kohl-lined eyes (to protect them from the glare of the sun) and Berber-like tanned skin. Another source of inspiration was clear to him: he was going to pirate the film from the inside.

'I thought that pirates were like the rock 'n' roll stars of the eighteenth century', he explained to *The Guardian*. The archetypal rock star in his

The character of Jack Sparrow does not have much history. In the Disney attraction, he is the archetypal pirate with a red beard, a booming laugh and a parrot on his shoulder. Depp therefore had a lot of freedom.

eyes is Keith Richards: the 'soul' of the Rolling Stones. 'Keith has a beautiful confidence, a graceful quality, an elegance and wisdom that I wanted the character to have', he added.[179] He was also inspired by Shane MacGowan, lead singer of The Pogues (for his bad teeth) and Pepe Le Pew, the stinking cartoon-character skunk with the French accent. *Pirates of the Caribbean* also owes a great deal to Roman Polanski's *Pirates* (1986), with its permanent irony that almost tips over into parody, Brueghelian faces, drunkenness and filth.

Depp admits to sharing Sparrow's insolence.[180] The figure of the pirate, like that of the musician or the writer, had inspired his previous roles, as his old friend John Waters recognizes, 'First of all, Johnny is a pirate in real life. It's the closest part he's ever played to his real self, but the fact that he played it kind of nelly was a big risk. If only real gay pirates were that much fun …'[181]

So Depp dons the classic attire of an eighteenth-century pirate (three-cornered hat, loose-fitting white shirt, boots, red bandana, belt) adding his own personal touch to it: dreadlocks, little plaited goatee, bracelets – some of which were made for him by his children – rings, beads and other signs of his own adventures (like his tattoos).

The film studios gave Depp free rein and they knew that he would come up with something eccentric, but the initial screen tests left them dubious. The four gold teeth and questionable breath raised some concerns and questions: 'Why's he wearing mascara?', 'Why's he walking like that?', 'Is he drunk?', 'Is he gay?', 'He's ruining the movie!' Depp even said to one of the Disney-ites: 'But didn't you know that all my characters are gay?'[182] In the end he asked them to trust in him. And they did, even though some of his suggestions were rejected, such as wearing a fake nose.[183] However, this idea was taken up by Ragetti (Mackenzie Crook), who is constantly misplacing his glass eye in the movie.

The creation of a legend

Depp had established his costume. He now had to go about making his character into a legend. After a prologue introducing the two leading men, we see Jack Sparrow from behind, perched at the top of a mast. But despite his striking attire, which seems to add stature to his slender frame, his majestic entrance is immediately discredited. He is actually a pitiful figure of a pirate: the ship he is swaggering about on is little more than a leaky old tub, which sinks no sooner than Sparrow sets foot on the dock. There is something slightly quixotic about him, out of step with the triumphant music of Hans Zimmer. When Commodore Norrington (Jack Davenport)'s men arrest him, they laugh in his face. He ends up in prison and when Barbossa's pirates attack Port Royal, nobody comes to his rescue. Later, on Isla de Muerta, he is ridiculed by the women he has abandoned and gets a fair few slaps in the face from them.

In the sequels, Depp-Sparrow continues to ensure that his first appearance in the movie has maximum impact. In *Dead Man's Chest*, he shoots the crow that has landed on top of the coffin he is hiding in, then rips off the leg of the corpse he has been sharing the coffin with and uses it as an oar to row away in the moonlight. To prepare for this scene, Depp spent an entire night locked in a coffin. In *At World's End*, Sparrow's entrance is surreal: thirty minutes into the film, his nose appears first, in an extreme close-up, sniffing at a peanut. In *On Stranger Tides*, his eagerly anticipated entrance is an optical illusion: he is no longer the condemned pirate, but disguised as a judge in a white wig. His entrances are always mock-pretentious, and above all, are not supposed to be taken seriously.

Depp sets the tone with theatricality and rhythm

The first thing we notice about Sparrow is his swaying walk. Depp plays Sparrow as slightly effeminate, swaggering to the verge of almost toppling over, as if his sea legs are uneasy on solid ground. The actor purposefully made him ambiguous, remembering that ships' crews were exclusively made up of men, as women onboard were thought to be bad luck.[184] Will thinks he is 'odd' because he has spent too long under the hot sun, and at sea. Sparrow hovers, as if always in suspension. Ethereal, bird-like, Depp seems to be beating time and he revels in using hand gestures, as in *Ed Wood* or *Fear and Loathing in Las Vegas*.

He used his body a great deal for this very physical role: he dives, runs, handles a sword. Although the actor had several stunt doubles, he had to be trained to fence in order to make the fight scenes more realistic. He also had to be trained in sailing, knowing how to hold the bar, hoist the sails and haul aft the sheets, during some shots. But Depp is not as acrobatic as Errol Flynn (who starred in Michael Curtiz's *Captain Blood* in 1935 and *The Sea Hawk* in 1940) or as imposing as Walter Matthau (Captain Red in Polanski's *Pirates)*. The sparrow cannot twirl in his weighty costume. He runs almost in slow motion.

For Depp, it's all in the tempo. Even for this role, he refers back to silent actors. 'For me, there's a real fine art to the timing that I'm still working on because you go back and watch guys like Chaplin and Keaton or even in the dramatic roles, Lon Chaney. The timing, especially in those silent films, is just astonishing'.[185] To provide rhythm, he also plays on words and their resonance. He takes a musician's delight in them, seemingly improvising certain intonations depending on their musical potential. He mumbles, invents

Top: Sao Feng (Chow Yun-fat), Captain Barbossa (Geoffrey Rush) and Jack Sparrow in *At World's End* (2007).

Bottom: Sparrow and Elizabeth Swann (Keira Knightley), the governor's daughter, in *The Curse of the Black Pearl* (2003).

Following pages: In the third film, *At World's End*, Elizabeth casts off her fancy dresses and joins the mêlée.

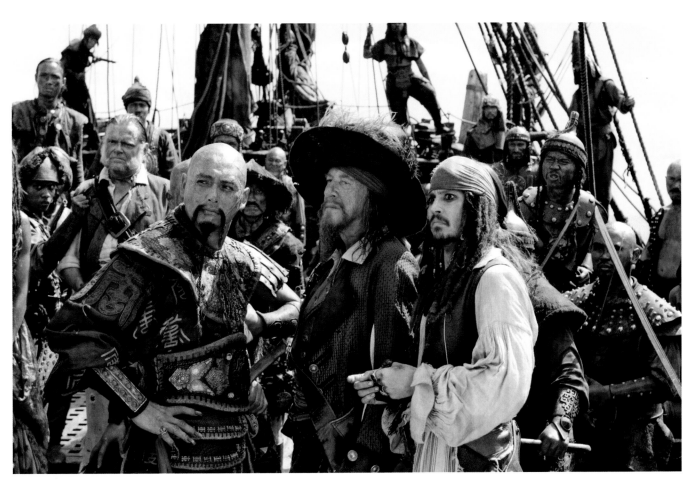

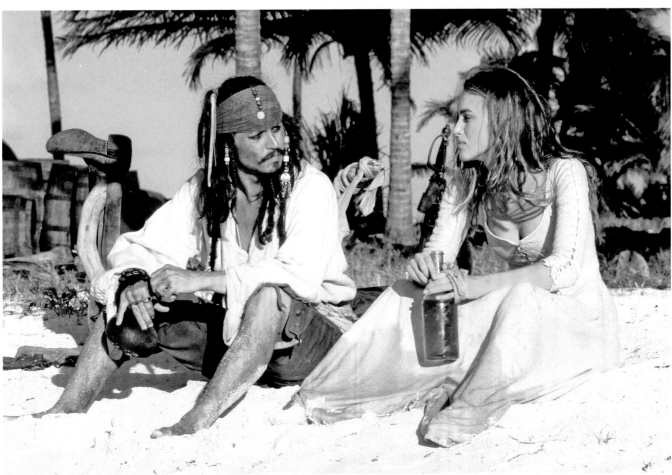

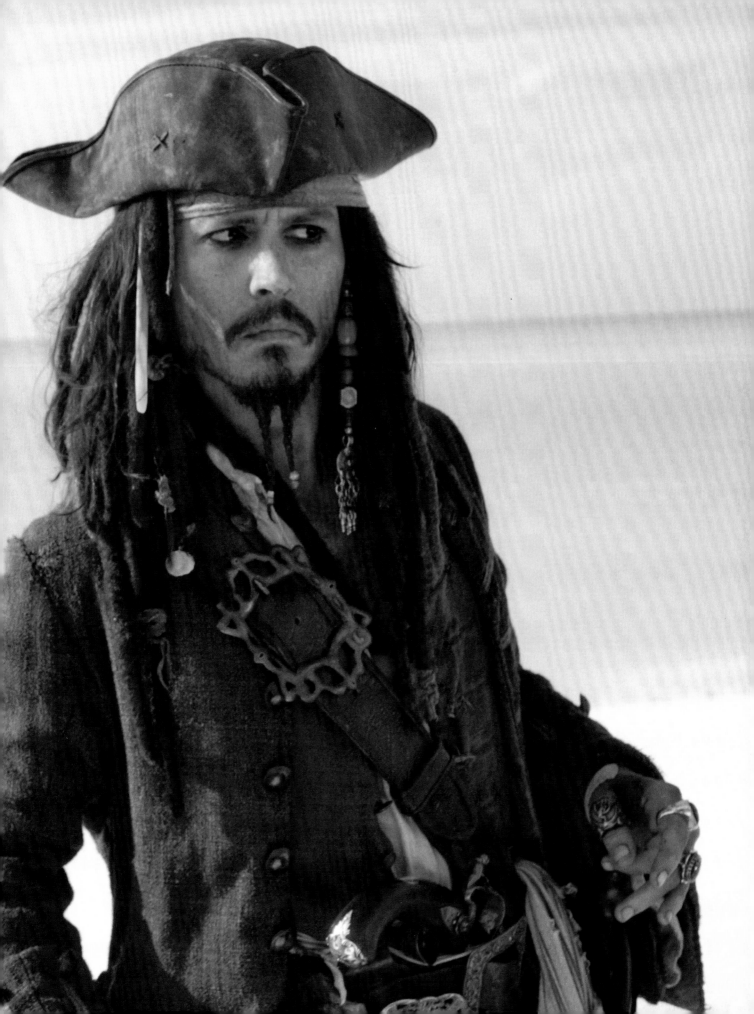

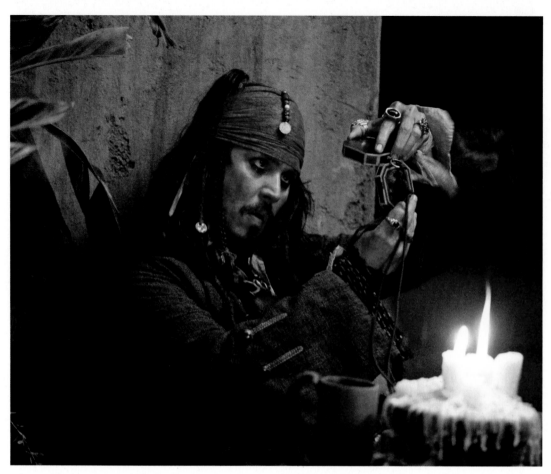

a language, uses comic repetition, like the riposte that comes up time and again: 'You will always remember this as the day that you almost caught Captain Jack Sparrow', which was improvised with the director in the studios.

A skilled comedian

Having been trained in Burtonian irony, Depp had realized the joy of making people laugh long before he took the role in *Pirates of the Caribbean*, becoming aware of his comic potential very early on. In 2006, he admitted that it was easier to play Jack Sparrow or Willy Wonka (in *Charlie and the Chocolate Factory* by Tim Burton) than a darker character such as in Laurence Dunmore's *The Libertine* (2004): 'With *Pirates* or *Charlie and the Chocolate Factory*, it was all about making Tim Burton laugh or making the crew laugh. With this [Wilmot], it was very intense and emotional and a little ugly; so I guess it was more difficult'.[186]

Even in the burlesque, and contrary to what one might imagine, his performance as Sparrow is to some extent influenced by his previous roles. Depp cultivates his mannerisms, hobo look and borrowed accent, while not neglecting the art of timing: he shows that he has manners by shaking Norrington's hand, jumping, tapping on a tree and hopping around on the sand. The other actors play their characters at face value; not him. Depp delivers parody in a film

that is not supposed to be one. He pushes his reactions to an outrageous limit. His comic genius is sometimes based on his response to something trivial – a passing chimpanzee or a feather from his hat that is bothering him. His face is not elastic, but he can create humour with a simple eye movement.

Depp knows he is incapable of being scary, so he opts for the ironic approach, squinting when he announces something solemn, or highlighting the dead-pan aspect of his comedy. He defuses grandiloquent phrases, sometimes forcing a smile to show his gold teeth, raising his eyebrows and playing up his amazement. He uses recurring gestures: the raised upper lip to show surprise, disgust or doubt, and the slight wrinkling of the nose to show disdain or cowardice.

Throughout the episodes, Depp makes fun of his own character more and more. He steers Sparrow toward the cartoon-like, often defying the laws of gravity with exaggerated falls, constant blunders, acrobatic pirouettes, great long strides, fainting, soaring leaps, being fired out of a cannon like something worthy of Buster Keaton's *The General*. In *Dead Man's Chest*, he is even hysterical when confronted with another master in the art of inversion: a monkey. For Gore Verbinski, Jack Sparrow is the character that is closest to Depp's personality: 'He's always Bud Cort [the lost young man in *Harold and Maude* by Hal Ashby], never Clint Eastwood. There's always

Johnny Depp and music

Understanding an actor sometimes also means understanding what drives them musically, in terms of rhythm. The saying 'Tell me what you listen to and I'll tell you who you are' is particularly relevant with an actor like Johnny Depp, whose penchant for rock music and singing is well known by the public. In many interviews over the years, several names of bands or artists have provided the key to his tastes and inspirations. An imaginary soundtrack in the actor's mind can therefore be patched together that includes The Clash, Sex Pistols, The Pogues, The Replacements and Red Hot Chili Peppers alongside Frank Sinatra, Louis Armstrong, Miles Davis, Charlie Parker, Coleman Hawkins, Iggy Pop, David Bowie, Pearl Jam and Booker T. Depp also loves gypsy music, lapping up the likes of the band Taraf de Haïdouks, and the blues of Robert Johnson, Son House, Howlin' Wolf, and so on. More surprisingly, the actor is not immune to classical music either: he plays Bach on the guitar and is a fan of the cellist Yo-Yo Ma, who he listens to sometimes between takes. Listening to music is an essential part of Depp's daily life during filming. He often plays music on-set, as if acting for the camera naturally requires a musical response outside of takes; as if one cannot exist without the other.

This passion for music is expressed in many different ways: firstly through the bands he has played in (notably The Kids) but also the music videos he has been involved in as both an actor and musician, in particular for Tom Petty, The Lemonheads, Shane McGowan, Johnny Cash, Marilyn Manson or Paul McCartney, and even as a director (under the name Richard Mudd) for Vanessa Paradis (including *Pourtant, que fait la vie?* and *L'Incendie*). Beyond his ability to sing in his own films (notably in Tim Burton's *Sweeney Todd* in 2007), Depp has also influenced the 'sound' of his films, by inviting Iggy Pop to perform on many occasions, for example. When one talks about the actor, one can almost associate a musical footprint, a style of soundtrack and a family of musicians with him. In this respect, Depp himself could almost be considered an original soundtrack.

113

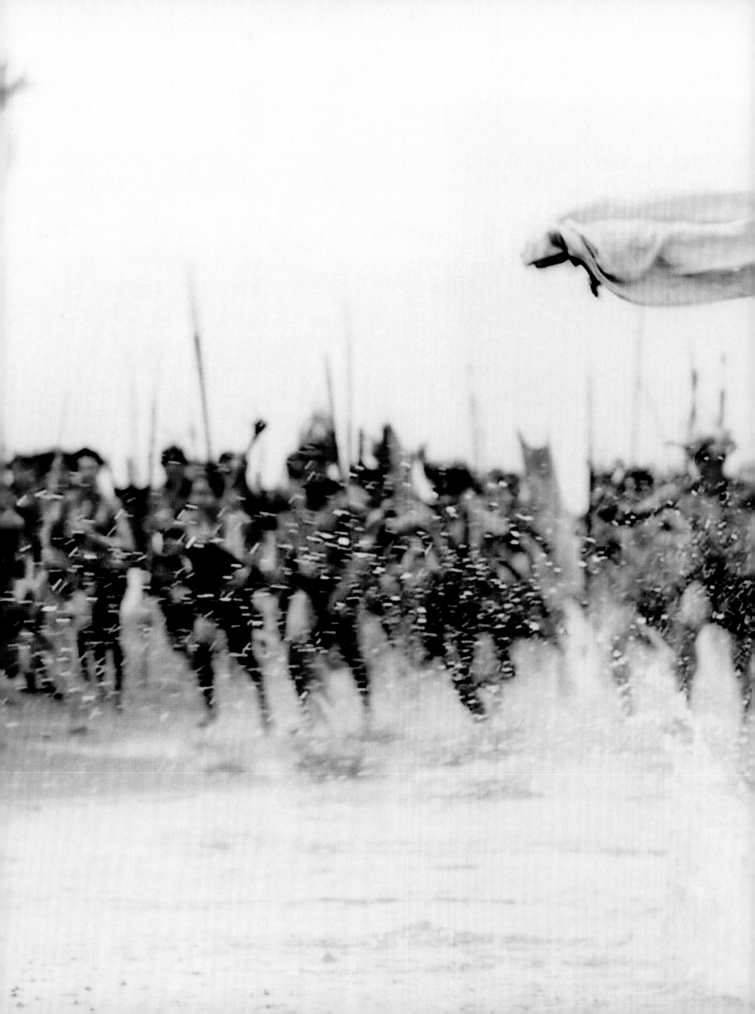

Left: The actor added personal touches to the classic attire of the eighteenth-century pirate: dreadlocks, a little plaited goatee and bracelets (some of them made by his children).

Opposite: In *At World's End*, Depp found himself opposite his hero Keith Richards, the archetypal rock star.

Following pages: Jack Sparrow and Will Turner (Orlando Bloom) in *Dead Man's Chest*.

an internalization, where he's standing back and watching things'.[187]

The man of a thousand faces

At first sight, Sparrow is a rogue pirate, a fickle thief who spends all his time tricking the people he comes across, an unpredictable pathological liar. Hans Zimmer's music often punctuates his fox-like gestures. He has shrouded himself in so much legend that it is impossible to pick out the true from the false. His second-in-command, Barbossa, abandoned Sparrow on a desert island with a single bullet. Sparrow claims that he built a raft using rope made from human hair, that he drifted in the ocean for two days, pulled along by two turtles, and a tribe named him their chief; but nobody believes him. However, this first impression gradually crumbles away and Sparrow ends up taking command of *The Intrepid*, with Will Turner, and his stature grows.

Finally, there is nothing left of the pitiful pirate that he claims to be, and the reality is even more improbable than the fiction. We understand that there are curses that exist, that 'off the edge of the map, [...] Here there be monsters', who have really made them his chief, and that he is a fantastical character. Depp makes Sparrow a 'man of a thousand faces', a new Ulysses, whose main strength lies in his cunning. Sparrow's crew, after having aped the plot of the Cyclops

Polyphemus, also then reproduce that of the Trojan Horse to get inside Barbossa's lair.

Just as he was in the original Disney attraction, Jack Sparrow is a guide. He appears to be looking ahead and knows the things he must keep to himself. According to Patti Smith, who interviewed Depp for *Vanity Fair*, Sparrow even has something of John Barrymore about him: 'He doesn't really want people to comprehend that he knows everything'.[188] The actor worked closely with the scriptwriters to purposefully make Sparrow's motivations more complex, sometimes even obscure. He is always striking a bargain and talking the talk. Coming across as boastful, sometimes he does the opposite to what he says. In *Dead Man's Chest*, when the Kraken attacks, he disappears, leaving Will to direct operations. We find him a few sequences later on, fleeing in a boat. But he comes back to fight and kills the Kraken by sacrificing himself. He even rubs off on the other characters, making them evolve. Will Turner, a prisoner aboard the *Flying Dutchman*, imitates Jack's tricky escape. Elizabeth casts aside her corsetry and learns to be as cunning as Jack, even engaging in a very unclear game of seduction with him.

Sparrow the conjurer

Jack Sparrow is the antithesis of Captain Hook, who, in *Peter Pan*, is the adult who has accepted

growing older. But he is not immortal. In *Dead Man's Chest*, Sparrow's fate seems sealed from the outset: the coffin, the hourglass, the black mark (which evokes the plague that would have decimated the real *Flying Dutchman*), the way he falls into a grave. Sparrow's freedom belongs to the old world. Maps are becoming increasingly accurate; globalization and capitalism are already on the rise. It is the beginning of the modern age. The East India Trading Company is even making its mark on the remotest corners of the world (except the island of Tortuga, the refuge of outlaws, similar to Tatooine in *Star Wars*). Sparrow must adapt or perish.

Depp communicates his insatiable curiosity through the character. He likes getting lost, playing an unpredictable character who flees from the camera. From the first movie, Sparrow is wearing a metaphorical mask. Nobody seems to know who he is. His compass directs him toward his deeper desires, but it does not always work properly, and this idea is the pretext for his entire performance. Does Jack really know what he wants? Are certain things forbidden? Even the scriptwriters do not seem to really know who he is, given that Jack Sparrow was never really their creation. 'Do you think he plans it all out, or just makes it up as he goes along?', asks one of the Royal Navy officers, with a hint of admiration. 'He's always got a plan! Even when he doesn't have a plan, he's got a plan. Amazingly,

he always sort of lands on his feet. He's kind of feline in that way', explains the actor.[189] A feature that runs throughout the fourth movie is the improvisation that occurs frequently in the dialogues.

Sparrow is the quintessential anti-hero: he is individualistic, not much of a fighter, and great at ducking and diving. When a fight breaks out in a tavern on Tortuga he manages to stay out of it, striding through the chaos unscathed, more concerned with his hat. 'The most interesting thing about him is that he is a monomaniac: his eye firmly on his compass, he lives inside his obsession, unfazed by those around him,' Stéphane Delorme wrote in *Cahiers du cinéma*.[190]

With each new film, the character of Jack Sparrow becomes increasingly ambiguous and is transformed into a kind of devil. When he surrounds Davy Jones like a snake to get behind him in *Dead Man's Chest*, it is no longer clear who is bargaining with whom. When he manipulates Elizabeth using his compass to find the *Flying Dutchman*, he vanishes like a magician (an idea he worked out with the scriptwriters). Returning to the screen from below, only to vanish again soon after, he unwittingly uses one of the early forms of appearance of the devil in movies: the vanishing trick. By making his entrance on a roasting spit at the start of *Dead Man's Chest*, just as in *Faust in Hell* by George Méliès (1903), he makes reference to the cinema of attractions, an early

form of cinema that gained popularity along with fun fairs. With his sudden entrances, Sparrow–Mephisto recreates the pleasure of the immediate effect, bursting onto the screen the old-fashioned way, like a Jack-in-the-box. Like his character, Depp evolves in a genre whose rules he is supposed to respect. The first episode ends with a closed box, with a compass that has gone haywire. Depp is in a box, but his desire for freedom is still intact.

Multifaceted Depp

Given that he was free to develop his character as he liked, Depp was so brimming with ideas that Jack Sparrow became an amalgamation of his previous roles. In the prologue to *Dead Man's Chest*, along with the bird feathers he also sports the daubing of an indigenous king: six eyes painted on his cheeks, two more on his eyelids, as in Cocteau (which Depp referenced in *The Brave*) and a green insect on his nose (as in Maori paintings). Depp is constantly making reference to his previous films and to certain themes. This is expressed particularly through being daubed in certain ways: he was covered in milk and soot in *Arizona Dream*, slathered in cream in *Edward Scissorhands*, washed out in *Ed Wood*, garishly made-up in *Dead Man*. Here, he is often splattered with sticky substances, by Davy Jones and by the Kraken, which covers him in mucus.

Sparrow is the man of a thousand faces: bird, monkey, parrot, cat, lizard, fox … In *At World's End*, he wanders around in the afterlife, leading a crew of clones. Sparrow is faced with the different sides of his personality and moviegoers get ten Depps for the price of one: the chicken in *Arizona Dream*, the timid Edward, the ghost-like Bill Blake, the anachronistic Ichabod Crane, the enthusiastic Ed Wood, the apathetic Gilbert Grape … Depp draws inspiration from independent cinema to enrich the blockbuster. His clones make a comeback on the *Flying Dutchman*. Sparrow–Depp becomes one with the boat, holding his brain in his hand: his roles seem to haunt him. With Sparrow, Deep is almost less of a composition actor than a 'compositing' actor: his characters seem to be superimposed over each other like sheets of tracing paper. In all of the *Pirates of the Caribbean* movies, the question of immortality arises: 'You've seen it all, done it all. You survived. That's the trick, isn't it? To survive?', says Sparrow. 'It's not just about living forever, Jackie. The trick is living with yourself forever', replies Teague.

It's the theme of duality again: Teague returns in the fourth film, just long enough to give his son some guidance on the necessary rituals for finding the fountain of youth, before vanishing through a twist of scriptwriting. Depp himself falls into the trap of repetition. Sparrow the monkey is aped by a woman he can, in a burst of narcissism, kiss.

Sparrow the parrot repeats things over and over again. But despite the fountain of youth, Depp cannot regenerate himself at will. And the theme of deception finds its climax in the last episode, when the weary actor seems to let the role get away from him.

Unprecedented success

When the movie was released in March 2003, Depp, who was pushing forty, became a box-office hit against all the odds. The tabloids were delighted, as if they had always expected to see him in a blockbuster, and regretted his 'lesser watched' films like *Arizona Dream* or *Dead Man*.

But why are family audiences so attached to this lazy, alcoholic, thieving, dishonest character? The 2000s seemed to favour superheroes who don't take themselves too seriously, and Sparrow (who came on the scene just after Shrek) has something of the rascal about him; that 'bottom-of-the-class' aspect that appeals to young people. When the film had made more than $250 million (after being predicted as a flop), Disney executives called Depp to congratulate him. For the first time in his life, he began to dream of a sequel. The success of the film affected him and revealed his paradoxes. His audience had so far been underestimated; Depp was very aware of this. Since *21 Jump Street*, he always claimed that he did not want to end up 'stapled to a box of cereal […] A franchise boy, fucked and plucked with no escape'.[191]

Depp, nominated for an Oscar for Best Actor, was thrilled to be given the chance to explore the role in more depth and declared that he had a whole load of ideas to expand on. Whoever the scriptwriters were (Ted Elliott and Terry Rossio for the first four movies and Jeff Nathanson for the fifth), Sparrow was still his creation, at least while the box office still smiled favourably at him. In the end, *The Curse of the Black Pearl* raked in $650 million worldwide. Depp's fees skyrocketed and he entered the vicious circle of money that is hard to refuse.

The Disney attraction inspired the film. The film now inspires attraction. Despite the sometimes confusing storylines and the overblown aspect of some episodes, moviegoers are still hooked. Depp sees himself as a pirate in Hollywood: 'It's cool to see that you've planted your flag deeply in enemy territory and the enemy is kind of okay with it'.[192] The more successful the film became, the more fun Depp had. 'I am the proud owner of a Captain Jack Sparrow doll with detachable bottle of rum', he says.[193] In a way, creating a character who is known all over the world, with a strong visual identity and an instantly recognizable silhouette, like Charlie Chaplin, Indiana Jones or Don Corleone, was a real challenge for this lover of literature.

Captain Jack Sparrow in *The Curse of the Black Pearl*. In 2003, against all expectations, Depp became a box-office hit.

Although the French press did not have high expectations, they were pleasantly surprised. They found the films rather long but in general they appreciated the 'horror for all ages' aspect, harking back to adventure films of old, and the character of Sparrow, the ambiguous antihero, so far removed from Douglas Fairbanks and Errol Flynn. He is an endearing character, and Depp seems to be in a state of grace. *Le Canard Enchaîné* felt that he had 'as much panache as Gérard Philipe in his heyday'.[194] But the two sequels were disappointing. From 2003 onward, Depp's career took another course. Sparrow had gotten under his skin and the actor struggled to pack away his pirate paraphernalia. When asked about the evolution of the franchise, in 2006, he admitted the possibility of a '*Pirates* 4, 5 and 6 [...] If they had a good script, why not? I mean, at a certain point, the madness must stop, but for the moment, I can't say that he's done'.[195]

However, the dark, sumptuously monochrome world of another great director would enable him to explore a new side of his acting.

John Dillinger

Public Enemies (2009)
Michael Mann

'Dillinger is certainly like an actor. But as I've said before, when somebody hands you the ball, depending on where you've been in your life, […] you run with it as far as they'll let you, which is all I've been doing for 25 years'.[196]
Johnny Depp, 2009

At the age of forty-six, Depp joined the pantheon of actors who have worked with Michael Mann (Robert De Niro, Al Pacino, Jamie Foxx, Tom Cruise, James Caan, Daniel Day-Lewis) when he played John Dillinger. This most famous bank robber of the Great Depression really left his mark on American culture. The project had been in the pipeline since 2004 and Leonardo DiCaprio was approached for the part but, because of scheduling problems, it was Depp who took on the role previously played by Lawrence Tierney (*Dillinger* by Max Nosseck, 1945) and Warren Oates (*Dillinger* by John Milius, 1973).
 Public Enemies is based on a book by Bryan Burrough that gives an account of the final years of the gangster's life and how he was hunted down by the FBI agent Melvin Purvis (Christian Bale). After breaking his accomplices out of prison, Dillinger meets Billie Frechette (Marion Cotillard), the cloakroom girl, who goes on the run with him. He is arrested, escapes from prison and hides out in an isolated farmhouse, where he is tracked down. Billie is arrested in front of his eyes. Betrayed by one of his acquaintances, the gangster is shot by the FBI as he is coming out of the cinema. To the general public, who were hungry for justice in times of crisis, Dillinger was seen as a hoodlum with a big heart, in the same way as Jesse James or Clyde Barrow, and the legend far exceeded the man. Dillinger was not actually a notorious criminal. Prosecuted for the murder of an FBI agent, he mainly robbed banks, sometimes putting his overzealous cronies in their places. But he was no Robin Hood, either. Dillinger stole from the rich, but kept it all for himself. However, he did want to be popular with the general public, and with women.

Dillinger, the invisible man

What the director found interesting was the way Dillinger faced the world after spending ten years in prison. Was he aware of the changes

society had undergone, did he have plans, a strategy, a future? Mann was looking for an actor who had faith in the character, which is why he thought of Depp: 'What was inherent in him were these deep currents of meaning, a sense of the unseen that's not necessarily demonstrative, but you sense darker currents, you sense the layered awareness behind his eyes'.[197] The actor is very knowledgeable about that period in history. As a child, he was fascinated by the films of Humphrey Bogart, James Cagney and Fred Astaire. He knows everything there is to know about 1930s blues music. Also, he did not see the character as a public enemy.[198] To Depp, John Dillinger is 'the common man who said: "I am going to stand up against the establishment and do what I have to for me and mine,"' during a period of great social injustice.[199] He admires that energy and drew inspiration from it for the role. 'To have gotten so far and to have become that kind of really existentialist hero, every day was his last. He had made peace with that. He was fine with that. Yesterday doesn't exist. He just kept moving forward. There is something admirable about that', he explained.[200]
 The film begins in 1933, with Dillinger arriving at Indiana State Penitentiary and the escape of several prisoners. Depp first appears in the dark of the back seat of a car. When he gets out, we cannot see his face. He is then filmed from behind, in a long black overcoat, reminiscent of bat wings. Mann's *mise en scène* plays on his receding profile in order to rouse the viewer's curiosity. Never had Depp been filmed so much in the dark, or backlit. From the outset, he is presented as a kind of Horla, an invisible being, often out of frame, or off screen.
 Mann was inspired by Depp's classic beauty. The antithesis of the burlesque Jack Sparrow, Dillinger is based on the uniform fashion of the 1930s. The fluidity of the camera makes reference to Magritte's standardized images of people, and the interchangeable nature of silhouettes. Dillinger sports the same haircut, the same sophisticated suit, the same hat and even uses the same methods as Melvin Purvis. The FBI agents are depicted as 'cowboys' who use questionable methods. Dillinger, on the other hand, is a nineteenth-century bandit who believes he is invisible. Yet this is the end of an era, the end of old-fashioned robberies where gangsters, like pirates, could find islands

Mann was inspired by Depp's classic beauty. The antithesis of the burlesque Jack Sparrow, Dillinger dresses in typical conservative 1930s fashion.

to hide on that were off the radar. Dillinger spent ten years cut off from the world in a world of grey granite and then returns to a society that he is no longer a part of. Communication networks have been modernized. Cinema has gone from silent to sound. Depp is once again playing a transitional character, like Ichabod Crane and Jack Sparrow: one who has arrived too late to a world that is rapidly changing.

Depp seems fascinated by Dillinger's ability to become invisible whenever he saw fit (*The Invisible Man* by James Whale was also released in 1933, the year the action in *Public Enemies* begins). 'John Dillinger had the ability to sort of blend in that I don't somehow. To be able to wander the streets without being recognised would be fun', he explains to *The Age* magazine.[201] Despite the massive technological advances he was confronted with, Dillinger continued to believe he was invincible. In the opening scene in the cinema, he is discussing their next heist with his accomplices when the news item displays his picture up on the big screen. Nobody in the cinema recognizes him. Dillinger sits there looking straight ahead of him, with a victorious half-smile playing on his lips, which is also partly Depp playing with the audience. Dillinger is so convinced of his invincibility at that point that he wanders right inside the FBI office, in broad daylight, and asks an agent who is listening to the radio in there about the baseball game score. 'He actually did that. He also went to 1933's World Fair and handed his brownie camera to a cop and said: "Here, would you take a photo of my girlfriend and me?"', explains Depp, clearly impressed by his boldness.[202] However, while he tries to reassure his fiancée Billie who is frightened by the constant threat of danger, we know from the outset that this invincibility is an illusion. Despite the blazing sun overhead, a shadow is growing over the couple and the kiss they share is an omen of the tragedy to come.

Hardened face, sad smile

While he may have the same initials as the outlaw, Depp does not look like the real Dillinger. He does not have the same mature face (even though Dillinger died at the age of thirty-one), although the youthfulness of Cry-Baby had faded and the features of the actor were somewhat tired. His beauty was not damaged, but it had hardened. There was no need for special effects: make-up and lighting were all sufficient to create shadows. In the only scene in which he acts opposite Purvis, the lighting directed on Depp's forehead alone was enough to accentuate the wrinkles and dark circles. His eyes no longer shined; they were dark, often determined, always looking down. They bore through surfaces, just like Mann's camera.

What is striking is the distance between the actor and the sadness of some of his smiles.

The ironic shape of his mouth and his casual stance, accentuated by gum he chews on, are all borrowed from the real Dillinger. In the restaurant scene, Depp is filmed in long focus, smiling, but rarely have we seen him so far from the camera like this, isolated in the middle of the crowd.

Mann wanted an actor who was capable of letting out his emotions. For example, he likes the scene where, distraught and powerless, Dillinger watches the police take Billie away. 'Johnny plays very strongly when he feels an inner identification, […] As a Johnny Depp fan, what I wanted to see Johnny Depp do – something I hadn't seen him do for a long time – was play a tough man. And Johnny is a man – he's not a boy […]. I know some of the deeper currents within him, and I wanted to see an emotionally exposed piece of work from him'.[203]

The actor keeps his normal expressions, his focus, his internalization and his artful timing which completely fits with the character: a gentle voice with a hardened face (Dillinger is also a predator). He could have played a charming show-off but he resists, managing to alternate different levels of emotions: coldness, fear, sadness, desire. Through his gentleness he brings something extra to the character. When he gives Billie a mink coat as a gift, he seems reluctant to let himself show tenderness. In the scene on the dunes, Depp plays a considerate guy who wants to preserve the fragility of that moment with his fiancée.

The voice of memory

In his early career and for several years, Depp rarely used his real voice, which pronounces words with precision. He often liked to distort it, disguising it with accents, particularly English and Scottish (like in *From Hell*, in which he adopted the accent of a worker from London's East End for the role of Abberline). This ability to modulate the sounds of language is an undeniable asset. As someone who has always needed to do research to prepare for a role, Depp drew on all his influences to help Dillinger to find his uniqueness. And once again, it was through the use of his voice that he created his character.

Although he used archive footage to help him perfect some of the impressions, Depp did not manage to find any audio recordings relating to the gangster, apart from a tape of Dillinger's father asking for clemency for his son, in his nasal voice. Once again, the actor drew on his own personal memories. Depp was born in Owensboro, Kentucky, 200 kilometres from Mooresville where the gangster grew up. 'I wanted to salute my grandfather through Dillinger and salute Dillinger through my grandfather. You know, my grandfather drove a bus by day back in the '30s and ran moonshine by night', he explained to the *Los Angeles Times*.[204]

Right: In the opening sequence, Dillinger is led to the Indiana State Penitentiary by an accomplice, Red (Jason Clarke). The *mise en scène* plays on his receding profile to rouse the viewer's curiosity.

Following pages: Depp and Michael Mann during the filming of a sequence that was cut from the film.

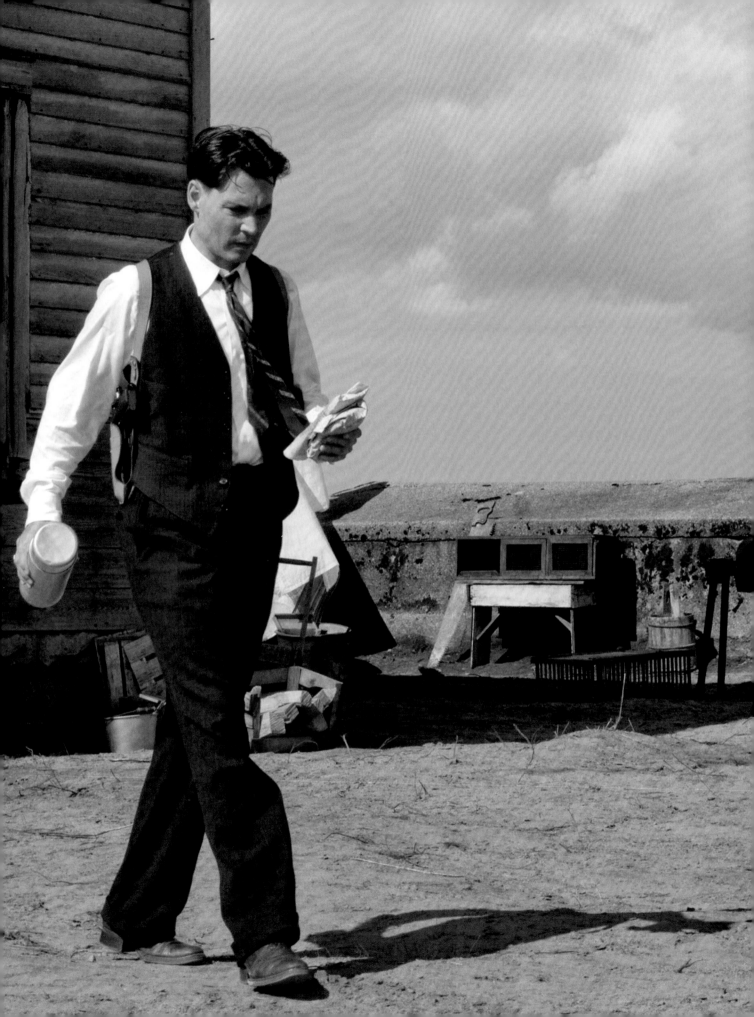

In an interview with *The Telegraph*, he added: 'My stepfather also had been a bit of a rogue and done burglaries and robberies and had spent some time in Statesville Prison in Illinois where we ended up shooting some of the film'.[205]

Mann was hoping for a macho Latino intonation, in the style of Tony Soprano. The actor suggested something else: 'So I just made the decision to sound not aggressively southern but to adopt a bit of a drawl', he explains in *Vanity Fair*.[206] On the set he listened to Artie Shaw's 'Nightmare' (1938), a melancholy melody that resembles him and that, in his opinion, 'can be applied to almost every scene'.[207] After the *Sweeney Todd* experience, he was making a timid return to singing. He breaks out into a traditional cowboy ballad – *Git Along, Little Doggies* – in one scene when Dillinger, riding high on the adrenaline of his successful escape, indulges himself in a moment of enjoyment.

Acting, filming, robbing and fast living

Depp does not owe his rise to fame to Hollywood action films. But Mann's slick, tight editing involved quick-fire dialogue and made his acting more nervous, more percussive. To avoid giving his film a look that was too retro and classical, the director used a digital HD camera to create a feeling of extreme realism, of instantly being plunged into the 1930s, which also created a strange incongruity between cinemascope and digital.

Unlike Robert De Niro's character in *Heat* (which the director filmed fifteen years before), Dillinger as a character seems to have been only lightly touched on. Mann devoted more time to the exchanges between De Niro and Al Pacino in that film than he did to the dialogue between Johnny Depp and Christian Bale in *Public Enemies*. When Dillinger introduces himself to Billie, at first under the name of Jack, Depp recites his lines in the style of a telegram: 'I was raised on a farm in Mooresville, Indiana. My ma died when I was three. My daddy beat the hell out of me because he didn't know no better way to raise me […]. I like baseball, movies, good clothes, fast cars, and you'. He condenses his life into a few lines because he thinks that there is nothing else to know but also because he offers several lives merged into one. Mann explains: 'Red had a fatalism, and those were the attitudes that were prevalent among these men', referencing *Death in the Afternoon* by Ernest Hemingway, which came out in 1932.[208] And, when Dillinger goes to find Billie at her cloakroom, that is exactly how Depp plays him. He holds out her red coat like a matador who faces death every day. He has to live fast; there is no time to lose.

After playing a drug dealer in *Blow* (Ted Demme, 2001) and Jack Sparrow, the actor once again plays an outlaw who, in his quest to live an intense life, enters an infernal spiral. Like Corso in *The Ninth Gate*, he is a damaged man caught up by the lure of money. 'It reminded me of when I started acting because I didn't want to be this at all when I first started out', Depp reflected after the release of *Blow*. 'I started making money like I'd never seen before in my life. One thing led to another and suddenly I was on the rise and there was no stopping it'.[209]

When he robs a bank, Dillinger bursts into the arena as if it is a film set. It is risky, loud, bright, and just like in Hollywood's star system, can all be over in an instant. Depp takes a tremendous leap over the counter just like Dillinger, who thought of himself as an actor and who, with emphatic movements, used to imitate his favourite star, Douglas Fairbanks. When the character gives a press conference, which increases his feeling of invincibility, Depp plays it with the nonchalance of a young male lead actor or a rock star, amused and delighted by the swarm of journalists. Charming, passionate, a stylish amateur, Dillinger made his own accessories, such as a wooden revolver shined with shoe polish, which he used to escape from prison. These objects, his hat and his revolver, are actually all that we have left of him.

Depp plays Dillinger with an energy born out of desperation; he is always on the edge, transient. His suitcases are never unpacked. 'What do you want?' Billie asks him, after their first night together. 'Everything. Right now', is his reply. Like Mann (who sleeps for only four hours a night), everything for Dillinger had to be perfect and fast. It was the extreme media coverage of Dillinger (who was hunted by the FBI, the press and photographers), and the fierceness of the attention focused on him that in the end led to his killing. Depp certainly also felt this fragility, inherent in his line of work, and his later career choices were perhaps born out of this feeling of insecurity. In 2009, after three *Pirates of the Caribbean* films, he was delighted that he was still popular at the box office. 'The suicide of his friend Hunter S. Thompson, the stories about the hazards of a career in acting told to him by the great legends he mingled with on set, such as Martin Landau, Robert Mitchum and Faye Dunaway […] It all gave Johnny Depp, from the off, a feeling that his career could be over from one day to the next, and that those who worshipped him one day, could forget about him the next', Sophie Benamon recalled in *L'Express*.[210]

Just a colour on the palette

The frequent frames within the framing (in cars, between prison bars, door openings, windows) often single out his face. Like film stars, Dillinger seems to be disconnected from reality. Mann

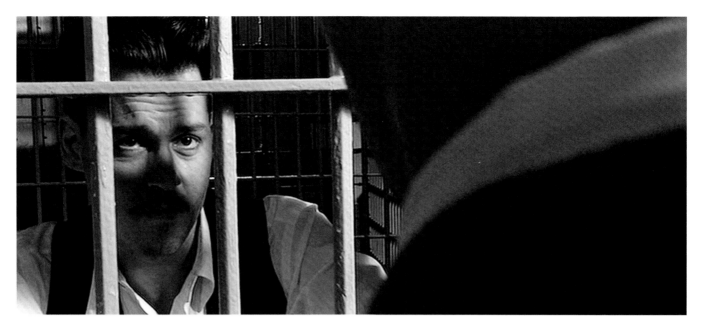

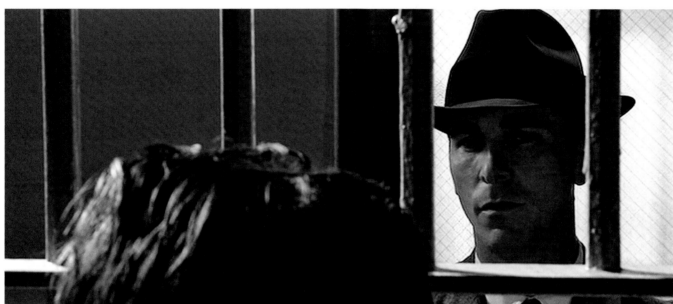

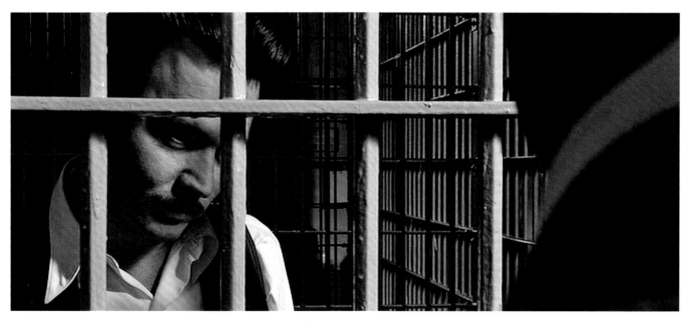

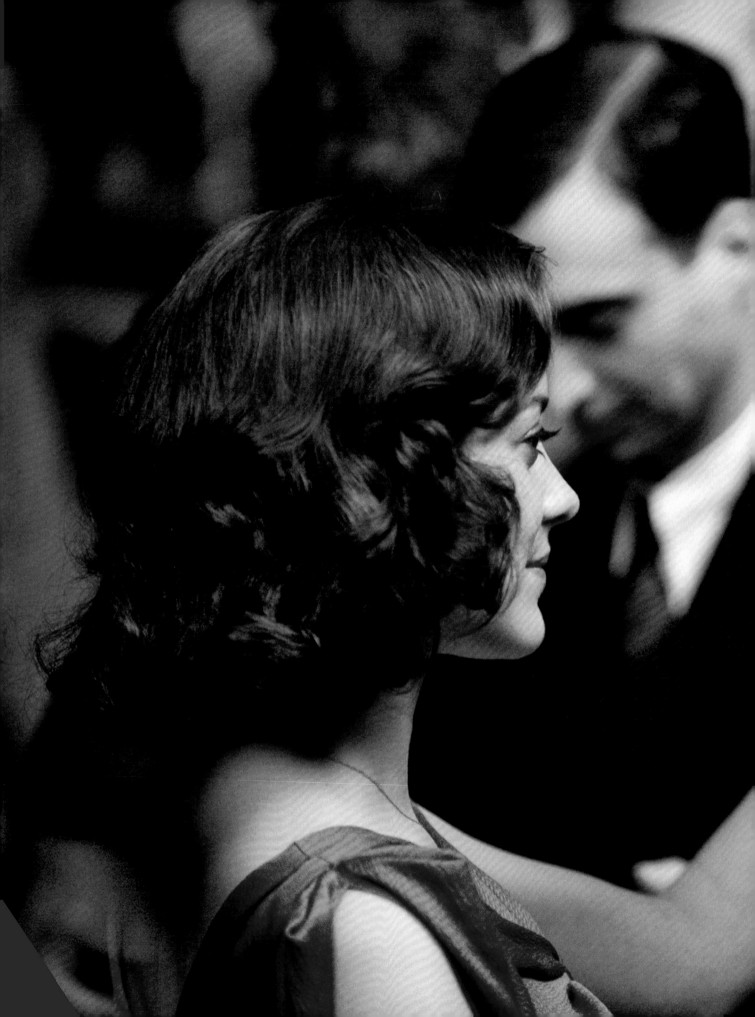

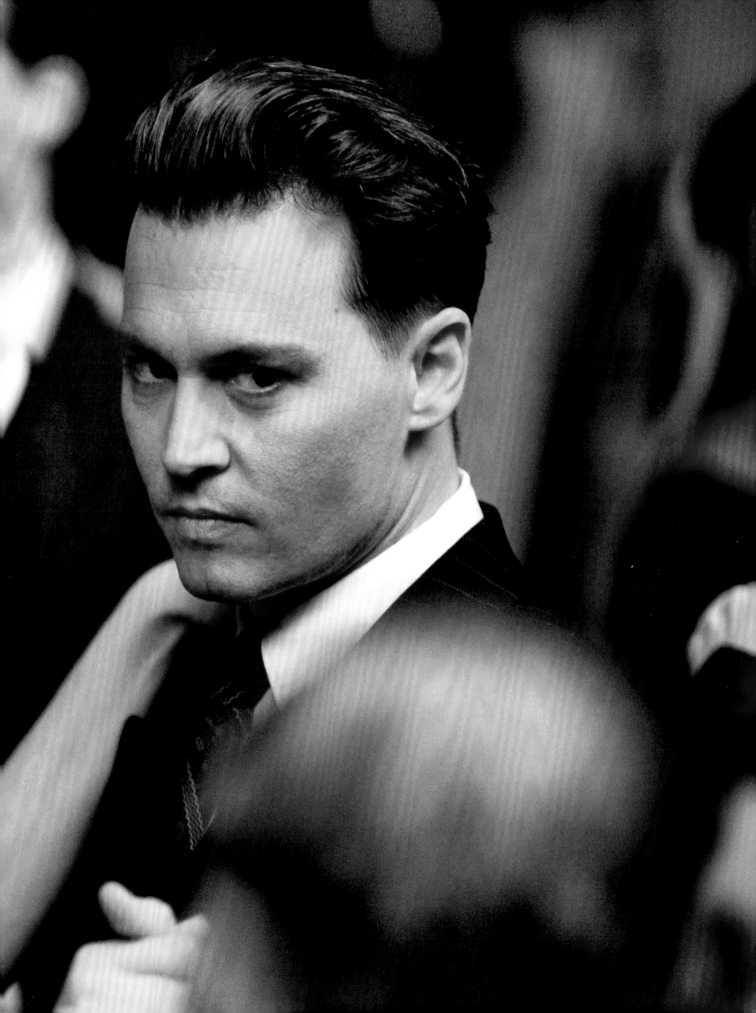

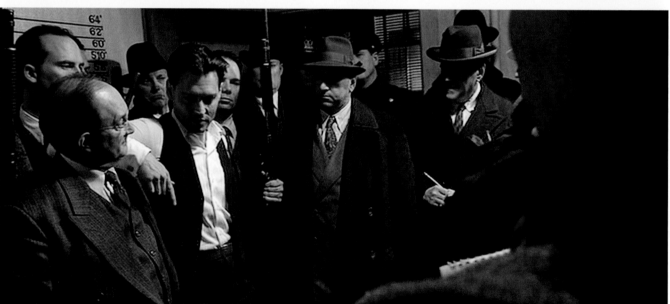

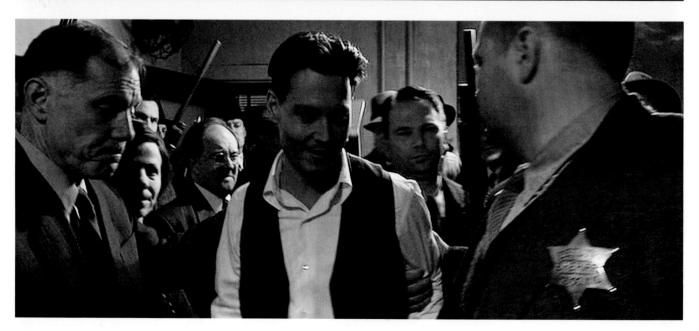

Opposite: Depp plays the
scene of the impromptu
press conference with the
nonchalance of a young male
lead or a rock star, amused
and delighted by the swarm
of journalists.

Right: Michael Mann and
Johnny Depp during the
filming of the first bank heist.

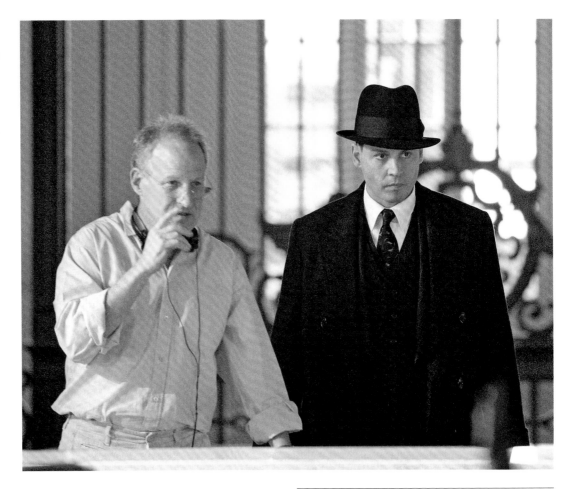

focuses on the isolation of characters so much
because he is particularly influenced by the painter
Edward Hopper. Depp and Cotillard spent
hours with him at the museum, soaking up
the atmosphere of the paintings, and that feeling
of tension, exclusion and impending doom
that drives his work.

But although Dillinger's voice was down
to Depp, the actor was not always as in harmony
with Michael Mann as he was with Tim Burton
or Gore Verbinski. The director is an obsessive
perfectionist, and Depp resented his lack of
freedom, as he had done when he filmed Polanski's
The Ninth Gate. Mann was the painter here
and Depp could not get used to that. 'I'm definitely
not good at just being a color on the palette,
you know', he admitted when the film was
released.[211]

In this film, he had to be part of a general
atmosphere. It was more about blending in,
disappearing, than acting. Just as Dillinger suggests
to Billie that night on the dunes, on their last
night together, it was about how to 'slide off the
edge of the map'. Mann seems to want to strip
the whimsical Hollywood actor down to the bare
bones, to water him down. And the hardened
face evolves as he plays against type, in a role
very different from anything he had done before.
The director tried to make his oval face fit into
something square, and to make it as straight
as the architecture of the time.

Spectral actor, machine-actor

After spending so many years isolated in prison,
Dillinger, when he got out, enjoyed going to
the movies to try to form an idea of the modern
world. Through his insatiable need to absorb
everything, he made up for lost time thanks
to these cinema sessions, and even used a movie-
influenced vocabulary to seduce Billie. It was also
the screening of a film that cost him his life. Just
before he was shot down in the street, Dillinger
had been to the cinema to see W. S. Van Dyke's
film *Manhattan Melodrama*, about the friendship
between Blackie, a charming outlaw (Clark
Gable) and his childhood friend turned cop
(William Powell). In this scene, Depp's Dillinger,
who has not always been a gangster, seems
confronted with his own image. Just like Edward
Scissorhands, Dillinger is 'not finished, but
only in the process of becoming', notes Steven
Rybin in his book on Michael Mann.[212] He is
a lone wolf. Dillinger only becomes 'Dillinger'
by staring into the celluloid eyes of the gangster
played by Clark Gable (who sports the same
little moustache as him).

Depp really shows his art in this moment
of intimacy with Dillinger. What is the character
thinking about in this scene? About the adrenaline
rush he gets from bank robberies? About
the unsettling feeling that all of this will lead
nowhere? That he has no future, whatever

he does, whatever relationships he forms? With his chiaroscuro acting, Depp sets himself apart from other major iconic gangster figures such as Brando in *The Godfather* (Francis F. Coppola, 1972) or Al Pacino in *Scarface* (Brian DePalma, 1983). Dillinger is aware, in real time, of becoming an icon. He helps to construct the hero. But he feels that actress Myrna Loy's 'Goodbye, Blackie', addressed to Clark Gable, was really meant for him. With his piercing eyes and his sad smile, like a Buddhist monk, Depp finds the exact expression to convey the death drive that grips the gangster. He knows he will not live long, but it was worth it. The actor explains: 'John Dillinger was that era's rock and roll star. He was a very charismatic man and he lived the way he wanted to and didn't compromise. I feel he was a kind of a Robin Hood because he truly cared about people. He knew time was short and I believe he had found himself and was at peace with the fact that it wasn't going to be a very long ride, but it was going to be a significant ride'.[213]

This incredible cinematic sequence also raises Mann's favourite themes: machinery and the industrialization of crime (and of the star system), the shift toward modernity, the FBI and its phone-tapping, Hollywood and its idols, anonymity and the individual. Coming out of the cinema, Dillinger is shot and collapses in the street, his face covered in blood. Mann emphasizes the redness of this blood as if the character

has lived in black and white during the film and it is colour that has killed him. Who better than Depp could have played this spectral bank robber, making his way alone, already dead; this Dead Man, a hero from an ancient world, pursued by a Batman without wings, with his already 'high-tech' guns? Even when he acts in a realist film, Depp is like a fantastical character, a universal creature. He also presents a devilish paradox: his signature quality is his absence. Depp likes to make us believe that he does not exist.

A lukewarm reception

The strangeness of the film was disconcerting. The press criticized the film's narrow scope and the lack of depth of the characters. Mann himself questioned the end result, and wondered if he had truly managed to express Dillinger's motives and the character's ambiguity.[214] The critics had expected more references to the Great Depression; they wanted Mann to show the poverty that in some cases led to organized crime (by placing more emphasis on the parallel with the 2008 crisis). The director's approach did not offer an insight into Dillinger's family or sociological background (we know nothing about his past), which contributed to this general disappointment.

However, after roles such as Jack Sparrow, this was a refreshingly modest role for Depp, and one that was well received above all by fans

Johnny Depp and literature

On the website of the actor's production company, Infinitum Nihil (founded in 2004 with his sister, Christi Dembrowski), there is an extract from *Confessions* by Tolstoy: 'Force is force, matter is matter, will is will, the infinite is the infinite, nothing is nothing'. A curious literary quotation for a production company that also publishes books, such as *House of Earth* by the singer Woody Guthrie in 2013. The publication of *The Unraveled Tales of Bob Dylan* by Douglas Brinkley is also planned for 2015. Johnny Depp is one of the rare actors in Hollywood's history to also become a publisher. An avid reader (of, among others, Baudelaire, Poe, Kerouac and Salinger), Depp also collects rare books, like the characters in Roman Polanski's *The Ninth Gate* (1999). This little-known passion of his goes some way to explaining why his name has so often been associated with the roles of writers (*Secret Window* by David Koepp, 2004) and novelists, including J.M. Barrie (Marc Forster's *Finding Neverland,* 2004), but particularly with adaptations of novels, such as those of Washington Irving (*Sleepy Hollow*), Roald Dahl (*Charlie and the Chocolate Factory*), Lewis Carroll (*Alice in Wonderland*) and his friend Hunter S. Thompson (*Fear and Loathing in Las Vegas* and *The Rum Diary*). A publisher and a collector, Johnny Depp is also an occasional author, writing forewords (for Tim Burton, mostly) but also some beautiful articles, such as *The Night I Met Allen Ginsberg* (which appeared in *Rolling Stone* in July 1999) and *A Pair of Deviant Bookends* (also for *Rolling Stone,* in March 2005), as a tribute to Hunter S. Thompson, for whom he also wrote the introduction to *Gonzo* in 2006. Depp also penned a text on Basquiat, entitled 'Basquiat Paintings – for Enrico – Under the Influence of Pork', for the catalogue of an exhibition in Paris in 2003.

of his early work. 'Depp's Dillinger is more evocative of Melville's existential samurai than James Cagney in Walsh's movie *White Heat* (no mood swings, no exuberance, but an ever-present cool, sophisticated elegance,' wrote Jean-Baptiste Thoret in *Charlie Hebdo*.[215] For *Libération*, Depp was 'perfect again, having wiped off his gothic mascara'.[216]

In *Variety*, Todd McCarthy wrote that 'Curiously, though, after letting loose in the *Pirates of the Caribbean* pictures and other films, Depp reverts to a more withdrawn, self-regarding posture, portraying Dillinger as a man who, having discovered his role in life, determined to play it according to a script of his own devising'.[217] For Roger Ebert, of the *Chicago Sun-Times*, Depp 'starts cold. He plays Dillinger as a Fact. My friend Jay Robert Nash says 1930s gangsters copied their styles from the way Hollywood depicted them; screenwriters like Ben Hecht taught them how they spoke. Dillinger was a big movie fan; on the last night of his life, he went to see Clark Gable playing a man a lot like him, but he didn't learn much. No wisecracks, no lingo. Just military precision and an edge of steel'.[218]

Mann's films are in keeping with the actor's melancholic nature and the feeling of absence he creates on screen, and although Depp likes to bring his own ideas to a film, he can sometimes be even more interesting when framed by a director who does not necessarily have the same cinematic tastes as him. However, after this experience, Depp returned to Tim Burton and his world of whimsical characters for a striking new look to add to this rogue's gallery of a career, and one of his biggest commercial successes.

On the run, Dillinger has found Billie again, but the woman he loves is about to be taken from him.

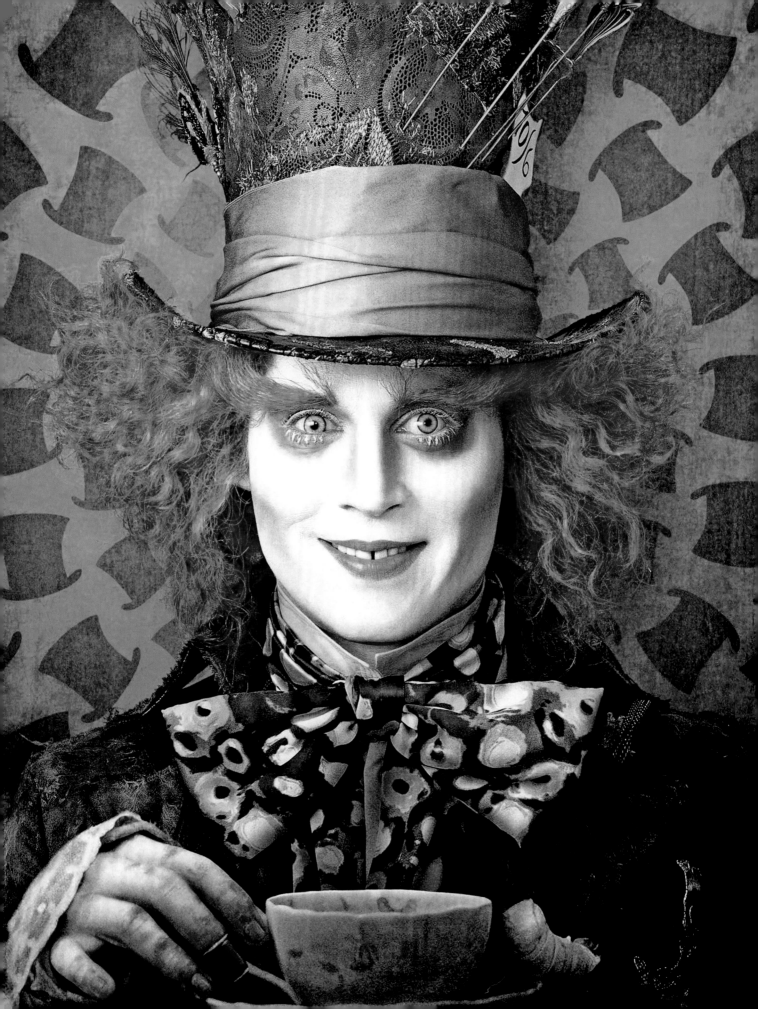

The Mad Hatter

Alice in Wonderland (2010)
Tim Burton

'That's the opportunity you dream of as an actor, to say, "Look I'd like to try something. It might be absolute crap, but I'd like to see if it works." If you don't try to push a little harder or go a little bit outside, what's the point? And if it doesn't work, he'll just say, "All right, you tried it, now try this." But when it pays off, and I hear that cackle off screen, that's when I know I've hit something on the nose, for Tim'.[219]
Johnny Depp, 2010

During the filming of *Public Enemies*, Tim Burton offered his favourite actor the part of the Mad Hatter in a new version of *Alice in Wonderland*. Depp, who had just finished re-reading the book by Lewis Carroll, had already made notes that could be useful for the role. After *Edward Scissorhands, Ed Wood, Sleepy Hollow, Corpse Bride, Charlie and the Chocolate Factory* and *Sweeney Todd,* this was the seventh time that the two men would work together. However, since the success of *Pirates of the Caribbean,* the director no longer needed to impose Depp on film studios. Better (or worse): it was the studios who suggested the name of the actor to him, even though Burton found the expectations heaped on them working together a little off-putting, fearing that it might hinder their freedom and disappoint moviegoers.

Alice in Wonderland is set ten years after *Alice's Adventures in Wonderland* and *Through the Looking Glass*, published respectively in 1865 and 1871. The little girl has become a young woman, about to marry an English lord who she does not like, let alone love. When the White Rabbit reappears in her life and gestures for her to follow him, Alice runs away, plunging once again into the world down the rabbit hole. Underground, she is reunited with her old acquaintances: the Mad Hatter, Absolem the Caterpillar, the White Queen and the Red Queen, who has seized power along with the Knave of Hearts. To restore peace, Alice must fight a monstrous creature, the Jabberwocky.

Burton chose a little-known actress, Mia Wasikowska, to play Alice, and Anne Hathaway for the part of the White Queen. Depp was working again with familiar faces: Helena Bonham Carter (the Red Queen), with whom he starred in *Corpse Bride* and *Sweeney Todd*, and Crispin Glover (the Red Knave) whom he came across in *What's Eating Gilbert Grape* and *Dead Man*. Two famous voices, anchored in fantasy, also punctuate the film with their cavernous tones: Christopher Lee (the Jabberwocky) and Alan Rickman (the Caterpillar).

The voice of time and madness

This time around, Depp did not play the leading role. The Mad Hatter is a secondary character, who does not appear until thirty minutes into the film, sitting in the background, head lowered, hidden, as often is the case with Depp. He is snoozing at a table full of empty plates and chipped teacups, against an ash grey landscape with a bleak, abandoned air about it. Awaking from his drowsy state, he cries enthusiastically, 'You're absolutely Alice, I'd know you anywhere. I'd know him anywhere!' The Mad Hatter, in high-pitched tones and bursts of shrill laughter, announces to Alice that he is trying to think of words beginning with M, then he whispers, then takes on a voice from beyond the grave, which he doesn't seem to have mastered, before falling back into apathy. As so often before, Depp drew inspiration from his previous parts. He takes a little of the high-pitched tone of Ed Wood, with hints of the affected, honeyed intonation of Ichabod Crane, and uses the vocal contrasts (lacklustre and enthusiastic, vibrant and dreary) of Willy Wonka. His voice betrays his madness and his flights of enthusiasm. Once in the forest, he works on the lower frequencies, with an inflection coming from the throat.

But he adds something else. The vocal timbre is that of an old man, despite his smooth facial features. In some ways it is like the voice of Bilbo in *The Lord of the Rings*. And Depp does not hold back from lisping to add ambiguity to his character and make him slightly like a retarded child. This first performance is an act of bravery. The approach he chose was a risky one and could have easily descended into the ridiculous, but Depp had a firm hold on his character: who is frightening yet at the same time pathetic.

'When I heard him do his scene for the first time, I loved everything that he had done with the very innocent, very hopeful, almost puppy-dog like thing [...] Another day he had fire in his eyes

Depp did not hold back from making the Mad Hatter an ambiguous character, a sort of retarded child who is both frightening and pathetic.

and was doing a Scottish accent. And I assumed that he must have been rehearsing something for another movie,' says Anne Hathaway.[220] When the Mad Hatter remembers the past, he rolls his 'r's (an intonation he had already experimented with in Marc Forster's *Finding Neverland* in 2004), in reference to Scottish comedy *Rab C. Nesbitt*.[221] 'The accents, the switching, it's the merging into another character as the Hatter; it's that safety mechanism that kicks in when he needs to become tough, when he needs to become angry, when he needs to be protective or when he's fearful. It's kind of like experiencing a kinder form of personality disorder, in a way,' explains Depp.[222] With time and his voice in total confusion, the Hatter is stuck there, condemned to sit and drink his tea in an immutable Victorian society.

Depp's panoply of characters

As with all of his roles, Depp had some images in his mind. For *Alice in Wonderland* he painted some watercolour pictures; as always with Tim Burton, he was thrilled to be able to put forward his own vision and use the film set as a laboratory of ideas. 'He leaves you such room to play, to mess around', says the actor.[223] For *Charlie and the Chocolate Factory*, Burton said, the actor's ideas got 'created organically, and he feels out. […] It's exciting because you're not quite sure what it is, ever. Part of the fun of it is an exploration of things'.[224] When the director was asked about how Depp had changed over the past ten years, he replied, 'The strange thing is, that guy never changes […] He doesn't give a damn about his image'.[225] Their collaboration is still just as stimulating but things have changed. For Burton, Depp is no longer the *alter ego* he might have been in *Edward Scissorhands*: 'I hear now and again that Johnny represents me on screen. That's becoming increasingly less true. We strive to create an identification with a character, like the Mad Hatter in *Alice ...*, but I try not to project myself onto them,' he explained when the film came out.[226]

Here, everyone brought their own designs to the drawing board. Burton was inspired by the prints of Arthur Rackham, who illustrated *Alice's Adventures in Wonderland* in 1907, and added his personal touch to it. His first sketches for the Mad Hatter are dark, with starkly contrasting proportions: huge hat, tiny face. Depp put forward something more hybrid and colourful.

In the first film version of the novel, in 1903, the Hatter's madness is represented, as in the prints of the early twentieth century, through polychromatic clothing (checks, patterns) and excess (garish colours, trousers too short, hats too big), evoking the infamy of the holders of colourful fabrics in the Middle Ages, the devils, but also all those on the fringes of society.[227] Depp's Mad Hatter underwent some subtle modifications; he wears worn-out clothes, in autumnal colours: khaki, ochre and earthy brown. He is an almost plant-like character, an Arcimboldo painting that, having waited so long, has blended into the landscape. Later on, when he goes off to battle against the Red Queen, he is dressed like a Scotsman, in a dirty peacock blue jacket, kilt, and mismatched socks. The spotted headscarf of the original illustrations has been replaced by a scarf covered with the eyes of butterflies and dragonflies, representing his transience, his inconsistency, but also his capacity for regeneration and for camouflage. As in the original prints, the price tag is still attached to the top hat, which is bound with old satin ribbon, and his hand is bandaged.

Like Jack Sparrow, the Mad Hatter keeps all his tools on his person: bobbins, thread, needles, thimbles, scissors, ribbon. He even has a lace shirt under his frock coat, a sophisticated edge to the character that could only be Depp's doing. Although each garment is an extension of the actor's body, often a fabric is wrapped or strapped around him, lengthened by a looser piece of fabric that hangs down, as if the actor is keeping hold of his role through shyness or a desire for precision, wanting to experiment above all else. His attire often seems deceptively tight, and this stylistic device sums up Depp's whole approach.

A sad clown with wild eyes

However, it is his face that is most radically transformed. Depp has the white face of Edward, with heavy make-up on the eyebrows and around the eyes, giving him an almost skeletal or vampire-like appearance (Marilyn Manson style), a painted-on mouth, and gaps in his teeth. In Carroll's novel, the Mad Hatter's crazed mind is explained by the mercury used in the hat-making industry, and the expression 'mad as a hatter' is taken at face value. Depp took this idea and ran with it, wondering if perhaps the mercury might have affected the colour of the Hatter's clothes, his hair, his skin. Garish tones are nothing new for Burton, who is fond of madness and circus colours (Beetlejuice, the Joker, Willy Wonka, Sweeney Todd).[228] Depp combines, once again, several traditions: the Victorian elegance and the clown-like aspect of the 1903 version, while making his own mark with the red hair and frightening look. He suggested adding a bright orange wig made from yak's hair (in the Walt Disney version, the character has grey hair). Suffering from 'coulrophobia' (a fear of clowns) for many years, Depp based his Hatter on the traditional evil clown, a major figure in American popular culture (in 1990, Depp referenced the paintings of the serial killer John Wayne Gacy, the killer clown, in *Interview Magazine*[229]).

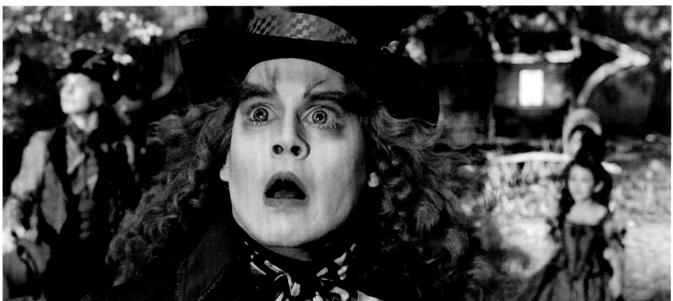

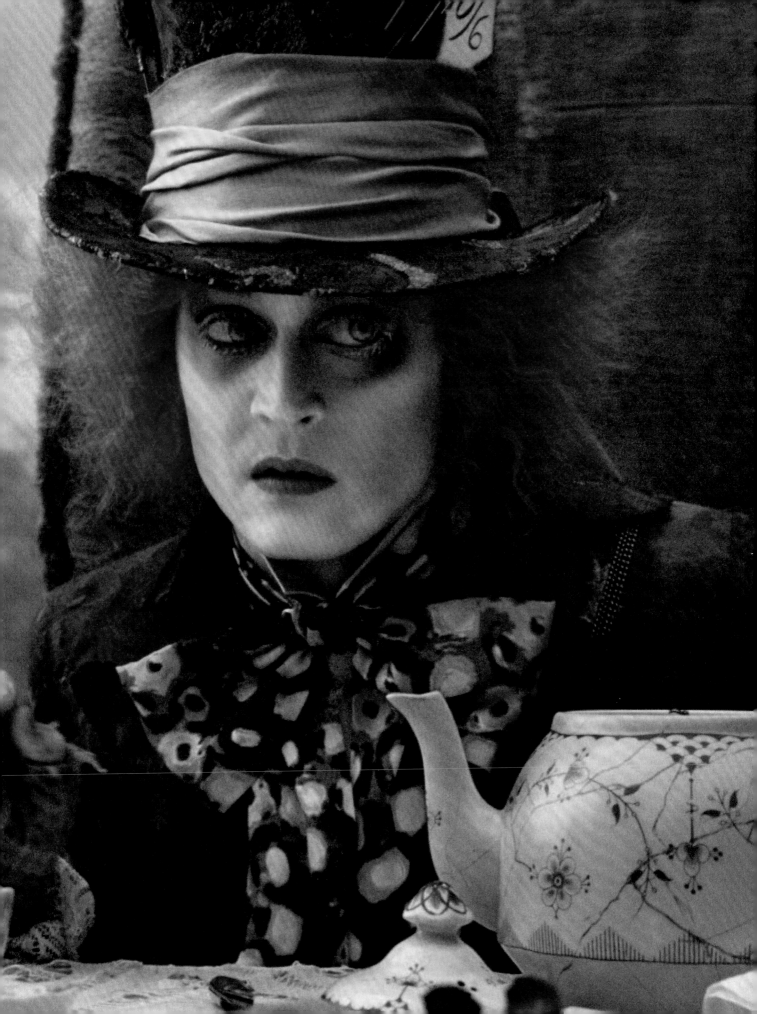

Burton's contribution was the bulging eyes, enhanced using 3D effects, of course. They are reminiscent of Edward's glassy eyes or the get-up of Ichabod Crane, with his binoculars and magnifying lenses. Depp added: 'I wanted him to have electrified kind of eyes, you know, so we got these unbelievably green lenses and had one of them painted just ever so slightly off, so it's like he's never really looking straight at you, he's always looking a little bit [...] further'.[230] He worked with make-up artist Patty York and costume designer Colleen Atwood, who also worked on *Edward Scissorhands*, who incorporated the suggestions of both actor and director. In keeping with Burton's style – he always has characters with big heads and large eyes – the make-up artists enlarged Depp's eyes, giving him a madcap look, as though he had eyes made from glass, forcing him to keep them wide open, like Alex in Stanley Kubrick's *A Clockwork Orange*. Depp manages to find a synthesis between Sparrow's uniqueness and the darkness of Sweeney Todd, a character that enabled him to test his ability to scare viewers.

Tim Burton explains, 'I've found that when you put make-up on people it actually frees them. They're able to hide behind a mask and therefore show another side of themselves, which is great'.[231] And as Yann Calvet points out in *Éclipses*, 'this character that is so attached to the mask and the possibility of revealing the inner workings of the one wearing it once again turns the actors into puppets, as Burton plays with their expressions as if by stop-motion: he turns them into objects in order to make them more "alive"'.[232] Depp's face lends itself to this approach, which is 'more graphic than psychological'.[233] Retouched by computer, transformed, deformed, the actor goes even further in his metamorphosis. His head becomes a sort of virtual operating table, filled with new possibilities.

The musicality of words

As someone with an interest in poetry, Depp strove to respect the prosody of Lewis Carroll. When his friend Patti Smith interviewed him in 2011, she asked him about his points of reference in the acting world, and was surprised that such a 'master of language, voice, script, words,'[234] always cited silent actors. Depp is fascinated by this element: 'the amazing thing about those guys is that they didn't have the luxury of language. So what they were doing, what they were feeling, what they were trying to express, had to come out through being, had to be alive, had to be in there behind the eyes'.[235] However, his voice, which he was so scared of not being able to control in the beginning, seemed to interest him more and more.

Depp is intrigued by the world of Lewis Carroll, with its portmanteau of absurd associations ('What is the hatter with me?') and unsolvable riddles ('Why is a raven like a writing desk?'), which imply that the adult world is a cryptic place where energy is wasted on unanswerable questions. The actor focuses on certain passages, on the letter M, associated with mercury, and revels in alliteration. In his frenzy, the Mad Hatter launches into a list of all the hats he knows and here we can sense Depp's interest in certain sounds, like that of the word 'boudoir', for example. He wants to push his role further, into the musicality of words, which he started doing in *Pirates*. He pronounces his list as if singing a solo, full of rhythms and breaks between verses. Alice always has to cut him off, to contain his ardour. 'Depp is Depp', Todd McCarthy wrote in *Variety*, 'slip-sliding among moods, accents, looks, rhythms and keys like a jazz player on his own wavelength, to disarming, if transient, effect'.[236]

Between schizophrenia and distortion

Although the novel is scary, Tim Burton wanted to adapt it to be suitable for a younger audience. He moved away from the Gothic side of his movies and chose a medieval aesthetic combining elements of the Pre-Raphaelites, Ingres and heroic fantasy, with pink, emerald blue and ash grey tones, and a confrontation of two worlds, the red and the white. Designed for 3D, the film was shot in 2D then converted in post-production by bringing another colour into the mix: green tones, necessary for computer-generated imagery. A sickly colour *par excellence* (associated with, among other things, the devil and madmen in medieval imagery), the green was exhausting for the actors during filming.

But this problem did not seem to affect Depp's acting too much. 'The novelty of the green wears off very quickly [...]. I like an obstacle – I don't mind having to spew dialogue while having to step over dolly track while some guy is holding a card and I'm talking to a piece of tape,' explains the actor.[237] Burton found it amusing that 'the only one who didn't have a problem with it was Johnny Depp, because Johnny is downright mad ...'[238]

All of the characters in *Alice* are mad, each of them having to mark out the boundaries of their own madness. The courtiers surrounding the Red Queen support their sovereign's madness by pretending to be, like her, afflicted by a physical defect by using fake body parts. Time and mercury have driven the Hatter mad; he seems physically depleted. When Alice grows, the Hatter's body looks small and shrivelled. His madness has invaded every part of his body: his skin, eyes, voice, clothing, but also in his hurried walk, a more or less conscience resurgence of that of Groucho Marx in *Duck Soup* (1933). As in *Ed Wood* and *Charlie and the Chocolate Factory*,

149

Even though he has played numerous Americans in exile in their own country, Depp is strangely close to European culture, through his artistic tastes, his love of cigarettes and fine wines and his choice of characters (J.M. Barrie is Scottish; Fred Abberline and John Wilmot, English). In the 2000s, he also split his time between Los Angeles, London, Paris and the south of France. But Depp appears to have adopted this culture right down to the subtle intonations of his voice, particularly in *Sweeney Todd*, a story inspired by English folklore and Stephen Sondheim's 1979 musical comedy, in which he plays a serial killer who gets rid of the bodies by using them for stuffing the pies of his accomplice, Mrs Lovett. When Tim Burton offered him the role, Depp knew that he could play the guitar but was not sure that he could sing. However, he managed to bring something uniquely European, something guttural, and so different from the American accent of the original Broadway productions. 'Organically, there's something natural in my voice that happens when you push it. And it's aggressive stuff. But one thing I do – that I don't remember hearing any of the other Sweeneys do – is English, oddly. Especially that East End English', the actor explains.[e] For the role of Barnabas in Burton's *Dark Shadows* (2012), he plays an eighteenth-century vampire who is struggling to find his place in the twentieth century, an English nobleman who has emigrated to Maine; a character in transit once again. Depp's voice has changed a great deal in twenty years, as evidenced by Danny Elfman, the appointed composer of his favourite director: 'It's fun watching Johnny Depp grow. He's developed a beautiful, rich voice that he didn't have. He sounded like a kid in *Gilbert Grape* [...]. His voice as Barnabas and his voice in *Sweeney Todd*, it's really a beautiful voice'.[f] According to *The Guardian*, 'His voice loiters somewhere between a drawl and a growl – a deep Kentucky slurry of mumbles – but punctuated by surprise bursts of Queen's English, with the odd anglicism'.[g] Over time, Depp's voice seems to have travelled across eras and continents.

Opposite: With Helena Bonham
Carter in *Sweeney Todd: The
Demon Barber of Fleet Street*
(2007) by Tim Burton.

Right: The Mad Hatter is led
before the Red Queen (Helena
Bonham Carter), who orders
a hat from him.

Following pages: A frightening
Johnny Depp, whose character
has just escaped having his
head chopped off.

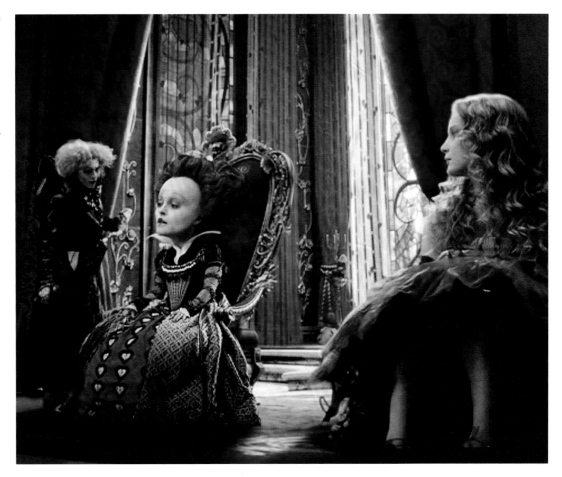

Depp's acting is similar to expressionist theatre,
'with his tense, strained manner, and abrupt, jerky,
sometimes violent movements'.[239] It is also
a psychedelic role, which matches his literary
penchant for writers of the Beat Generation.

Another aspect of his madness is contained
in his hat, which acts as a means of transport,
and which Depp sometimes holds under his arm
like a severed head. Symbolically dislocated in
this way, the Hatter is similar to some of Burton's
female characters, such as Catwoman (in *Batman
Returns*, 1992) or Sally (in *The Nightmare
Before Christmas*, 1993), patched up characters
'constantly trying to pull [themselves] together'.[240]
The Hatter is the anti-Ichabod Crane, in that
the Cartesian hero in *Sleepy Hollow* had only
one fear: losing his mind.

Depp enjoys distorting the family genre, adding
little touches to make his character downright
terrifying. After playing with vocal dissonances
and piercing looks in the tea party scene, he
plays the perverse, lifting his head and smiling as
he is just about to be beheaded, as if it gives him
pleasure. The way he uses safety pins during the
battle scene, as a way of mocking the American
male hero, is a detail very typical of Depp. We
are still out of step, not sure if he is acting the
schizophrenic or the hybrid, caught between
horror and the grotesque. He is one of the few
contemporary actors who likes to blend genres.
Moreover, unlike what he did with Jack Sparrow,

Depp makes his character asexual. With his
slightly glam-rock, androgynous look, the actor
likes to cover his tracks.

Playing another mad artist

The Mad Hatter, this old young man, is an echo
of Alice's father, who appears in the prologue.
The little girl, plagued by nightmares, asks her
father, 'Do you think I've gone "round the bend?"'
On the other side of the looking glass, the roles
are reversed and it is the Hatter, reduced
to a child-like state (by his voice and size) who
asks Alice, 'Have I gone mad?' Before he utters
this line, Depp seems to hesitate for a moment,
as if the question applies to him personally.
In this scene, moviegoers feel like they are
holding his face in their hands, and are drawn
into the depths of his vast, sad, eyes.

'Depp portrays an Ed Wood who has gone
from the black and white of B movies
to pop colours, a psychedelic Wonka who
despite his mask cannot hide any of his feelings,
his deceptions, his powerlessness. He lives
the tragic existence of a cursed and despised
artist, a designer of hats kept in a state of homeless
by the Red Queen,' Antoine de Baecque wrote
in *Cahiers du cinéma*.[241]

This madness is necessary for Alice, however,
as she has arrived at a pivotal age and must not
lose her 'muchness' (her energy, heart, faith).

She must turn to the 'Futterwacken' (a dance that is actually not that well-delivered in the film), which thumbs its nose at conventions and Victorian society, as opposed to the reserved square dance, which does not reveal even a flash of leg. Like her father (who set off overseas on adventures to remote corners of the world, and confessed to thinking of six impossible things before breakfast), it is thanks to the impossible that Alice ends up fighting the Jabberwocky. Like her, the Hatter must accept his madness in order to be able to create. Depp, like Burton, surely also feared losing his 'muchness', that internal energy so necessary for creativity, at the risk of monomania. The Hatter is 'like those rings that change colour depending on your mood' the press release explains.[242] Burton added, 'He has faith in himself and in his inventions; he is like Ed Wood in that respect. [...] These are perpetual children who hide behind their masks. In real life, they are awkward and unhappy, anxious and out of place, but in their world, they are princes'.[243]

Depp, who possesses an energy and a real faith in cinema, ends up time and again playing mad artist types who are sometimes consumed by their own passion and their naive enthusiasm but are always ready to take risks. In this way, the actor remains close to the world of his childhood and his genius, seeking exploration at all costs. However, by pursuing his experiments with Burton, and trading scars and stitches for a digital facelift, Depp is increasingly transforming into an animated character. After the battle against the Jabberwocky, the Mad Hatter's head vanishes. (This taste for dissolving into thin air would later lead Depp to completely dematerialize in Wally Pfister's *Transcendence* in 2014.)

Critical success

The film was a worldwide box-office hit (and smashed the billion dollar mark). The critics gave it a fairly warm reception, but fans of Burton were expecting something darker and more artisanal. Opinion was divided over Depp. 'Mr. Depp's strenuously flamboyant turn embodies the best and worst of Mr. Burton's filmmaking tendencies even as the actor brings his own brand of cinematic crazy to the tea party', Manohla Dargis wrote in the *New York Times*.[244] To Roger Ebert of the *Chicago Sun-Times*, 'Johnny Depp is that rare actor who can treat the most bizarre characters with perfect gravity'.[245] But some were still not satisfied. In *Entertainment Weekly*, Owen Gleiberman wrote, 'There isn't much to him, really – he's just a smiling Johnny one-note with a secret hip-hop dance move – and so we start to react to him the way that Alice does to everything else: by wondering when he's going to stop making nonsense'.[246] According to *Le Nouvel Observateur*, however, 'Johnny Depp as the Mad Hatter brings a strangeness to the film that it lacks'.[247]

What with the *Pirates of the Caribbean* franchise and the sequel to the *Alice* adventures (with Tim Burton just as a producer this time), the actor seemed to have less time to accept smaller projects. In 2011, he played a gonzo journalist again in Bruce Robinson's *The Rum Diary*, adapted from a novel by Hunter S. Thompson. And, two years after Alice, the collaboration between Burton and Depp continued on another project under the impetus of Depp, *Dark Shadows*. But this time Depp's face disappeared behind the too-thick make-up of Barnabas, an eccentric, aging vampire who is disconnected from reality. Depp, who likes to play on shifting ethics – as Fabien Gaffez explored in his book about the actor[248] – and to give voice to society's rejects or marginalized groups (Indians, gypsies, poor people, crazy people, monsters, impoverished film-makers, ghosts, accursed writers), now found himself confronted with a strange conundrum. How could he go on playing characters that condemn the system now that he was a fully fledged member of it?

Alice in Wonderland was Depp's seventh film with Burton, who found the expectations heaped on them working together a little off-putting, fearing that it might hinder his freedom and disappoint moviegoers.

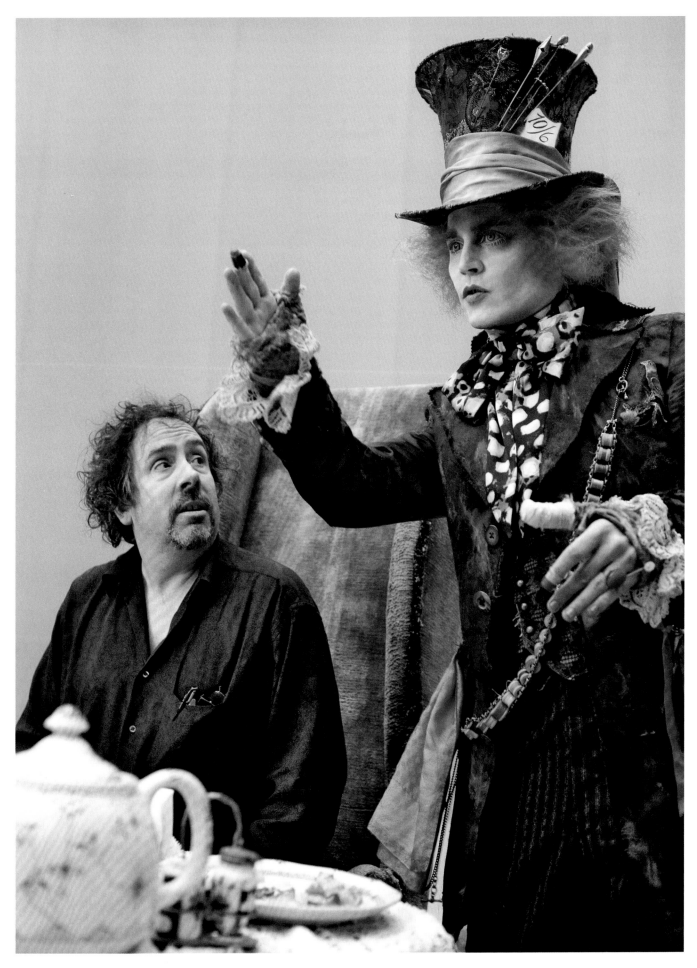

10 Tonto

The Lone Ranger (2013)
Gore Verbinski

'There are a lot of differences between Captain Jack and Tonto [...] Captain Jack needs other people to manipulate to get what he wants. He couldn't – he wouldn't work on his own. Tonto is sort of a lone wolf. If there are any similarities at all, I suppose it's just because it's born out of my head'.[249]
Johnny Depp, 2013

Gore Verbinski decided to give the part of Tonto in the western *The Lone Ranger* to Depp after the filming of the second *Pirates of the Caribbean* film (*Dead Man's Chest*) in 2005.[250] Disney studios announced the project in 2008 but they had to wait until 2010 to hire the director, and for filming to be finished on Tim Burton's *Dark Shadows*, before they could start production.

The Lone Ranger was originally a very famous American radio drama of the 1930s, which was also adapted for TV from 1949 to 1957. It recounts the meeting of two men who have nothing going for them, a former Texas Ranger, John Reid (Armie Hammer), who has turned vigilante to avenge his brother and goes by the name of the Lone Ranger, and a solitary Indian called Tonto, who teams up with him to fight corruption. In their attempt to catch the criminal Butch Cavendish (William Fichtner), they end up thwarting a more serious conspiracy involving the officials of the railroad, including Latham Cole (Tom Wilkinson), who expropriated the Comanche Indians in America at the end of the nineteenth century.

A controversial portrait

While filming Bruce Robinson's *The Rum Diary* in Puerto Rico, Depp thought about the part of Tonto and took advantage of his relationship with the studios to make some suggestions to them. 'I'd actually seen a painting by an artist named Kirby Sattler, and looked at the face of this warrior and thought: That's it,' he admitted, a year before the film was released.[251] It was his make-up artist, Joel Harlow, who showed him the painting *I Am a Crow*, depicting an Indian warrior whose face, painted white with wide black vertical stripes, evoked for the painter 'the inseparable relationship between the Native American and their spiritual and natural world'.[252] Depp sent photos

to the producer, Jerry Bruckheimer, and to Verbinski, who gave him the green light. Tonto is Comanche and this portrait, which mixes history with mythology, does not represent any particular tribe; nevertheless, Depp was inspired by the warrior painting: 'There's this very wise quarter, a very tortured and hurt section, an angry and rageful section, and a very understanding and unique side. I saw these parts, almost like dissecting a brain, these slivers of the individual'.[253] In Sattler's picture, a crow is flying close behind the warrior's head, but Depp saw something else: 'It just so happened Sattler had painted a bird flying directly behind the warrior's head. It looked to me like it was sitting on top. I thought: Tonto's got a bird on his head. It's his spirit guide in a way. It's dead to others, but it's not dead to him. It's very much alive'.[254]

In the original television series, Tonto is simply a foil, known for his pithy one-liners.[255] But Depp knew from 2011 onward that he did not want to go in the same direction with it: 'I'm part Cherokee, and an old time Lone Ranger fan. To me Tonto was the stoic fox of the operation. He was the insider in America and the Lone Ranger was the newcomer to the land. I've got a great feel to how Tonto should be played'.[256] On CBS, before the release of the film, he also said: 'I liked watching the series. I was always somewhat confused about Tonto's position'.[257] Verbinski felt the same about which direction the storyline should go in: 'Once we had the idea of casting Johnny as Tonto, you have to make his character relevant, or the whole thing's going to be tipped out of balance. It's the Lone Ranger origin story, but told from Tonto's perspective and set against the backdrop of the Transcontinental Railroad's construction'.[258]

Depp therefore wanted to do away with the stereotypes and the way Native Americans are represented in cinema with a character that links to his own history. Certain Native American tribes had big expectations of the role and the involvement of the actor. Michelle Shining Elk, a member of the Colville Tribes of the Pacific Northwest, hoped he would avoid yet another depiction of Native Americans as uneducated and sponging off society. She hoped Depp would deliver his lines in a more realistic and modern

In giving more importance to the character of Tonto in this adaptation of the famous TV series, Depp wanted to do away with the stereotypical way in which Native Americans are represented in film.

manner, 'not like a caricature from a John Wayne movie, or 1920s cartoon'.[259]

He also needed to make viewers laugh, however, because the studios had their sights set on a new Jack Sparrow and hoped to reform the winning duo of the *Pirates of the Caribbean* with Depp and Verbinski together again. On paper, all of these parameters seemed impossible to reconcile, especially since a photo of Tonto with his crow on his head was published before the film was released and was already stirring debate on social networks. People wondered why Depp had chosen to base Tonto on a portrait by a non-Indian painter. Natanya Ann Pulley, a lecturer at the University of Utah also had her concerns: 'I'm worried about the Tonto figure becoming a parody or a commercialized figure that doesn't have any dimension or depth. Or consideration for the contemporary context of Native Americans'.[260] She even published an open letter to Johnny Depp in the online magazine *McSweeney's*, voicing her annoyance: 'Does he, like so many others, have a distant Indian princess in his lineage? He's said his great grandmother is Creek or Cherokee. Creek *or* Cherokee …'[261] Furthermore, the violent contrast of the black-and-white face did not work in her opinion. 'So mostly I hope you don't end up in a bag-made costume to sell at Halloween', she concludes.[262]

Comanche film director Rod Pocowatchit was surprised that Tonto was not going to be played by a Native American and also questioned the choice of outfit, which had nothing Comanche about it, in the *Wichita Eagle*: 'We have to tell our own stories in our own way. And we need to get them seen. No easy feat. But images like Depp's crazy bird hat aren't helping'.[263] To shield themselves from criticism, Disney worked with Native American tribes and hired a Comanche advisor, William Voelker, to consult on the film. In May 2012, Depp even became an honorary member of the Comanche Nation, under the name Mah Woo May, which means 'shape shifter'.[264]

A statue with a mud mask

The movie opens in San Francisco in 1933 (the year that *Lone Ranger* started to be broadcast over the radio waves), in one of those exhibitions showing many acts and personalities of the Wild West. The statue of the old man Tonto appears for the first time to a boy dressed as a cowboy, in a museum, like an animal in a zoo, with a little sign that says: 'The Noble Savage in his natural habitat'. All the boy knows about Tonto is the legend. The old Native American looks like a cartoon character, a stereotypical Indian in front of a faded panorama of Monument Valley. Then the statue comes alive. Depp moves one eye first, then his lips, very slowly, an arm, a foot, like an ancient oak coming to life. His hand trembles. As in *Little Big Man* by Arthur Penn (1970),

he wants to tell the story to the boy, if only to give his version of events.

As usual, Depp was involved with creating his costume. Joel Harlow says: 'He is very involved in the process and he'll see things in the mirror that I don't. It's very collaborative. He's as much of a makeup artist as I am when it comes to creating these characters'.[265] Six and a half hours were needed every day just to put on the silicone prosthesis for the face of Tonto as an old man. Hands moulded his cheeks, down to his chin, neck, nose, lips […] Gradually Depp was completely mummified. The make-up for the young Tonto also required daily work: black and white paint caked heavily on his face and cracked, seeming to run down like rivulets of tears, eyes so dark they looked gauged out, and a false, slightly bumpy nose. 'I wanted to incorporate a cracked-earth feel', adds Harlow. 'The idea being that Tonto has smeared this earth on himself and it's dried over a period of time, and has cracked almost like a mud mask'.[266] Depp sometimes kept his prosthesis on for several days at a time, saying that, 'this makeup specifically looks better the longer you sleep in it, as long as it's more than three days'.[267] For him, as for Harlow, it was the only way to truly become one with the character.

Depp's intention was to make Tonto into a great warrior. He also posed on the cover of *Rolling Stone* in June 2013 with his dark eyes and hunched shoulders, a pose that fuelled the controversy. Depp plays Tonto like a Golem figure, a clay colossus. He wanted to turn him into an ancient monument. Tonto is a dark character, taciturn, wounded, and his face inspired the actor because he could play on the imagery of the stripes. When he crawls under the train and detaches two of the carriages, his head appears twice underneath the iron rods, as if the train has passed over him. Here, Depp is developing the theme of inversion; the face of the Native American replacing the screws of the Industrial revolution, and the American machine passing symbolically over his head.

However, the actor seems to be constantly wavering between serious and *mise en abyme*. Despite the presence of the crow, which gives the character stature (and which Depp certainly chose for this reason), Tonto is smaller than the Lone Ranger. Yet again, the actor uses this physical incongruity to mock the fear he inspires. When he meets his future sidekick, Tonto is being held prisoner in a train carriage with his hands and feet bound. He is sitting with his back slightly hunched, as if he has been there since time began. Then suddenly he leaps up, his hands free, ready to grab the ranger. At that moment, and even though Depp has changed over the past twenty-three years, one cannot help but think of the first time we see Edward, who has been locked away in his attic.

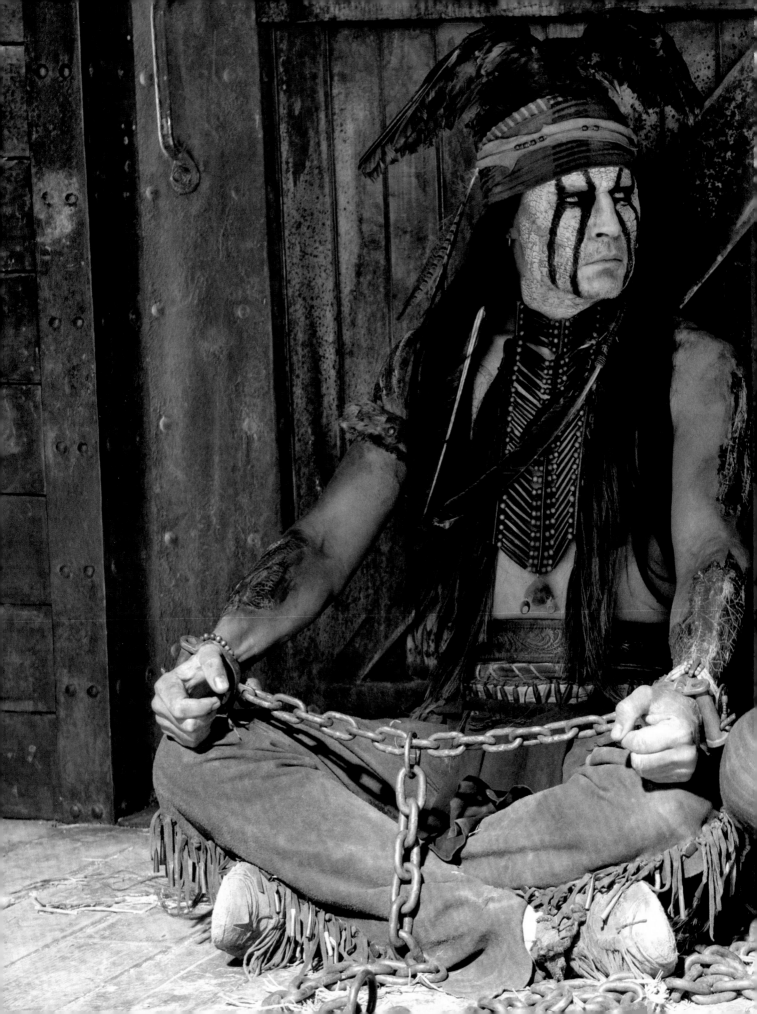

It was not until the 2000s that Johnny Depp finally received three Oscar nominations (for *Pirates of the Carribean*, *Finding Neverland* and *Sweeney Todd: The Demon Barber of Fleet Street*). The Golden Globes paid him more attention, giving him nine nominations for *Edward Scissorhands* (1991) and finally awarding him Best Actor for *Sweeney Todd* (2007). His career has also been punctuated with less prestigious awards, but ones that have been chosen by the public (the 'People's Choice Awards' and 'Teen Choice Awards'). It is perhaps his César Award in 1999 that people will remember best: much to everyone's surprise, the actor gave a pre-recorded speech in French by holding a tape recorder up to the microphone. Depp did not say a word directly to the audience, a clear sign of his shyness and his detachment from the world of awards. There are not many Hollywood actors who have never sought to make 'Oscar movies', with monologues containing messages designed to seduce the academics and critics. Johnny Depp appears to have always wanted to avoid this trap, which so many great performers have fallen into more than once over the decades. That detachment is much to his credit, but it is also one of his main personality traits and is indicative of his choices as an actor.

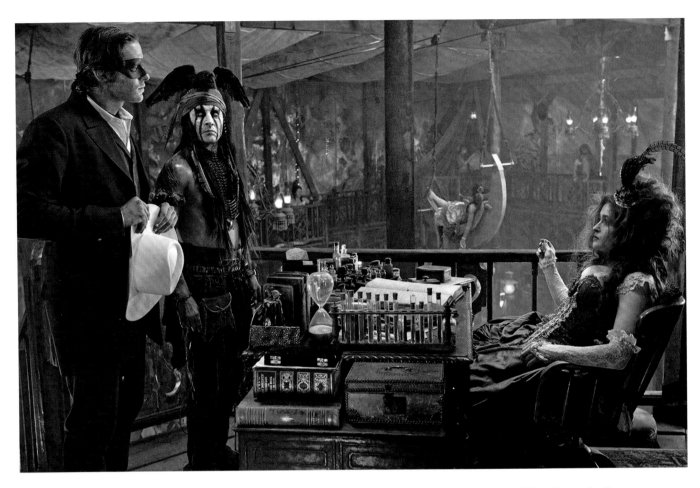

In another scene, Tonto sings to himself when he is locked in a jail cell. Will (John's nephew) can see only the shadow of an Indian, with his huge arms outspread like wings. Then Tonto turns his head suddenly. Depp's tattooed body has been covered in the same mud as his face, but without the white paint that emphasizes his face, which seems to surge up like a terrifying medallion, a Medusa head. The boy screams in fright. This is what the Comanche are reduced to: that is what this scene seems to say. With his thick make-up, he frightens children just like the monsters of Universal cinema did in the 1930s.

Crazy about accessories

Depp's penchant for accessories was still alive and kicking. For him it is second nature. Costume designer Penny Rose says, 'Johnny is really good about costume. He knows immediately what works and what doesn't [...] The concept is that Tonto has picked up different pieces on his journey, bits and bobs of his own personal history'.[268] The fact that Tonto is a nomad, exiled from his tribe, meant that the make-up team could take liberties. But this fantasy quickly became pervasive, and the role would have done better to steer clear of folklore and exoticism.

Tonto's love of accessories is also conveyed by his almost constant observation of what

is going on around him. From the first scene, Tonto fiddles with a broken compass, just like Jack Sparrow. Later on we learn that this seemingly useless object was the reason for his exile. When he finds himself in the world of the white men, in the saloon of Red Harrington (Helena Bonham Carter), he likes to sniff out smells, browse, handle objects, maps, photos, boxes, a bird cage, jackets, mirrors, snowshoes. We can sense that Depp likes to fight with old-fashioned tools – a knife, stones – against opponents who use firearms.

By working with directors who know and trust him, Depp can bring with him his 'trunk' as it were: his reassuring personal treasure trove, which he uses like a compass to orientate himself. He brings a cabinet of personal curiosities with him, in which he keeps all his characters: 'I always picture it as this chest of drawers in your body – Ed Wood is in one, the Hatter is in another, Scissorhands is in another. They stick with you. Hunter is certainly in there – you know, Raoul Duke [...]. They're still very close to the surface'.[269]

In *The Lone Ranger*, more than ever, Depp seems fascinated by the metamorphoses of the body, but he appears to have trouble playing characters that are not like him. It is an issue that bothers him. In 2011, he said that '[o]ne of the primary concerns of an actor is "Can I, do I have the ability

to change, to travel somewhere else wholly and completely not me?'"[270]

A balanced actor

If Depp mimics the unsmiling, poker-faced style of Buster Keaton when he tries to jump off the train and catch the Lone Ranger, a nod to the actor in *The General* (1926), it is also because the question of balance and corruption of the system is ever-present throughout the film. 'Nature is definitely out of balance', Tonto sighs, when he sees his horse drinking alcohol or cowboys dressed as women or Comanche Indians attempting to sabotage a treaty. The aim of the film – a virulent one for such a big-budget production – is to show how America was built on the dispossession of Native Americans and the exploitation of Chinese immigrants during the construction of the railroads.

What concessions did Depp have to make? 'I think he's really struggled to keep it authentic, but also a very entertaining character,' says Verbinski of Depp's portrayal.[271] Under the Disney banner, however, he could not make the character too dark or complex. And the idea of the stuffed crow on his head, which fuelled such controversy, was used for comic purposes in the end: Tonto is constantly pretending to feed it with seeds. But this gag struggled to fit into the film. The actor sometimes tries to delve into his treasure chest, slipping into the costume of Nobody in *Dead Man* to try and find the poetic timing of Jarmusch. Sometimes, unfortunately, his too-full brain overflows and the characters meet when they should not, creating unlikely links and unintended affinities: by trying to mock the primitive way in which Native Americans are represented in Hollywood movies, Depp risks feeding the stereotype rather than disposing of it. All he does is show that Tonto has neither the sufficient eloquence nor the knowledge to defend his point of view.

The actor settled for reusing some of the invaluable little gestures he had already tried and tested in other roles. When he thinks that the Lone Ranger is dead, he jumps up, hits him and starts casually sweeping the land for his grave. When he wants to touch the prostitute Red Harrington's fake ivory leg, he furtively withdraws his hand. Depp likes making people laugh but he also seems to be afraid of being taken seriously. Since *Pirates of the Caribbean* it seems he has struggled to stay balanced and to draw back a bit out of the spotlight. If his acting is statue-like and his body blends in with the elements – the clay, the rocks or the plants – it is perhaps also because he misses being able to observe the world as he could in his early days. In 2008, he lamented that, 'I was no longer the observer – I was being

observed. That's obviously very dangerous because part of an actor's job is to observe'.[272]

A stranger among his tribe

Indians must always compensate for the murder of a living creature through a 'trade'. Tonto repeats this line in the prologue to the film. Killing is neither futile nor free, and it was in fact a bad trade (a compass in exchange for a silver mine) that is the reason he was banished from the tribe. Another dubious exchange sends Latham Cole to the bottom of a river, with his train carriages and his cargo of silver. The notion of exchange between the two lead actors, Depp and Hammer, therefore makes perfect sense. In fact, the emphasis is on the duo. Depp wants Tonto to be able to give as good as he gets, on a par with the hero. Although he might not say much, he is no longer the submissive sidekick of the original. For example, he does not hold back from slapping the Lone Ranger to diffuse the conflict between them, claiming that it is his bird that is angry. Throughout the film he also tries to build a rapport with children: the boy in the prologue, and Will, who ends up no longer being afraid of him.

Tonto's little wistful smile is explained by his life story. He lives alone like a coyote. His spirit is broken and disorientated since the white men betrayed him for a wealth of silver. He invents stories, makes up legends, like the ones you tell to children. He has not really grown up all that much. Without an identity, he is rejected by both sides. He sees Butch Cavendish as a 'Wendingo' (a kind of supernatural ogre in some Native American traditions). To kill him, he keeps a silver bullet with him, like the ones that are supposed to kill werewolves. His relationship with the afterlife and mysticism are counterbalanced by the Lone Ranger's pragmatic nature, and the disillusioned Comanche chiefs, for whom the time of the Indians has passed: 'There are no more tribes. We are already ghosts', says Big Bear, the Comanche chief, to the Lone Ranger.

Tonto is also filmed like that, as a ghost who emerges in dreams or reappears in the passageways of the mine, made up as a Chinese worker, holding a cage in his hand with his dead bird inside. His body even blends into the cave paintings. Once again, Depp plays a haunted character that has trouble staying dead; an actor on the frontier, ingrained into the cinematic landscape like a fossil. In this film, he pushes the organic element of his acting to its limits.

A critical and commercial flop

The movie was released in July 2013. For the preview, held in California, seats were selling for one thousand dollars, with the proceeds going to the American Indian College Fund. However,

Opposite, top: Tonto crawls under the train to detach two of the carriages, a symbol of an industrial revolution that crushed Native Americans.

Opposite, centre: Tonto has no scruples about bartering with dead men he comes across along his route.

Opposite, bottom: The Native American greets the unexpected apparition of the horse spirit.

Opposite, top: Tonto is fascinated by Harrington's ivory leg.

Opposite, centre: On the trail of the assassins who have taken hostage the Lone Ranger's sister-in-law.

Opposite, bottom: Tonto on a runaway train in the magnificent final action sequence.

Right: Locked in a cell, the Native American sings. In this sequence, Tonto's face reflects the fantasies that white men have about his people.

due to the many reviews that preceded the film's release and high expectations, it got a fairly mixed reaction. It was considered to be too violent and too long. It received praise for its numerous cinematic references (John Ford, Sergio Leone, Clint Eastwood, Sam Peckinpah, Buster Keaton, etc.), for its script and for its action sequences, including the final train hold-up, but the seriousness of the subject seemed out of kilter with Verbinski's cartoon-esque style. It did not do well at the box office and was something of a money pit for Disney.

Depp received generally negative reviews. Chris Wallace of the *New York Times* questioned the relevance of Tonto as a character, and remained sceptical about the impact on the viewer. 'It would be impressive, even for a self-styled subversive like Mr. Depp, to turn Hollywood's long, ugly history of American Indian representation on its head with a single movie', he remarked.[273]

Depp's intention was clearly to provide young Native Americans with a hero who makes them laugh. 'Native people are divided. Some embrace Depp's characterization. Some don't', wrote the sociologist Wayne Baker in *The Ann Arbor News*, wondering whether the film would perhaps resurrect stereotypes rather than destroy them. Depp's performance also raised some other more general questions: 'Can actors portray other cultures competently? Should they? Do people get to own the way their culture is portrayed?'[274]

On the other hand, for Matt Zoller Seitz, *The Lone Ranger* is a misunderstood film that will be re-evaluated after twenty years.[275] Angie Errigo wrote in *Empire*: 'Tonto's broken English and wackier rants are his mask; there is intelligence, wisdom, cunning and long-term planning in his seeming madness'.[276] *The Inquirer*[277] and *Forbes*[278] also liked the portrayal of Tonto, which they felt was infused with respect, dignity and Depp's trademark humour.

The French press defended the film still further but, unusually, were not very kind about Johnny Depp. 'His wonderfully flexible expressions of yesteryear now look like some kind of facial workout, and could be likened to a form of yoga,' said *Le Monde*.[279] For *Télérama*, 'Johnny Depp seems like he is somewhere else, even more so than usual'.[280]

Nonetheless, the actor defended what he considered to be a bold film. He also wanted to use his celebrity status to draw attention to the plight of Native Americans. But the disaster of *The Lone Ranger* came after bad earnings for *Dark Shadows* and *The Rum Diary*. In 2014, Depp continued on his streak of bad luck with another flop, Wally Pfister's *Transcendence*. His biographers, including Steven Daly, questioned his choices, which often seemed to be motivated by the script or an affinity with the director.[281]

The issue of age has also started to rear its ugly head, for an actor whom people always said

The end of a beautiful friendship. The film's failure at the box-office probably marks the end of this particular duo.

Right: The two heroes in a very uncomfortable position at the camp of the Comanches.

had made a pact with the devil, like Dorian Gray. Depp has recently turned fifty, and he is starting to have doubts. He does not know if he will still be acting in ten years, and even made this strange statement to the *Yorkshire Post*: 'I'm old, acting is a strange job for a grown man. I don't think I've developed a taste for acting yet. I'm not sure I ever will, to be honest'.[282]

Following on from *The Lone Ranger*, Depp has plans to work on other Disney films: after *Into the Woods* by Rob Marshall (which came out in 2014), he will star in *Alice in Wonderland 2* (planned for 2016) and *Pirates of the Caribbean 5* (announced for 2017). Whatever their results at the box office might be, at the moment Johnny Depp's main concern seems to be reconnecting with the independent films of his early days; to become the observer he would like to be.

Conclusion

Johnny Depp's is the story of an actor who wanted to disappear from the screen just as the flames of glory started to ignite and fame threatened to consume him. So it is hardly surprising that he has taken on multiple cameo roles and other fleeting appearances or voice parts here and there – like so many pebbles that he has dropped discreetly behind him so as not to get entirely lost. He briefly played himself in an episode of *The Vicar of Dibley* (1999), lent his voice to a scene in the animated series *King of the Hill* (2004) and to *SpongeBob SquarePants* (2009) and replayed Edward Scissorhands in the animated series *Family Guy* (2011) and William Blake (*Dead Man*) in Mika Kaurismäki's film *L.A. Without a Map* in 1998. He also appeared briefly as himself in the comedy *Jack and Jill* (Dennis Dugan, 2011) with Al Pacino, and played the role of a handsome stranger alongside Charlotte Gainsbourg in *Happily Ever After* (Yvan Attal, 2004), an appearance so momentary it is almost ghostlike. A narrator for several documentaries, including *Top Secret* (Discovery, 1999), *Deep Sea* (Howard Hall, 2006) and *Gonzo: The Life and Work of Dr. Hunter S. Thompson* (Alex Gibney, 2008), Depp has also done voice-overs for radio, in a documentary about James Dean broadcast on BBC2 in 2005. There are many facets to Depp, who sometimes vanishes behind his roles.

What if all that was left in the end was the sound of Johnny Depp? The actor, who has always dreamed of being a musician more than anything, has finally achieved his most important *tour de force*: leaving behind his physical incarnation as a young leading actor, only to hide, when the opportunity arises, behind a voice, to blend in, to disappear as quickly as he appeared, like the ghosts he so fears in life. An angel figure, a fantasy being, an outlaw actor, maybe not so silent after all, a masked figure moving forward, the devilish Johnny Depp would have us believe that he never existed.

Following pages:
Depp as Sweeney Todd
in Tim Burton's
2007 adaptation.

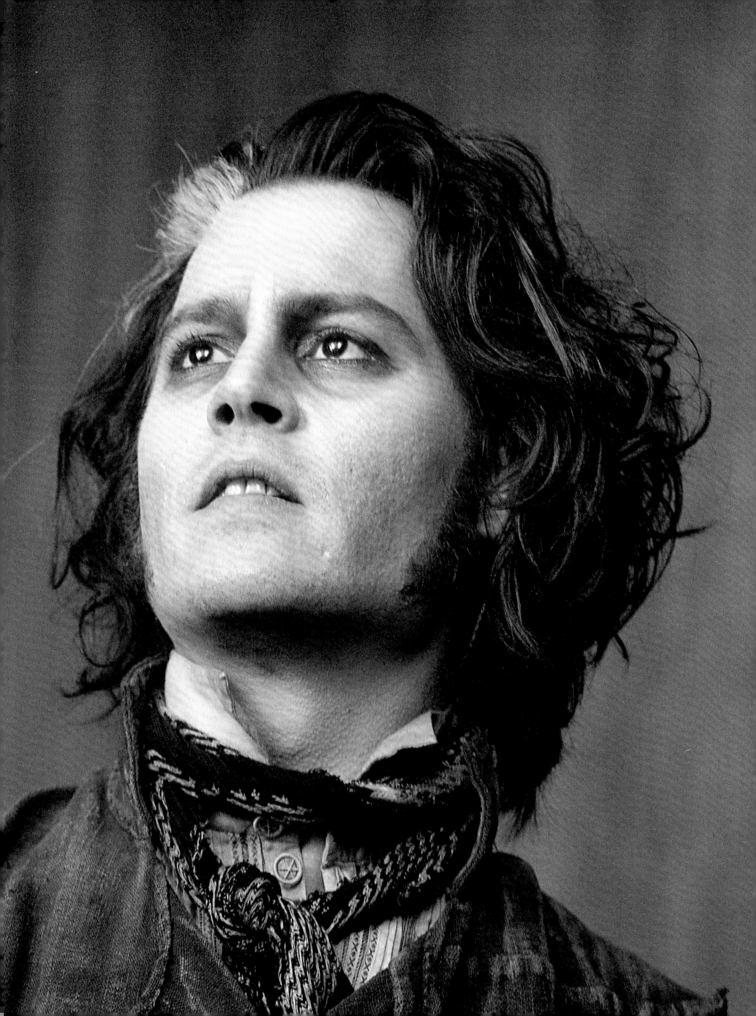

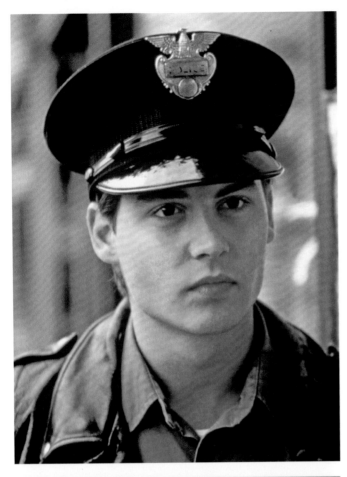
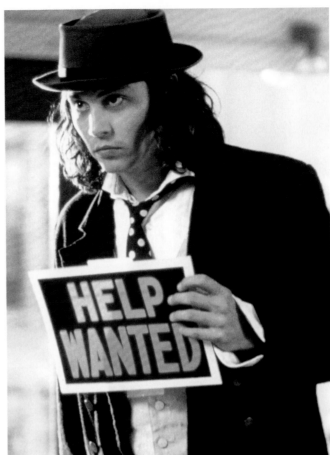

1963
June 9: Born John Christopher Depp II in Owensboro, KY.

1979
Leaves school to pursue music, and plays in bands, including The Kids.

1983
Marries Lori Allison.

1984–5
Meets Nicolas Cage in Los Angeles and begins his acting career. Makes his debut in *A Nightmare on Elm Street* by Wes Craven. Divorces Lori Allison and enrols in Loft Studio. Appears in the short film *Dummies* by Laurie Frank, and the series *Lady Blue*.

1986
Shoots *Platoon* by Oliver Stone, the TV movie *Slow Burn* directed by Matthew Chapman.

1987–90
Enjoys unexpected success in the series *21 Jump Street*, in the role of Tom Hanson.

1990
John Waters chooses Depp for his film *Cry-Baby*, a musical parody of the fifties. Meets Tim Burton, who puts him forward to studios to play the leading role in *Edward Scissorhands*.

1991
Plays Eddie Rebel in *Into the Great Wide Open*, a music video by Tom Petty, and makes an appearance

in *Freddy's Dead: The Final Nightmare* by Rachel Talalay.

1992
Appears in the video for *It's A Shame About Ray* by The Lemonheads. Meets Emir Kusturica. Plays Axel Blackmar in *Arizona Dream*.

1993
Plays Sam in *Benny and Joon* by Jeremiah S. Chechik, and the title role in Lasse Hallström's *What's Eating Gilbert Grape*. Breaks up with his girlfriend, the actress Winona Ryder. Directs *Stuff*, a 12-minute documentary about Red Hot Chili Peppers guitarist John Frusciante.

1994
Works with Tim Burton again as the lead role in *Ed Wood*, presented at Cannes in May 1995. Films *Don Juan DeMarco* by Jeremy Leven. Appears in a music video for Shane MacGowan & The Popes, *That Woman's Got Me Drinking*.

1995
Stars in *Dead Man* by Jim Jarmusch and *Nick of Time* by John Badham.

1997
Plays Joe D. Pistone in Mike Newell's *Donnie Brasco*, alongside Al Pacino. Directs his first and only feature-length film, *The Brave*, with Marlon Brando. The Oasis album *Be Here Now* includes his contribution on guitar to the track 'Fade In/Out'.

1998
Plays Raoul Duke in *Fear and Loathing in Las Vegas* by Terry Gilliam. Prepares for the role with his friend Hunter S. Thompson.

1999
Birth of Lily-Rose Melody, his daughter with the singer and actress Vanessa Paradis. Receives a César Award for career achievement. Acts in Rand Ravich's *Intrusion*, as well as *Sleepy Hollow*, his third film with Tim Burton. Narrator for two episodes of the documentary series *Top Secret*.

2000
Films *The Man Who Cried* by Sally Potter and *Before Night Falls* by Julian Schnabel. Works with Lasse Hallström again, this time on *Chocolat*. Appears in the British TV series *The Fast Show*. Involved in *The Man Who Killed Don Quixote* by Terry Gilliam, with Jean Rochefort. The film remains unfinished at the time of writing.

2001
Directs the music videos for Vanessa Paradis' songs *Pourtant* and *Que fait la vie?* from the album *Bliss*, for which he co-wrote two songs (*Saint-Germain* and *Bliss*). Films *Blow* by Ted Demme and *From Hell* by Albert and Allen Hughes.

2002
Birth of Jack John Christopher, his second child with Vanessa Paradis.

2003
Films Gore Verbinski's *Pirates of the Caribbean* and *Desperado 2* by Robert Rodriguez. First Oscar nomination for Best Actor.

2004
Films David Koepp's *Secret Window*, the TV series *King of the Hill* (in which he lends his voice to Yogi Victor), *Happily Ever After* by Yvan Attal, *Finding Neverland* by Marc Forster and Laurence Dunmore's *The Libertine*.

2005
Works once again with Tim Burton, on *Charlie and the Chocolate Factory* and *Corpse Bride* (voice of Victor Von Dort). Presents a documentary on James Dean for BBC Radio 2.

2006
Dons the costume of Jack Sparrow once more in *Pirates of the Caribbean: Dead Man's Chest* by Gore Verbinski. Narrator for the documentary *Deep Sea* by Howard Hall. Appears in *God's Gonna Cut You Down*, a posthumous Johnny Cash music video.

2007
Films *At World's End*, the third instalment of *Pirates of the Caribbean*. Works with Tim Burton again, on *Sweeney Todd*, which earns him a Golden Globe for Best Actor in a Musical or Comedy. Directs the music video for *L'Incendie* by Vanessa Paradis, from the album *Divinidylle*,

for which he designed the cover, inspired by Gustav Klimt.

2008
Narrator for *Gonzo: The Life and Work of Dr. Hunter S. Thompson*, a documentary by Alex Gibney.

2009
Provides the voice of Jack Kahuna Laguna in the animated series *SpongeBob SquarePants*. Films *The Imaginarium of Doctor Parnassus* by Terry Gilliam, and Michael Mann's *Public Enemies*.

2010
Films *Alice in Wonderland* (his seventh collaboration with Tim Burton) and *The Tourist* by Florian Henckel von Donnersmarck.

2011
Provides the voice of Rango in the animated film of the same name, directed by Gore Verbinski. Works with Rob Marshall again in *On Stranger Tides*, the fourth *Pirates of the Caribbean* movie. Films Bruce Robinson's *The Rum Diary*, and plays himself in Dennis Dugan's comedy *Jack and Jill*, and the series *Life's Too Short* by Ricky Gervais and Stephen Merchant.

2012
Breaks up with Vanessa Paradis, with whom he lived for fourteen years. Plays Barnabas Collins in *Dark Shadows* by Tim Burton. Appears in *My Valentine*, a music video by Paul McCartney, with Natalie Portman. Appears as Edward Scissorhands in an episode of the TV series *Family Guy*. Makes an appearance in Phil Lord and Christopher Miller's *21 Jump Street*.

2013
Plays Tonto in Gore Verbinski's *The Lone Ranger*.

Appears in *Lucky Them* by Megan Griffiths.

2014
Plays a scientist in *Transcendence* by Wally Pfister, the big bad wolf in the musical comedy *Into the Woods* by Rob Marshall, and appears in *Tusk* by Kevin Smith.

2015
Plays an eccentric art historian in *Mortdecai* by David Koepp.

177

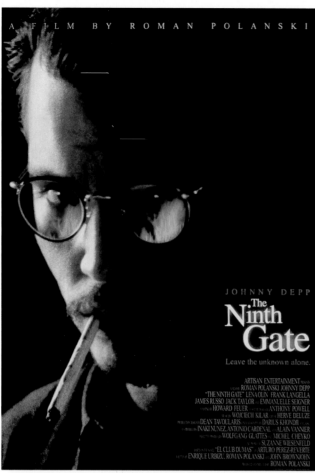

A FILM BY ROMAN POLANSKI

JOHNNY DEPP
The Ninth Gate

Leave the unknown alone.

JOHNNY DEPP

FROM THE WRITER OF "PANIC ROOM"

SECRET WINDOW

SOME WINDOWS SHOULD NEVER BE OPENED.

FROM THE DIRECTOR OF "PIRATES OF THE CARIBBEAN"

JOHNNY DEPP
IS

RANGO

YESTERDAY

DR. WILL CASTER

WAS ONLY HUMAN

JOHNNY DEPP
TRANSCENDENCE

IN IMAX & CINEMAS APRIL 17

1984
A Nightmare on Elm Street
Director Wes Craven
Screenwriter Wes Craven
Cinematographer Jacques
Haitkin *Production designer*
Gregg Fonseca *Composer*
Charles Bernstein *Editors*
Patrick McMahon, Rick
Shaine *Producer* Robert
Shaye *Cast* John Saxon
(Donald Thompson),
Ronee Blakley (Marge
Thompson), Johnny Depp
(Glen Lantz), Robert Englund
(Fred Krueger).

1985
Dummies (short)
Director Laurie Frank.
Cast Johnny Depp, Sherilyn
Fenn, Max Perlich.

Lady Blue (TV)
Season 1, episode 4
(*Beasts of Prey*)
Director Guy Magar
Screenwriter Nancy
Lawrence *Composer*
John Cacavas *Producers*
Anthony and Nancy
Lawrence *Cast* Jamie Rose
(Katy Mahoney), Danny
Aiello (Lt. Terry McNichols),
Lorenzo Clemons (Rev.
Sykes), Johnny Depp
(Lionel Viland).

Private Resort
Director George Bowers
Screenwriter Gordon
Mitchell *Cinematographer*
Adam Greenberg *Production
designer* Michael Corenblith
Editor Samuel D. Pollard
Producers R. Ben Efraim,
Don Enright *Cast*
Rob Morrow (Ben),
Johnny Depp (Jack),
Emily Longstreth (Patti)

1986
Platoon
Director Oliver Stone
Screenwriter Oliver Stone
Cinematographer Robert
Richardson *Production
designer* Bruno Rubeo
Composer Georges Delerue
Editor Claire Simpson
Producer Arnold Kopelson
Cast Tom Berenger (Sgt.
Barnes), Charlie Sheen
(Chris), Willem Dafoe (Sgt.
Elias), Johnny Depp (Lerner).

R.P.G. (short)
Director Charlie Sheen
Producer Charlie Sheen.
Cast Clint Howard,
Johnny Depp.

Slow Burn (TV)
Director Matthew Chapman
Screenwriters Matthew
Chapman, Arthur Lyons
Cinematographer Tim
Suhrstedt *Production
designer* Bo Welch
Composer Loek Dikker
Editor Battle Davis
Producer Mark Levinson
Cast Eric Roberts (Jacob
Asch), Beverly D'Angelo
(Laine Fleischer), Johnny
Depp (Donnie Fleischer).

1987
Hotel (TV)
Season 4, episode 15
(*Unfinished Business*)
Creators John Furia, Barry
Oringer *Director* James
L. Conway *Screenwriter*
Doris Silverton, from
the novel by Arthur Hailey
Cinematographer Charles
W. Short *Production designer*
Marc E. Meyer Jr *Composer*
John E. Davis *Editor*
G. Gregg McLaughlin

Producers Henry Colman,
Duane Poole, Tom Swale.
Cast James Brolin (Peter
McDermott), Connie Sellecca
(Christine Francis), Nathan
Cook (Billy Griffin), Michael
Spound (Dave Kendall),
Johnny Depp (Rob Cameron).

21 Jump Street (TV)
Creators Stephen J. Cannell,
Patrick Hasburgh *Cast*
Johnny Depp (Tom Hanson),
Peter DeLuise (Officer Doug
Penhall), Steven Williams
(Captain Adam Fuller),
Holly Robinson Peete
(Officer Judy Hoffs).

1988
R.P.G. II (short)
Director Charlie Sheen
Producer Charlie Sheen.
Cast Clint Howard,
Johnny Depp, Dolph
Lundgren.

1990
Cry-Baby
Director John Waters
Screenwriter John Waters
Cinematographer
David Insley *Production
designer* Vincent Peranio
Composer Patrick Williams
Editor Janice Hampton
Producers Jim Abrahams,
Brian Grazer *Cast* Johnny
Depp (Cry-Baby), Amy
Locane (Allison Vernon-
Williams), Polly Bergen
(Ms. Vernon-Williams),
Ricki Lake (Pepper Walker),
Susan Tyrrell (Ramona).

Edward Scissorhands
Director Tim Burton
Screenwriter Tim Burton,
Caroline Thompson
Cinematographer Stefan

Czapsky *Production designer*
Bo Welch *Composer* Danny
Elfman *Editors* Colleen
and Richard Halsey *Costume
Designer* Colleen Atwood
Producers Tim Burton, Denise
Di Novi *Cast* Johnny Depp
(Edward), Winona Ryder
(Kim), Dianne Wiest (Peg),
Anthony Michael Hall (Jim),
Kathy Baker (Joyce), Vincent
Price (The Inventor).

1991
Freddy's Dead: The Final Nightmare
Director Rachel Talalay
Screenwriter Wes Craven
Cinematographer Declan
Quinn *Production designer*
C.J. Strawn *Composer*
Brian May *Editor* Janice
Hampton *Producers* Robert
Shaye, Aron Warner *Cast*
Robert Englund (Freddy
Krueger), Johnny Depp
(Oprah Noodlemantra).

1993
Benny and Joon
Director Jeremiah S. Chechik
Screenwriters Barry
Berman, Lesley McNeil
Cinematographer John
Schwartzman *Production
designer* Neil Spisak
Composer Rachel Portman
Editor Carol Littleton
Producers Susan Arnold,
Donna Roth *Cast* Johnny
Depp (Sam), Mary Stuart
Masterson (Juniper 'Joon'
Pearl), Aidan Quinn
(Benjamin 'Benny' Pearl),
Julianne Moore (Ruthie).

What's Eating Gilbert Grape
Director Lasse Hallström
Screenwriter Peter Hedges
Cinematographer Sven

Nykvist *Production designer* Bernt Amadeus Capra *Composers* Björn Isfält, Alan Parker *Editor* Andrew Mondshein *Producers* Lasse Hallström, Bertil Ohlsson, Meir Teper *Cast* Johnny Depp (Gilbert Grape), Leonardo DiCaprio (Arnie Grape), Juliette Lewis (Becky), Mary Steenburgen (Betty Carver), Darlene Cates (Bonnie Grape).

1994
Arizona Dream
Director Emir Kusturica *Screenwriter* Emir Kusturica, David Atkins *Cinematographer* Vilko Filac *Production designer* Miljen Kreka Kljakovic *Composer* Goran Bregovic *Editors* Rached M'Dini, Andrija Zafranovic *Producer* Claudie Ossard *Cast* Johnny Depp (Axel Blackmar), Jerry Lewis (Leo Sweetie), Faye Dunaway (Elaine Stalker), Lili Taylor (Grace Stalker), Vincent Gallo (Paul Blackmar).

Don Juan DeMarco
Director Jeremy Leven *Screenwriter* Jeremy Leven, from the poem by Lord Byron *Cinematographer* Ralf D. Bode *Production designer* Sharon Seymour *Composers* Michael Kamen, Robert John Lange *Editor* Antony Gibbs *Producers* Francis Ford Coppola, Michael De Luca, Fred Fuchs *Cast* Johnny Depp (Don Juan), Marlon Brando (Dr Jack Mickler), Faye Dunaway (Marilyn Mickler), Géraldine Pailhas (Doña Ana).

Ed Wood
Director Tim Burton *Screenwriters* Scott Alexander, Larry Karaszewski *Cinematographer* Stefan Czapsky *Production designer* Tom Duffield *Composer* Howard Shore *Editor* Chris Lebenzon

Costume Designer Colleen Atwood *Producers* Tim Burton, Denise Di Novi *Cast* Johnny Depp (Ed Wood), Martin Landau (Bela Lugosi), Sarah Jessica Parker (Dolores Fuller), Patricia Arquette (Kathy O'Hara), Jeffrey Jones (Criswell), Bill Murray (Bunny Breckinridge), Lisa Marie (Vampira).

1995
Dead Man
Director Jim Jarmusch *Screenwriter* Jim Jarmusch *Cinematographer* Robby Müller *Production designer* Bob Ziembicki *Composer* Neil Young *Editor* Jay Rabinowitz *Producer* Demetra J. MacBride *Cast* Johnny Depp (William Blake), Nobody (Gary Farmer), Lance Henriksen (Cole Wilson), Robert Mitchum (John Dickinson), John Hurt (John Scholfield), Gabriel Byrne (Charlie Dickinson), Crispin Glover (Train Fireman), Eugene Byrd (Johnny 'The Kid' Pickett), Iggy Pop (Salvatore 'Sally' Jenko), Michael Wincott (Conway Twill), Mili Avital (Thel Russell).

Nick of Time
Director John Badham *Screenwriter* Patrick Sheane Duncan *Cinematographer* Roy H. Wagner *Production designer* Philip Harrison *Composer* Arthur B. Rubinstein *Editors* Frank Morriss, Kevin Stitt *Producers* John Badham, D.J. Caruso *Cast* Johnny Depp (Gene Watson), Courtney Chase (Lynn Watson), Charles S. Dutton (Huey), Christopher Walken (Mr Smith), Roma Maffia (Ms Jones).

1997
The Brave
Director Johnny Depp *Screenwriters* Johnny Depp, Paul McCudden, Daniel Depp, from the novel by Gregory McDonald *Cinematographers*

Vilko Filac, Eugene D. Shlugleit *Production designer* Miljen Kreka Kljakovic *Composer* Iggy Pop *Editors* Pasquale Buba, Hervé Schneid *Producers* Charles Evans Jr, Carroll Kemp, Jeremy Thomas *Cast* Johnny Depp (Raphael), Marlon Brando (McCarthy), Marshall Bell (Larry), Elpidia Carrillo (Rita), Clarence Williams III (Father Stratton), Frederic Forrest (Lou Sr), Max Perlich (Lou Jr), Luis Guzmán (Luis), Floyd Westerman (Papa).

Donnie Brasco
Director Mike Newell *Screenwriter* Paul Attanasio, from the book by Joe Pistone and Richard Woodley *Cinematographer* Peter Sova *Production designer* Donald Graham Burt *Composer* Patrick Doyle *Editor* Jon Gregory *Producers* Louis DiGiaimo, Alan Greenspan, Mark Johnson, Barry Levinson *Cast* Al Pacino (Benjamin 'Lefty' Ruggiero), Johnny Depp (Joe D. Pistone/ Donnie Brasco), Michael Madsen (Sonny Black), Bruno Kirby (Nicky), James Russo (Paulie), Anne Heche (Maggie Pistone), Robert Miano (Sonny Red).

1998
Fear and Loathing in Las Vegas
Director Terry Gilliam *Screenwriters* Terry Gilliam, Tony Grisoni, Tod Davies, Alex Cox, from the novel by Hunter S. Thompson *Cinematographer* Nicola Pecorini *Production designer* Alex McDowell *Composer* Ray Cooper *Editor* Lesley Walker *Producers* Harold Bronson, Patrick Cassavetti, Richard Foos, Laila Nabulsi, Stephen Nemeth *Cast* Johnny Depp (Raoul Duke), Benicio Del Toro (Gonzo), Tobey Maguire (Hitch-hiker), Ellen Barkin (Waitress at North Star Café), Christina Ricci (Lucy), Gary Busey (Policeman).

L.A. Without a Map
Director Mika Kaurismäki *Screenwriters* Mika Kaurismäki, Richard Rayner *Cinematographer* Michel Amathieu *Production designer* Caroline Hanania *Composer* Sébastien Cortella *Editor* Ewa J. Lind *Producers* Pierre Assouline, Julie Baines, Sarah Daniel *Cast* David Tennant (Richard), Steve Huison (Billy), Julie Delpy (Julie), Vincent Gallo (Moss), Vinessa Shaw (Barbara), Johnny Depp (himself/ William Blake).

1999
The Astronaut's Wife
Director Rand Ravich *Screenwriter* Rand Ravich *Cinematographer* Allen Daviau *Production designer* Jan Roelfs *Editors* Timothy Alverson, Steve Mirkovich *Producer* Andrew Lazar *Cast* Johnny Depp (Commander Spencer Armacost), Charlize Theron (Jillian Armacost), Joe Morton (Sherman Reese).

The Ninth Gate
Director Roman Polanski *Screenwriters* Roman Polanski, John Brownjohn, Enrique Urbizu, from the novel by Arturo Pérez-Reverte *Cinematographer* Darius Khondji *Production designer* Dean Tavoularis *Composer* Wojciech Kilar *Editor* Hervé de Luze *Producers* Roman Polanski, Michel Cheyko, Wolfgang Glattes *Cast* Johnny Depp (Dean Corso), Frank Langella (Boris Balkan), Lena Olin (Liana Telfer), Emmanuelle Seigner (The Girl), Barbara Jefford (Baronness Kessler).

Sleepy Hollow
Director Tim Burton *Screenwriters* Andrew Kevin Walker, Kevin Yagher, from the novella by Washington Irving *Cinematographer* Emmanuel Lubezki *Production designer*

Rick Heinrichs *Composer* Danny Elfman *Editors* Chris Lebenzon, Joel Negron *Producers* Scott Rudin, Adam Schroeder *Cast* Johnny Depp (Ichabod Crane), Christina Ricci (Katrina Van Tassel), Miranda Richardson (Lady Van Tassel), Jeffrey Jones (Reverend Steenwyck), Ian McDiarmid (Doctor Lancaster), Christopher Walken (Hessian Horseman).

The Vicar of Dibley (TV)

Season 3 (*Red Nose Day Special*) *Screenwriters* Richard Curtis, Paul Mayhew-Archer *Cast* Dawn French (Geraldine Granger), Gary Waldhorn (David Horton), Roger Lloyd Pack (Owen Newitt), James Fleet (Hugo Horton), Johnny Depp (himself).

2000

The Fast Show (TV)

(*The Last-Ever Fast Show*) *Creators* Paul Whitehouse, Charlie Higson *Cast* Johnny Depp (Customer in suit store).

The Man Who Cried

Director Sally Potter *Screenwriter* Sally Potter *Production designer* Carlos Conti *Composer* Osvaldo Golijov *Editor* Hervé Schneid *Producer* Christopher Sheppard *Cast* Christina Ricci (Suzie), Johnny Depp (Cesar), Cate Blanchett (Lola), John Turturro (Dante Dominio).

Before Night Falls

Director Julian Schnabel *Screenwriters* Julian Schnabel, Cunningham O'Keefe, Lázaro Gómez Carriles *Cinematographers* Xavier Grobet, Guillermo Rosas *Production designer* Salvador Parra *Composer* Carter Burwell *Editor* Michael Berenbaum *Producer* Jon Kilik *Cast* Javier Bardem (Reinaldo Arenas), Johnny Depp (Bon Bon/Lieutenant Victor), Olivier Martinez (Lazaro Gomez Carilles), Sean Penn (Cuco Sanchez).

Chocolat

Director Lasse Hallström *Screenwriter* Robert Nelson Jacobs, from a novel by Joanne Harris *Cinematographer* Roger Pratt *Production designer* David Gropman *Composer* Rachel Portman *Editor* Andrew Mondshein *Producers* David Brown, Kit Golden, Leslie Holleran *Cast* Juliette Binoche (Vianne Rocher), Leslie Caron (Madame Audel), Johnny Depp (Roux), Lena Olin (Josephine Muscat), Alfred Molina (Comte de Reynaud).

2001

Blow

Director Ted Demme *Screenwriters* David McKenna, Nick Cassavetes, from a novel by Bruce Porter *Cinematographer* Ellen Kuras *Production designer* Michael Z. Hanan *Composer* Graeme Revell *Editor* Kevin Tent *Producers* Ted Demme, Denis Leary, Joel Stillerman *Cast* Johnny Depp (George Jung), Penélope Cruz (Mirtha Jung), Franka Potente (Barbara Buckley), Ray Liotta (Fred Young), Cliff Curtis (Pablo Escobar)

From Hell

Directors Albert and Allen Hughes *Screenwriters* Terry Hayes, Rafael Yglesias, from the graphic novel by Alan Moore and Eddie Campbell *Cinematographer* Peter Deming *Production designer* Martin Childs *Composer* Trevor Jones *Editors* George Bowers, Dan Lebental *Producers* Jane Hamsher, Don Murphy *Cast* Johnny Depp (Inspector Frederick Abberline), Heather Graham (Mary Kelly), Ian Holm (Sir William Gull), Robbie Coltrane (Sgt. Peter Godley).

2003

Pirates of the Caribbean: The Curse of the Black Pearl

Director Gore Verbinski *Screenwriters* Ted Elliott, Terry Rossio *Cinematographer*

Dariusz Wolski *Production designer* Brian Morris *Composer* Klaus Badelt *Editors* Stephen E. Rivkin, Arthur Schmidt, Craig Wood *Producer* Jerry Bruckheimer *Cast* Johnny Depp (Jack Sparrow), Geoffrey Rush (Captain Hector Barbossa), Orlando Bloom (Will Turner), Keira Knightley (Elizabeth Swann), Jack Davenport (Norrington), Jonathan Pryce (Governor Weatherby Swann), Mackenzie Crook (Ragetti).

Once Upon a Time in Mexico

Director Robert Rodriguez *Screenwriter* Robert Rodriguez *Cinematographer* Robert Rodriguez *Production designer* Robert Rodriguez *Composer* Robert Rodriguez *Editor* Robert Rodriguez *Producers* Robert Rodriguez, Elizabeth Avellan, Carlos Gallardo *Cast* Antonio Banderas (El Mariachi), Salma Hayek (Carolina), Johnny Depp (Sands), Mickey Rourke (Billy), Eva Mendes (Ajedrez).

2004

Happily Ever After

Director Yvan Attal *Screenwriter* Yvan Attal *Cinematographer* Rémy Chevrin *Production designer* Katia Wyszkop *Composer* Brad Mehldau *Editor* Jennifer Augé *Producer* Claude Berri *Cast* Charlotte Gainsbourg (Gabrielle), Yvan Attal (Vincent), Alain Chabat (Georges), Emmanuelle Seigner (Nathalie), Johnny Depp (Stranger).

King of the Hill (TV)

Season 8, Episode 20 (*Hank's Back*) *Creators* Mike Judge, Greg Daniels *Director* Robin Brigstocke *Screenwriters* Aron Abrams, Gregory Thompson *Voices* Mike Judge (Hank Hill/Boomhauer), Kathy Najimy (Peggy Hill), Johnny Depp (Yogi Victor).

Secret Window

Director David Koepp *Screenwriter* David Koepp, from a novella by Stephen King *Cinematographer* Fred Murphy *Production designer* Howard Cummings *Composer* Philip Glass, Geoff Zanelli *Editor* Jill Savitt *Producers* Gavin Polone *Cast* Johnny Depp (Mort Rainey), John Turturro (John Shooter), Maria Bello (Amy Rainey), Timothy Hutton (Ted Milner).

Finding Neverland

Director Marc Forster *Screenwriter* David Magee, from the play by Allan Knee *Cinematographer* Roberto Schaefer *Production designer* Gemma Jackson *Composer* Jan A.P. Kaczmarek *Editor* Matt Chesse *Producers* Nellie Bellflower, Richard N. Gladstein *Cast* Johnny Depp (Sir James Matthew Barrie), Kate Winslet (Sylvia Llewelyn Davies), Julie Christie (Emma du Maurier), Dustin Hoffman (Charles Frohman), Radha Mitchell (Mary Ansell Barrie), Freddie Highmore (Peter Llewelyn Davies).

2005

Charlie and the Chocolate Factory

Director Tim Burton *Screenwriter* John August, from the novel by Roald Dahl *Cinematographer* Philippe Rousselot *Production designer* Alex McDowell *Composer* Danny Elfman *Editor* Chris Lebenzon *Producers* Brad Grey, Richard D. Zanuck, Lorne Orleans *Cast* Johnny Depp (Willy Wonka), Freddie Highmore (Charlie Bucket), Helena Bonham Carter (Mrs Bucket), Noah Taylor (Mr Bucket), David Kelly (Grandpa Joe), Christopher Lee (Dr Wonka).

Corpse Bride

Directors Tim Burton, Mike Johnson *Screenwriters* Tim Burton, Carlos Grangel, Caroline Thompson,

John August, Pamela Pettler *Cinematographer* Pete Kozachik *Production designer* Alex McDowell *Composer* Danny Elfman *Editors* Chris Lebenzon, Jonathan Lucas *Producers* Tim Burton, Allison Abbate *Voices* Johnny Depp (Victor Van Dort), Helena Bonham Carter (Corpse Bride), Emily Watson (Victoria Everglot), Tracey Ullman (Nell Van Dort/Hildegarde), Paul Whitehouse (William Van Dort/Mayhew/Paul, the Head-Waiter), Joanna Lumley (Maudeline Everglot).

The Libertine

Director Laurence Dunmore *Screenwriter* Stephen Jeffreys *Cinematographer* Alexander Melman *Production designer* Ben van Os *Composer* Michael Nyman *Editor* Jill Bilcock *Producers* Lianne Halfon, John Malkovich, Russell Smith *Cast* Johnny Depp (Rochester), Paul Ritter (Chiffinch), John Malkovich (Charles II), Kelly Reilly (Jane), Samantha Morton (Elizabeth Barry).

2006

Pirates of the Caribbean: Dead Man's Chest

Director Gore Verbinski *Screenwriters* Ted Elliott, Terry Rossio *Cinematographer* Dariusz Wolski *Production designer* Rick Heinrichs *Composer* Hans Zimmer *Editors* Stephen E. Rivkin, Craig Wood *Producer* Jerry Bruckheimer *Cast* Johnny Depp (Jack Sparrow), Orlando Bloom (Will Turner), Keira Knightley (Elizabeth Swann), Jack Davenport (Norrington), Bill Nighy (Davy Jones), Jonathan Pryce (Governor Weatherby Swann), Naomie Harris (Tia Dalma), Mackenzie Crook (Ragetti), Stellan Skarsgård (Bootstrap Bill Turner).

2007

Pirates of the Caribbean: At World's End

Director Gore Verbinski *Screenwriters* Ted Elliott, Terry Rossio *Cinematographer* Dariusz Wolski *Production designer* Rick Heinrichs *Composer* Hans Zimmer *Editors* Stephen E. Rivkin, Craig Wood *Producer* Jerry Bruckheimer *Cast* Johnny Depp (Jack Sparrow), Orlando Bloom (Will Turner), Keira Knightley (Elizabeth Swann), Geoffrey Rush (Captain Hector Barbossa), Jack Davenport (Norrington), Bill Nighy (Davy Jones), Jonathan Pryce (Governor Weatherby Swann), Naomie Harris (Tia Dalma), Mackenzie Crook (Ragetti), Kevin McNally (Gibbs), Keith Richards (Captain Teague).

Sweeney Todd: The Demon Barber of Fleet Street

Director Tim Burton *Screenwriter* John Logan, from the musical by Hugh Wheeler and Christopher Bond *Cinematographer* Dariusz Wolski *Production designer* Dante Ferretti *Composer* Stephen Sondheim *Editor* Chris Lebenzon *Producers* John Logan, Laurie MacDonald, Richard D. Zanuck, Walter F. Parkes *Cast* Johnny Depp (Sweeney Todd), Helena Bonham Carter (Mrs Lovett), Alan Rickman (Judge Turpin), Timothy Spall (Beadle Bamford), Sacha Baron Cohen (Adolfo Pirelli).

2009

The Imaginarium of Doctor Parnassus

Director Terry Gilliam *Screenwriters* Terry Gilliam, Charles McKeown *Cinematographer* Nicola Pecorini *Production designer* Anastasia Masaro *Composers* Jeff and Mychael Danna *Editor* Mick Audsley *Producers* Terry and Amy Gilliam, Samuel Hadida,

William Vince *Cast* Christopher Plummer (Dr Parnassus), Andrew Garfield (Anton), Richard Riddell (Martin), Lily Cole (Valentina), Heath Ledger (Tony), Johnny Depp (Imaginarium Tony 1), Jude Law (Imaginarium Tony 2), Colin Farrell (Imaginarium Tony 3).

Public Enemies

Director Michael Mann *Screenwriters* Michael Mann, Ann Biderman, Ronan Bennett, from the book by Bryan Burrough *Cinematographer* Dante Spinotti *Production designer* Nathan Crowley *Composer* Elliot Goldenthal *Editors* Jeffrey Ford, Paul Rubell *Producers* Michael Mann, Kevin Misher *Cast* Johnny Depp (John Dillinger), Christian Bale (Melvin Purvis), Marion Cotillard (Billie Frechette), Channing Tatum (Pretty Boy Floyd), Billy Crudup (J. Edgar Hoover), James Russo (Walter Dietrich), Giovanni Ribisi (Alvin Karpis).

SpongeBob SquarePants (TV)

Season 6, Episode 11 (*SpongeBob SquarePants vs. The Big One*) *Screenwriters* Steven Banks, Aaron Springer, Paul Tibbitt *Voices* Tom Kenny (SpongeBob Squarepants), Bill Fagerbakke (Patrick Star), Rodger Bumpass (Squidward Tentacles), Carolyn Lawrence (Sandy Cheeks), Johnny Depp (Jack Kahuna Laguna).

2010

Alice in Wonderland

Director Tim Burton *Screenwriter* Linda Woolverton, from the novel by Lewis Carroll *Cinematographer* Dariusz Wolski *Production designer* Robert Stromberg *Composer* Danny Elfman *Editor* Chris Lebenzon *Producers* Joe Roth, Jennifer

Todd, Suzanne Todd, Richard D. Zanuck *Cast* Mia Wasikowska (Alice Kingsleigh), Johnny Depp (Mad Hatter), Helena Bonham Carter (Red Queen), Anne Hathaway (White Queen), Crispin Glover (Stayne, Knave of Hearts), Christopher Lee (Voice of the Jabberwocky), Matt Lucas (Tweedledee/Tweedledum).

The Tourist

Director Florian Henckel von Donnersmarck *Screenwriters* Florian Henckel von Donnersmarck, Christopher McQuarrie, Julian Fellowes, from the film *Anthony Zimmer* by Jérôme Salle *Cinematographer* John Seale *Production designer* Jon Hutman *Composer* James Newton Howard *Editors* Joe Hutshing, Patricia Rommel *Producers* Roger Birnbaum, Jonathan Glickman, Tim Headington, Graham King, Gary Barber *Cast* Johnny Depp (Frank Tupelo), Angelina Jolie (Elise Clifton-Ward), Timothy Dalton (CI Jones), Paul Bettany (Inspector John Acheson), Rufus Sewell (The Englishman), Steven Berkoff (Reginald Shaw).

2011

Jack and Jill

Director Dennis Dugan *Screenwriters* Steve Koren, Adam Sandler *Cinematographer* Dean Cundey *Production designer* Perry Andelin Blake *Composer* Rupert Gregson-Williams, Waddy Wachtel *Editor* Tom Costain *Producers* Todd Garner, Jack Giarraputo, Adam Sandler *Cast* Adam Sandler (Jack/Julie Sadelstein), Katie Holmes (Erin Sadelstein), Al Pacino (himself), Johnny Depp (himself).

Life's Too Short (TV)

Season 1, Episode 2 *Creators* Ricky Gervais, Stephen

Merchant, Warwick Davis *Directors* Ricky Gervais, Stephen Merchant *Screenwriters* Ricky Gervais, Stephen Merchant *Cast* Warwick Davis (himself), Ricky Gervais (himself), Stephen Merchant (himself), Johnny Depp (himself).

Pirates of the Caribbean: On Stranger Tides

Director Rob Marshall *Screenwriters* Ted Elliott, Terry Rossio *Cinematographer* Dariusz Wolski *Production designer* John Myhre *Composer* Hans Zimmer *Editors* David Brenner, Wyatt Smith *Producer* Jerry Bruckheimer *Cast* Johnny Depp (Jack Sparrow), Penélope Cruz (Angelica), Geoffrey Rush (Captain Hector Barbossa), Ian McShane (Blackbeard), Kevin McNally (Gibbs), Keith Richards (Captain Teague), Sam Claflin (Philip), Astrid Bergès-Frisbey (Syrena), Richard Griffiths (King George II).

Rango

Director Gore Verbinski *Screenwriters* John Logan, Gore Verbinski, James Ward Byrkit *Production designer* Mark 'Crash' McCreery *Artistic Direction* John Bell *Animation* Hal Hickel *Composer* Hans Zimmer *Editor* Craig Wood *Producers* Gore Verbinski, John B. Carls, Graham King *Voices* Johnny Depp (Rango/Lars), Isla Fisher (Beans), Abigail Breslin (Priscilla), Ned Beatty (Mayor), Alfred Molina (Roadkill).

The Rum Diary

Director Bruce Robinson *Screenwriter* Bruce Robinson, from the novel by Hunter S. Thompson *Cinematographer* Dariusz Wolski *Production designer* Chris Seagers *Composer* Christopher Young *Editor* Carol Littleton *Producers* Johnny Depp, Christi Dembrowski,

Tim Headington, Graham King, Robert Kravis, Anthony Rhulen *Cast* Johnny Depp (Kemp), Aaron Eckhart (Sanderson), Michael Rispoli (Sala), Amber Heard (Chenault), Richard Jenkins (Lotterman).

2012
Dark Shadows

Director Tim Burton *Screenwriters* Seth Grahame-Smith, John August, from the TV series by Dan Curtis *Cinematographer* Bruno Delbonnel *Production designer* Rick Heinrichs *Composer* Danny Elfman *Editor* Chris Lebenzon *Producers* Johnny Depp, Christi Dembrowski, David Kennedy, Graham King, Richard D. Zanuck *Cast* Johnny Depp (Barnabas Collins), Michelle Pfeiffer (Elizabeth Collins Stoddard), Helena Bonham Carter (Dr Julia Hoffman), Eva Green (Angelique Bouchard), Jackie Earle Haley (Willie Loomis), Chloë Grace Moretz (Carolyn Stoddard).

Family Guy (TV)

Season 11, Episode 6 (*Lois Comes Out of Her Shell*) *Creators* Seth MacFarlane, David Zuckerman *Director* Joe Vaux *Screenwriter* Danny Smith *Voices* Seth MacFarlane (Peter Griffin), Alex Borstein (Lois Griffin), Seth Green (Chris Griffin), Mila Kunis (Meg Griffin), Johnny Depp (Edward Scissorhands).

21 Jump Street

Director Phil Lord, Christopher Miller *Screenwriter* Michael Bacall, from the TV series created by Stephen J. Cannell, Patrick Hasburgh *Cinematographer* Barry Peterson *Production designer* Peter Wenham *Composer* Mark Mothersbaugh *Editor* Joel Negron *Producers* Stephen J. Cannell, Neal H. Moritz *Cast* Jonah Hill (Schmidt), Channing Tatum (Jenko), Brie Larson (Molly Tracey),

Dave Franco (Eric Molson), Johnny Depp (Tom Hanson).

2013
The Lone Ranger

Director Gore Verbinski *Screenwriters* Ted Elliott, Terry Rossio, Justin Haythe *Cinematographer* Bojan Bazelli *Production designers* Jess Gonchor, Mark 'Crash' McCreery *Composer* Hans Zimmer *Editors* James Haygood, Craig Wood *Producers* Gore Verbinski, Jerry Bruckheimer *Cast* Johnny Depp (Tonto), Armie Hammer (John Reid, The Lone Ranger), William Fichtner (Butch Cavendish), Tom Wilkinson (Latham Cole), Ruth Wilson (Rebecca Reid), Helena Bonham Carter (Red Harrington).

Lucky Them

Director Megan Griffiths *Screenwriters* Huck Botko, Emily Wachtel, from an original idea by Caroline Sherman *Cinematographer* Ben Kutchins *Production designer* John Lavin *Composer* Craig Wedren *Editor* Meg Reticker *Producers* Adam Gibbs, Amy Hobby, Emily Wachtel *Cast* Toni Collette (Ellie Klug), Thomas Haden Church (Charlie), Oliver Platt (Giles), Ryan Eggold (Lucas Stone), Johnny Depp (Matthew Smith).

2014
Into the Woods

Director Rob Marshall *Screenwriter* James Lapine, from the musical comedy by Stephen Sondheim, James Lapine *Cinematographer* Dion Beebe *Production designer* Dennis Gassner *Composer* James Lapine, Stephen Sondheim *Editor* Wyatt Smith *Costume Designer* Colleen Atwood *Producers* Rob Marshall, John DeLuca, Marc Platt *Cast* Johnny Depp (Wolf), Emily Blunt (Baker's Wife), Anna Kendrick (Cinderella),

Chris Pine (Cinderella's Prince), Meryl Streep (Witch), Lucy Punch (Lucinda), James Corden (Baker).

Transcendence

Director Wally Pfister *Screenwriter* Jack Paglen *Cinematographer* Jess Hall *Production designer* Chris Seagers *Composer* Mychael Danna *Editor* David Rosenbloom *Producers* Kate Cohen, Broderick Johnson, Andrew A. Kosove, Annie Marter, Marisa Polvino, David Valdes, Aaron Ryder *Cast* Johnny Depp (Will Caster), Rebecca Hall (Evelyn Caster), Paul Bettany (Max Waters), Cillian Murphy (Agent Buchanan).

Tusk

Director Kevin Smith *Screenwriter* Kevin Smith *Cinematographer* James Laxton *Production designer* John D. Kretschmer *Composer* Christopher Drake *Editor* Kevin Smith *Producers* Sam Englebardt, David S. Greathouse, William D. Johnson, Shannon McIntosh *Cast* Justin Long (Wallace Bryton), Michael Parks (Howard Howe), Haley Joel Osment (Teddy Craft), Genesis Rodriguez (Ally Leon), Johnny Depp (Guy LaPointe).

2015
Mortdecai

Director David Koepp *Screenwriter* Eric Aronson, from a novel by Kyril Ben Figlioli *Cinematographer* Florian Hoffmeister *Production designer* James Merifield *Composers* Mark Ronson, Geoff Zanelli *Editors* Jill Savitt, Derek Ambrosi *Producers* Johnny Depp, Christi Dembrowski, Andrew Lazar, Gigi Pritzker, Patrick McCormick *Cast* Johnny Depp (Charlie Mortdecai), Gwyneth Paltrow (Johanna), Ewan McGregor (Inspector Martland), Paul Bettany (Jock Strapp)

Bibliography

Books

Antoine de Baecque, *Tim Burton*, Cahiers du cinéma, 2010.

Robert Benayoun, *Le Regard de Buster Keaton*, Herscher, 1982.

Steven Daly, *Johnny Depp: A Retrospective*, Insight Editions, 2013.

Fabien Gaffez, *Johnny Depp, le singe et la statue*, Scope Éditions, 2010.

Nigel Goodall, *The Secret World of Johnny Depp*, John Blake Publishing, 2007.

Nigel Goodall, *What's Eating Johnny Depp?* Blake Publishing, 2004.

Christopher Heard, *Depp*, ECW Press, 2001.

Jim Jarmusch and Ludvig Hertzberg, *Jim Jarmusch, Interviews*, Roundhouse Publishing, 2001.

Jean-Louis Leutrat, 'The Brave', in *Les images honteuses*, Murielle Gagnebin (ed.), Champ Vallon, 2006.

Luc Moullet, *Politique des Acteurs*, Cahiers du cinéma, 1993.

Murray Pomerance, *Johnny Depp Starts Here*, Rutgers University Press, 2005.

Brian J. Robb, *Johnny Depp: A Modern Rebel*, Plexus Publishing, 2006.

Jonathan Rosenbaum, *Dead Man*, BFI Publishing, 2000.

Steven Rybin, *Michael Mann: Crime Auteur*, Scarecrow Press, 2013.

Steven Rybin, 'Style, Meaning and Myth in *Public Enemies*', in *The Philosophy of Michael Mann*, Steven Sanders, Aeon J. Skoble and R. Barton Palmer (eds.), University Press of Kentucky, 2014.

Mark Salisbury (ed.), *Burton on Burton*, Faber and Faber, 2006.

Michael Singer, *The Lone Ranger: Behind the Mask*, Insight Editions, 2013.

Jim Smith and J. Clive Matthews, *Tim Burton*, Virgin Books, 2002.

Articles

Rachel Abramowitz, 'Johnny Depp: An Outlaw Outlook', *Los Angeles Times* (28 June 2009).

Decca Aitkenhead, 'Johnny Depp: "I'm Not Ready to Give Up My American Citizenship"', *The Guardian* (6 November 2011).

Hervé Aubron, 'Zone quadrillée', *Cahiers du cinéma* (July-August 2009).

Philippe Azoury, '*Alice au pays des merveilles*', *Libération* (24 March 2010).

Philippe Azoury, 'Dillinger, l'ennemi ranimé', *Libération* (8 July 2009).

Antoine de Baecque, 'L'Amérique sous les fers', *Cahiers du cinéma* (April 1991).

Antoine de Baecque, 'Un asile de fous', *Cahiers du cinéma* (April 2010).

Claude Baignères, 'Bidonville et philosophie bidon', *Le Figaro* (11 May 1997).

Wayne Baker 'Cultural Competence: Is Johnny Depp's Portrayal of Tonto Offensive?' *Ann Arbor News* (26 June 2013).

Philip Berk, 'Heartbeat Poet', *FilmInk Magazine* (August 2006).

Mark Binelli, 'The Last Buccaneer', *Rolling Stone* (13 July 2006).

Jacques-André Bondy, 'Gonzo Interview', *Première (France)* (June 1998).

Emile Breton, 'Entretien avec Emir Kusturica: quand les poissons voleront', in *Les Lettres françaises* (29 January 1993).

Anthony Breznican, 'Johnny Depp Reveals Origins of Tonto Makeup from *The Lone Ranger*', *Entertainment Weekly* (22 April 2012).

Douglas Brinkley, 'Colonel Depp & the Rum Doctor Blues', *Aspen Peak* (Winter 2011).

Douglas Brinkley, 'Johnny Depp's Great Escape', *Vanity Fair* (July 2009).

Libby Brooks, 'If I Could Morph My Face, That'd Be Great', *The Guardian* (11 January 2000).

Jessamy Calkin, 'Johnny Depp ESQ', *Esquire* (February 2000).

Christophe Carrière, 'Tim Burton fait des merveilles', *L'Express* (25 March 2010).

Glenn Collins, 'Johnny Depp Contemplates Life as, and After, *Scissorhands*', *The New York Times* (10 January 1991).

Manohla Dargis, 'What's a Nice Girl Doing in This Hole?' *The New York Times* (4 March 2010).

Aubrey Day, 'The End Is Nigh', *Total Film* (February 2007).

Anthony Decurtis, 'Johnny Depp', *Rolling Stone* (28 May 1998).

Johnny Depp, 'A Pair of Deviant Bookends', *Rolling Stone* (24 March 2005).

Johnny Depp, 'Allen Ginsberg', *Interview Magazine* (June 1994).

Johnny Depp (foreword), *Burton on Burton*, Faber and Faber, 2006.

Robert Ebert, '*Arizona Dream*', *Chicago Sun-Times* (6 January 1995).

Roger Ebert, '*Dead Man*', *Chicago Sun-Times* (28 June 1996).

Roger Ebert, '*Public Enemies*', *Chicago Sun-Times* (29 June 2009).

Angie Errigo, '*The Lone Ranger*, Hi-Yo Fidelity', *Empire* (5 August 2013).

Felicia Fonseca, 'Disney's Tonto Offensive to Some in Upcoming *Lone Ranger* Film', *The Huffington Post* (12 May 2013).

Rebecca Ford, '*Lone Ranger* Filmmakers on Making a Western That Works', *The Hollywood Reporter* (17 April 2013).

François Forestier, 'Terry Gilliam hallucine', *Le Nouvel Observateur* (14 May 1998).

Cal Fussman, 'The Continuing Adventures of Tim & Johnny', *Esquire* (January 2008).

Owen Gleiberman, '*Alice in Wonderland*', *Entertainment Weekly* (3 March 2010).

Christine Haas and Alain Kruger, 'Sexy Depp', *Première* (July 1995).

Chris Heath, 'Johnny Depp: Portrait of the Oddest as a Young Man', *Details* (May 1993).

Chris Heath, 'Johnny Depp's Savage Journey into *Fear and Loathing in Las Vegas*', *Rolling Stone* (11 June 1998).

John Hiscock, '*Public Enemies*', *The Telegraph* (25 June 2009).

Chrissy Iley, 'I Felt Weirdness for Many Years', *The Guardian* (3 July 2006).

Kent Jones, 'Le Parler franc de l'Amérique', *Cahiers du cinéma* (July-August 1998).

Iannis Katsahnias, 'Le Rock du bagne', *Cahiers du cinéma* (July-August 1990).

Jean-Marc Lahanne 'Public Enemies', *Les Inrockuptibles* (7 July 2009).

Jean-Pierre Lavoignat, 'Emir Kusturica, l'incorrigible rêveur', *Studio Magazine* (January 1993).

Brendan Lemon, 'Johnny Depp', *Interview Magazine* (December 1995).

Gilles Le Morvan, 'Sous la coupe de Hollywood', *L'Humanité* (13 April 1991).

Jean-Pierre Léonardini, 'Un flop signé de Jim Jarmusch', *L'Humanité* (29 June 1995).

Shelley Levitt, 'Love and Depp', *People Magazine* (3 October 1994).

Éric Libiot, 'Surenchère et flibustiers', *L'Express* (3 August 2006).

Noémie Luciani, 'Lone Ranger', *Le Monde* (7 August 2013).

Todd McCarthy, '*Alice in Wonderland*', *Variety* (25 February 2010).

Todd McCarthy, 'Public Enemies', *Variety* (24 June 2009).

Jill McClellan, 'Depp Charge', *The Face* (July 1991).

Elizabeth McCracken, 'Depp Charge', *Elle* (June 1998).

Joël Magny, 'Kusturica en voyage d'affaires', *Cahiers du cinéma* (January 1993).

Janet Maslin, 'And so Handy Around the Garden', *The New York Times* (7 December 1990).

Janet Maslin, '*Arizona Dream*: Lunacy with Missing Minutes', *The New York Times* (7 June 1995).

Portia Medina, 'Danny Elfman Discusses Film Scoring, Getting Along with Tim Burton, Johnny Depp the Thief', *billboard.com* (10 May 2012).

Holly Millea, 'Ghost in the Machine: Now You See Johnny Depp, Now You Don't', *Premiere (UK)* (February 1995).

Sean Mitchell, 'Accounting for His Image', *Newsday* (26 November 1995).

Susan Morgan, 'Depp Perception', *Harper's Bazaar* (May 1993).

Cécile Mury, 'Lone Ranger', *Télérama* (7 August 2013).

William Norwich, 'Vogue Men', *Vogue* (June 1992).

Martyn Palmer, 'Outsider on the A-List', *The London Times* (30 April 1997).

John Patterson, '#1 with a Bullet', *The Guardian* (26 June 2009).

Rod Pocowatchit, 'Will Depp's Portrayal of Tonto Add to Struggle Natives Face in Filmmaking?' *The Wichita Eagle* (27 May 2012).

Natanya Ann Pulley, 'An Open Letter to Johnny Depp's Tonto', *mcsweeneys.net* (4 December 2012).

Marie Queva, '*West Side Story*, version fifties', *Les Échos* (1 August 1990).

Steven Rea, 'Wild, Wacky *Lone Ranger* Is Epic Good Time', *The Inquirer* (3 July 2013).

Stephen Rebello, 'Interview: Johnny Depp', *Sky Magazine* (July 1993).

Stephen Rebello, 'Johnny Handsome', *Movieline* (May 1990).

Laurent Rigoulet, '*Las Vegas Parano* complètement party', *Libération* (19 August 1998).

Jonathan Rosenbaum, 'Acid Western', *Chicago Reader* (27 June 1996).

Josh Rottenberg, 'Days of Plunder', *Entertainment Weekly* (18 May 2007).

Marianne Ruuth, 'Les Métamorphoses de Johnny Depp', *Le Figaro* (10 April 1991).

Nicolas Saada, 'Entretien avec Jim Jarmusch', *Cahiers du cinéma* (January 1996).

Mark Salisbury, 'Tim Burton & Johnny Depp Interview', *The Telegraph* (15 February 2010).

Kevin Sessums, 'Johnny Be Good', *Vanity Fair* (February 1997).

Dana Shapiro, 'What Makes Johnny Famous?', *Icon* (June 1998).

Tom Shone, 'Johnny Depp Isn't Johnny Depp Anymore', *Talk Magazine* (October 1999).

Patti Smith, 'The Crowded Mind of Johnny Depp', *Vanity Fair* (January 2011).

François Thomas, 'Johnny Depp dans *Edward aux mains d'argent*', *Positif* (April 2010).

Kevin Thomas, 'Dazzling *Arizona Dream* of Tragicomedy', *Los Angeles Times* (11 July 1995).

Vincent Tolédano, 'Jim Jarmusch s'englue dans l'Ouest sauvage', *Info Matin* (4 January 1996).

Kenneth Turan, 'Not Even Johnny Depp Can Rescue *The Lone Ranger*', *Los Angeles Times* (3 July 2013).

Philippe Vecchi, '*Edward aux mains d'argent*', *Libération* (10 April 1991).

Chris Wallace, 'Equal Status, Kemo Sabe', *The New York Times* (28 June 2013).

Tim Walker, 'Behind the Mask Is Yet Another Forgettable Lone Ranger', *The Independent* (3 July 2013).

Donna Walker-Mitchell, 'Smooth Criminal', *The Age* (24 July 2009).

John Waters, 'Johnny Depp', *Interview Magazine* (April 1990).

Chris Willman, 'From Baby Face to *Cry-Baby*', *Los Angeles Times* (4 April 1990).

Christophe d'Yvoire, 'My Way', *Studio Magazine* (January 1992).

Christophe d'Yvoire, 'Sur la piste des géants', *Studio Magazine* (March 1997).

Christophe d'Yvoire, 'Un Gitan en Amérique', *Studio Magazine* (January 1991).

Christophe d'Yvoire, 'Un rebelle au cœur pur', *Studio Magazine* (January 1993).

Bill Zehme, 'Sweet Sensation', *Rolling Stone* (10 January 1991).

Audiovisual archives

Interview with Claudie Ossard and Johnny Depp, DVD bonus, *Arizona Dream*, Studio Canal (2002).

Audio commentary by Ted Elliott and Terry Rossio, DVD bonus, *Pirates of the Caribbean: Dead Man's Chest*, Walt Disney (2007).

Interview with John Waters, DVD bonus, *Cry-Baby*, Universal (2008).

Audio commentary by Michael Mann, DVD bonus, *Public Enemies*, Universal (2009).

Interviews with Johnny Depp and Anne Hathaway, DVD bonus, *Alice in Wonderland*, Walt Disney (2010).

Interview with Johnny Depp, BBC London (26 July 2013).

Interview with Johnny Depp, *The Late Show with David Letterman* (21 February 2013).

Notes

1 Brian J. Robb, *Johnny Depp: A Modern Rebel*, Plexus Publishing, 2006, p. 12.

2 Bill Zehme, 'Sweet Sensation', *Rolling Stone* (10 January 1991).

3 John Waters, 'Johnny Depp', *Interview Magazine* (April 1990).

4 Robb, *op. cit.*, p. 30.

5 Steven Daly, *Johnny Depp: A Retrospective*, Insight Editions, 2013.

6 Decca Aitkenhead, 'Johnny Depp: "I'm Not Ready to Give Up My American Citizenship"', *The Guardian* (6 November 2011).

7 Anthony Decurtis, 'Johnny Depp', *Rolling Stone* (28 May 1998).

8 Patti Smith, 'The Crowded Mind of Johnny Depp', *Vanity Fair* (January 2011).

9 *Ibid.*

10 Fabien Gaffez, *Johnny Depp, le singe et la statue*, Scope Éditions, 2010.

11 Smith, *op. cit.*

12 Gaffez, *op. cit.*, p. 93.

13 Chris Willman, 'From Baby Face to *Cry-Baby*', *Los Angeles Times* (4 April 1990).

14 Robb, *op. cit.*, p. 28.

15 *Ibid.*, p. 38.

16 Willman, *op. cit.*

17 *Ibid.*

18 Stephen Rebello, 'Johnny Handsome', *Movieline* (May 1990).

19 Waters, *op. cit.*

20 DVD bonus, *Cry-Baby*, Universal, 2008.

21 *Ibid.*

22 Robb, *op. cit.*, p. 41.

23 Iannis Katsahnias, 'Le Rock du bagne', *Cahiers du cinéma* (July-August 1990).

24 *Ibid.*

25 *Ibid.*

26 Robb, *op. cit.*, p. 41.

27 *Ibid.*, pp. 42–3.

28 Stephen Rebello, 'Interview: Johnny Depp', *Sky Magazine* (July 1993).

29 Maurice Fabre, 'Un Roméo et sa Juliette', *France-Soir* (14 May 1990).

30 Marie Queva, '*West Side Story*, version fifties', *Les Échos* (1 August 1990).

31 F. G., '*Cry-Baby*', *Ici Paris* (2 August 1990).

32 François Jonquet, 'Bon chic, bon rock', *Le Quotidien de Paris* (1 August 1990).

33 Danièle Heymann, '*Cry-Baby*', *Le Monde* (5 August 1990).

34 Willman, *op. cit.*

35 *Ibid.*

36 Kevin Sessums, 'Johnny Be Good', *Vanity Fair* (February 1997).

37 Willman, *op. cit.*

38 Mark Salisbury (ed.), *Burton on Burton*, Faber and Faber, 2006, p. XII.

39 *Ibid.*, p. x.

40 *Ibid.*

41 *Ibid.*

42 Zehme, *op. cit.*

43 Salisbury (ed.), *op. cit.*, p. XI.

44 *Ibid.*, p. 91.

45 Jim Smith and J. Clive Matthews, *Tim Burton*, Virgin Books, 2002, p. 97.

46 Jill McClellan, 'Depp Charge', *The Face* (July 1991).

47 Robb, *op. cit.*, p. 52.

48 *Ibid.*

49 Zehme, *op. cit.*

50 Antoine de Baecque, 'L'Amérique sous les fers', *Cahiers du cinéma* (April 1991).

51 McClellan, *op. cit.*

52 Salisbury (ed.), *op. cit.*, p. 92.

53 Robert Benayoun, *Le regard de Buster Keaton*, Herscher, 1982, p. 18.

54 François Thomas, 'Johnny Depp dans *Edward aux mains d'argent*', *Positif* (April 2010), pp. 10–15.

55 Gaffez, *op. cit.*

56 Salisbury (ed.), *op. cit.*, p. 94.

57 Stephen Rebello, 'Johnny Handsome', *Movieline* (May 1990).

58 Chris Heath, 'Johnny Depp: Portrait of the Oddest as a Young Man', *Details* (May 1993).

59 Janet Maslin, 'And so Handy Around the Garden', *The New York Times* (7 December 1990).

60 Robb, *op. cit.*, p. 54.

61 Philippe Vecchi, '*Edward aux mains d'argent*', *Libération* (10 April 1991).

62 Marianne Ruuth, 'Les Métamorphoses de Johnny Depp', *Le Figaro* (10 April 1991).

63 Gilles Le Morvan, 'Sous la coupe de Hollywood', *L'Humanité* (13 April 1991).

64 Glenn Collins, 'Johnny Depp Contemplates Life As, and After, *Scissorhands*', *The New York Times* (10 January 1991).

65 Tom Burke, 'Johnny Depp: Hollywood's Tough, Rough New Romeo', *Cosmopolitan* (January 1991).

66 Zehme, *op. cit.*

67 Robb, *op. cit.*, p. 54.

68 Zehme, *op. cit.*

69 Jill McClellan, *op. cit.*

70 Christophe d'Yvoire, 'Un rebelle au cœur pur', *Studio Magazine* (January 1993).

71 Jean-Pierre Lavoignat, 'Emir Kusturica, l'incorrigible rêveur', *Studio Magazine* (January 1993).

72 Heath, *op. cit.*

73 *Ibid.*

74 William Norwich, 'Vogue Men', *Vogue* (June 1992).

75 Lavoignat, *op. cit.*

76 DVD bonus, *Arizona Dream*, Studio Canal, 2002.

77 Nigel Goodall, *The Secret World of Johnny Depp*, John Blake Publishing, 2007, p. 125.

78 For this scene, read Charles Tesson, 'Les Enchaînés', *Cahiers du cinéma* (October 1998), p. 16.

79 Murray Pomerance, *Johnny Depp Starts Here*, Rutgers University Press, 2005, p. 53.

80 Christophe d'Yvoire, 'Un Gitan en Amérique', *Studio Magazine* (January 1991).

81 DVD bonus, *Arizona Dream, op. cit.*

82 Lavoignat, *op. cit.*

83 DVD bonus, *Arizona Dream, op. cit.*

84 *Ibid.*

85 Shelley Levitt, 'Love and Depp', *People Magazine* (3 October 1994).

86 Jessamy Calkin, 'Dear Johnny', *Elle* (UK) (April 1994).

87 Janet Maslin, '*Arizona Dream*: Lunacy with Missing Minutes', *The New York Times* (7 June 1995).

88 Kevin Thomas, 'Dazzling *Arizona Dream* of Tragicomedy', *Los Angeles Times* (11 July 1995).

89 Robert Ebert, '*Arizona Dream*', *Chicago Sun-Times* (6 January 1995).

90 Susan Morgan, 'Depp Perception', *Harper's Bazaar* (May 1993).

91 Stephen Rebello, 'Interview: Johnny Depp', *Sky Magazine* (July 1993).

92 Goodall, *op. cit.*, p. 123.

93 F. P., '*Arizona Dream*', *Le Canard enchaîné* (6 January 1993).

94 Joël Magny, 'Kusturica en voyage d'affaires', *Cahiers du cinéma* (January 1993).

95 Emile Breton, 'Entretien avec Emir Kusturica : quand les poissons voleront', *Les Lettres françaises* (29 January 1993).

96 Kevin Cook, 'Interview with Johnny Depp', *Playboy* (January 1996).

97 Nicolas Saada, 'Entretien avec Jim Jarmusch', *Cahiers du cinéma* (January 1996).

98 J.-M. F., 'La Balade de l'homme mort', *Le Monde* (4 January 1996).

99 Jessamy Calkin, 'Johnny Depp ESQ', *Esquire* (February 2000).

100 Rita Kempley, '*Nick of Time*: A Little Depp'll Do Ya', *The Washington Post* (22 November 1995).

101 Luc Moullet, *Politique des acteurs*, Cahiers du cinéma, 1993.

102 Holly Millea, 'Ghost in the Machine: Now You See Johnny Depp, Now You Don't', *Premiere* (UK) (February 1995).

103 *Ibid.*

104 Sean Mitchell, 'Accounting for His Image', *Newsday* (26 November 1995).

105 Francisco Ferreira, dossier *Dead Man*, Lycéens au cinéma, 2007.

106 Jim Jarmusch and Ludvig Hertzberg, *Jim Jarmusch, Interviews*, Roundhouse Publishing, 2001, p. 164.

107 Saada, *op. cit.*

108 Jonathan Rosenbaum, *Dead Man*, BFI Publishing, 2000, pp. 69-70.

109 Dana Shapiro, 'What Makes Johnny Famous?', *Icon* (June 1998).

110 *Ibid.*

111 Saada, *op. cit.*

112 Jarmusch, *op. cit.*, p. 149.

113 Rosenbaum, *op. cit.*, p. 21.

114 Roger Ebert, '*Dead Man*', *Chicago Sun-Times* (28 June 1996).

115 Stephen Holden, '*Dead Man*: Weirdos and Allegory in the Old West', *The New York Times* (10 May 1996).

116 C. B., 'Finalement, rien', *Le Figaro* (29 May 1995).

117 Jean-Pierre Léonardini, 'Un flop signé de Jim Jarmusch', *L'Humanité* (29 June 1995).

118 Vincent Tolédano, 'Jim Jarmusch s'englue dans l'Ouest sauvage', *Info Matin* (4 January 1996).

119 Jonathan Rosenbaum, 'Acid Western', *Chicago Reader* (27 June 1996).

120 Christophe d'Yvoire, 'Sur la piste des géants', *Studio Magazine* (March 1997).

121 Christopher Heard, *Depp*, ECW Press, 2001, p. 143.

122 Brendan Lemon, 'Johnny Depp', *Interview Magazine* (December 1995).

123 d'Yvoire, *op. cit.*

124 Heard, *op. cit.*, p. 146.

125 Martyn Palmer, 'Outsider on the A-List', *The London Times* (30 April 1997).

126 Kevin Sessums, *op. cit.*

127 Emmanuèle Frois, 'Johnny Depp: Je ne recommencerai plus!', *Le Figaro* (10 May 1997).

128 d'Yvoire, *op. cit.*

129 Jean-Louis Leutrat, '*The Brave*', *Les images honteuses*, Murielle Gagnebin (ed.), Champ Vallon, 2006.

130 Christophe d'Yvoire, 'My Way', *Studio Magazine* (January 1992).

131 Johnny Depp, 'Allen Ginsberg', *Interview Magazine* (June 1994).

132 Frois, *op. cit.*

133 Heard, *op. cit.*, p. 153.

134 *Ibid.*, p. 144.

135 Tom Shone, 'Johnny Depp Isn't Johnny Depp Anymore', *Talk Magazine* (October 1999).

136 *Ibid.*

137 Heard, *op. cit.*, p. 157.

138 *Ibid.*, p. 156.

139 Leutrat, *op. cit.*

140 Heard, *op. cit.*, p. 155.

141 Dana Shapiro, *op. cit.*

142 Jacques-André Bondy, 'Gonzo Interview', *Première (France)* (June 1998).

143 Douglas Brinkley, 'Johnny, Get Your Gun', *George* (June 1998).

144 Chris Heath, 'Johnny Depp's Savage Journey into *Fear and Loathing in Las Vegas*', *Rolling Stone* (11 June 1998).

145 *Ibid.*

146 *Ibid.*

147 Brinkley, *op. cit.*

148 Heath, *op. cit.*

149 *Ibid.*

150 François Forestier, 'Terry Gilliam hallucine', *Le Nouvel Observateur* (14 May 1998).

151 Elizabeth McCracken, 'Depp Charge', *Elle* (June 1998).

152 Heath, *op. cit.*

153 *Ibid.*

154 Nigel Goodall, *What's Eating Johnny Depp?* Blake Publishing, 2004.

155 Heath, *op. cit.*

156 *Ibid.*

157 McCracken, *op. cit.*

158 Heath, *op. cit.*

159 Bondy, *op. cit.*

160 Heath, *op. cit.*

161 McCracken, *op. cit.*

162 Libby Brooks, 'If I Could Morph My Face, That'd Be Great', *The Guardian* (11 January 2000).

163 Christine Haas and Alain Kruger, 'Sexy Depp', *Première* (July 1995).

164 Kent Jones, 'Le Parler franc de l'Amérique', *Cahiers du cinéma* (July-August 1998), p. 45.

165 Heath, *op. cit.*

166 McCracken, *op. cit.*

167 *France-soir* (16 May 1998).

168 *Le Canard Enchaîné* (9 August 1998).

169 Roger Ebert, '*Fear and Loathing in Las Vegas*', *Chicago Sun-Times* (22 May 1998).

170 Stephen Holden, 'A Devotedly Drug-Addled Rampage Through a 1971 Vision of Las Vegas', *The New York Times* (22 May 1998).

171 Laurent Rigoulet, '*Las Vegas Parano* complètement party', *Libération* (19 August 1998).

172 Jones, *op. cit.*, p. 45.

173 Heath, *op. cit.*

174 McCracken, *op. cit.*

175 Brooks, *op. cit.*

176 Sandra Benedetti, 'Johnny Depp, corsaire

Youpla Boum !', *Ciné Live* (July-August 2003).

177 Robb, *op. cit*, p. 171.

178 Smith, *op. cit.*

179 Chrissy Iley, 'I Felt Weirdness for Many Years', *The Guardian* (3 July 2006).

180 Emmanuèle Frois, 'Johnny Depp, toutes voiles dehors', *Le Figaro* (2 August 2006).

181 Sean Smith, 'Johnny Depp: Unlikely Superstar', *Newsweek* (June 2006).

182 Smith, *op. cit.*

183 Robb, *op. cit.*, p. 171.

184 Mark Binelli, 'The Last Buccaneer', *Rolling Stone* (13 July 2006).

185 Emmanuel Itier, 'Star Johnny Depp Lives a Pirates' Life Even Off Camera', *Magazine.com* (July 2006).

186 Philip Berk, 'Heartbeat Poet', *FilmInk Magazine* (August 2006).

187 Binelli, *op. cit.*

188 Smith, *op. cit.*

189 Aubrey Day, 'The End Is Nigh', *Total Film* (February 2007).

190 Stéphane Delorme, '*Pirates des Caraïbes* : le secret du coffre maudit', *Cahiers du cinéma* (September 2006).

191 Iley, *op. cit.*

192 Josh Rottenberg, 'Days of Plunder', *Entertainment Weekly* (18 May 2007).

193 Iley, *op. cit.*

194 D. F., '*Pirates des Caraïbes*', *Le Canard Enchaîné* (13 August 2003).

195 Smith, *op. cit.*

196 Rebecca Murray, 'Johnny Depp Talks About *Public Enemies*', *movie.about.com* (June 2009).

197 Audio commentary, DVD bonus, *Public Enemies*, Universal, 2009).

198 Rachel Abramowitz, 'Johnny Depp: An Outlaw Outlook', *Los Angeles Times* (28 June 2009).

199 Donna Walker-Mitchell, 'Smooth Criminal', *The Age* (24 July 2009).

200 Murray, *op. cit.*

201 Walker-Mitchell, *op. cit.*

202 *Ibid.*

203 John Patterson, '#1 with a Bullet', *The Guardian* (26 June 2009).

204 Abramowitz, *op. cit.*

205 John Hiscock, '*Public Enemies*', *The Telegraph* (25 June 2009).

206 Douglas Brinkley, 'Johnny Depp's Great Escape', *Vanity Fair* (July 2009).

207 Walker-Mitchell, *op. cit.*

208 Audio commentary, DVD bonus, *Public Enemies*, *op. cit.*

209 Robb, *op. cit*, p. 147.

210 Sophie Benamon, 'Où es-tu, Johnny Depp?' *L'Express* (12 August 2013).

211 Abramowitz, *op. cit.*

212 Steven Rybin, 'Style, Meaning and Myth in *Public Enemies*', *The Philosophy of Michael Mann*, Steven Sanders, Aeon J. Skoble and R. Barton Palmer (eds.), University Press of Kentucky, 2014, p. 111.

213 Hiscock, *op. cit.*

214 Steven Rybin, *Michael Mann: crime auteur*, Scarecrow Press, 2013, p. 243.

215 Jean-Baptiste Thoret, '*Public Enemies*', *Charlie Hebdo* (8 July 2009).

216 Philippe Azoury, 'Dillinger, l'ennemi ranimé', *Libération* (8 July 2009).

217 Todd McCarthy, '*Public Enemies*', *Variety* (24 June 2009).

218 Roger Ebert, '*Public Enemies*', *Chicago Sun-Times* (29 June 2009).

219 Mark Salisbury, '*Alice in Wonderland*', *The Telegraph* (15 February 2010).

220 Interview with Anne Hathaway, DVD bonus, *Alice in Wonderland*, Walt Disney, 2010).

221 Daly, *op. cit.*, p. 243.

222 DVD bonus, *Alice in Wonderland*, *op. cit.*

223 Salisbury, *op. cit.*

224 Salisbury (ed.), *op. cit.*, p. 230.

225 Interview with Stéphanie Belpêche and Carlos Gomez, 'Avec Johnny Depp, c'est toujours la première fois', *Le Journal du Dimanche* (21 March 2010).

226 Christophe Carrière, 'Tim Burton fait des merveilles', *L'Express* (25 March 2010).

227 Michel Pastoureau, *L'Étoffe du diable, une histoire des rayures et des tissus rayés*, Points histoire, 2007.

228 On the psychedelic aspect of Burton's films, see Franck Boulègue, 'Dead Man's Party', *Éclipses* (2010).

229 Waters, *op. cit.*

230 DVD bonus, *Alice in Wonderland*, *op. cit.*

231 Salisbury (ed.), *op. cit.*, p. 56.

232 Yann Calvet, 'Le Maître de marionnettes', *Éclipses* (2010).

233 *Ibid.*, p. 68.

234 Smith, *op. cit.*

235 *Ibid.*

236 Todd McCarthy, '*Alice in Wonderland*', *Variety* (25 February 2010).

237 Salisbury, *op. cit.*

238 Philippe Azoury, '*Alice au pays des merveilles*', *Libération* (24 March 2010).

239 Calvet, *op. cit.*

240 Salisbury (ed.), *op. cit.*, p. 123.

241 Antoine de Baecque, 'Un asile de fous', *Cahiers du cinéma* (April 2010).

242 JD, press release, Walt Disney (March 2010).

243 Antoine De Baecque, *Tim Burton*, Cahiers du cinéma (2010).

244 Manohla Dargis, 'What's a Nice Girl Doing in This Hole?' *The New York Times* (4 March 2010).

245 Roger Ebert, '*Alice in Wonderland*', *Chicago Sun-Times* (3 March 2010).

246 Owen Gleiberman, '*Alice in Wonderland*', *Entertainment Weekly* (3 March 2010).

247 O. B., '*Alice au pays des merveilles*', *Le Nouvel Observateur* (25 March 2010).

248 Gaffez, *op. cit.*

249 Interview for BBC London (26 July 2013).

250 Rebecca Ford, '*Lone Ranger* Filmmakers on Making a Western That Works', *The Hollywood Reporter* (17 April 2013).

251 Anthony Breznican, 'Johnny Depp Reveals Origins of Tonto Makeup from *The Lone Ranger*', *Entertainment Weekly* (22 April 2012).

252 Michael Singer, *The Lone Ranger: Behind the Mask: On the Trail of an Outlaw Epic*, Insight Editions, 2013, p. 152.

253 Breznican, *op. cit.*

254 *Ibid.*

255 *Ibid.*

256 Douglas Brinkley, 'Colonel Depp & the Rum Doctor Blues', *Aspen Peak* (Winter 2011).

257 Johnny Depp on *The Late Show with David Letterman*, CBS-TV (21 February 2013).

258 Singer, *op. cit.*, p. 54.

259 Felicia Fonseca, 'Disney's Tonto Offensive to Some in Upcoming *Lone Ranger* Film', *The Huffington Post* (12 May 2013).

260 Manuel Valdes, 'Native Americans Worried About Stereotypes in New *Lone Ranger* Film', *CBSnews.com* (25 July 2012).

261 Natanya Ann Pulley, 'An Open Letter to Johnny Depp's Tonto', *mcsweeneys.net* (4 December 2012).

262 *Ibid.*

263 Rod Pocowatchit, 'Will Depp's Portrayal of Tonto Add to Struggle Natives Face in Filmmaking?' *The Wichita Eagle* (27 May 2012).

264 Singer, *op. cit*, p. 42.

265 *Ibid.*, p. 154.

266 *Ibid.*, p. 152.

267 *Ibid.*, p. 154.

268 *Ibid.*, p. 75.

269 Patti Smith, *op. cit.*

270 *Screenslam.com* (14 February 2011).

271 Ford, *op. cit.*

272 Cal Fussman, 'The Continuing Adventures of Tim & Johnny', *Esquire* (January 2008).

273 Chris Wallace, 'Equal Status, Kemo Sabe', *The New York Times* (28 June 2013).

274 Wayne Baker, 'Cultural Competence: Is Johnny Depp's Portrayal of Tonto Offensive?' *The Ann Arbor News* (26 June 2013).

275 Matt Zoller Seitz, '*Lone Ranger*', *rogerebert.com* (3 July 2013).

276 Angie Errigo, '*The Lone Ranger*, Hi-Yo Fidelity', *Empire* (5 August 2013).

277 Steven Rea, 'Wild, Wacky *Lone Ranger* Is Epic Good Time', *The Inquirer* (3 July 2013).

278 Mark Hughes, '*The Lone Ranger* Is A Fun Summer Ride', *Forbes* (7 April 2013).

279 Noémie Luciani, '*Lone Ranger*', *Le Monde* (7 August 2013).

280 Cécile Mury, '*Lone Ranger*', *Télérama* (7 August 2013).

281 Daly, *op. cit.*

282 'Interview: Johnny Depp', *Yorkshire Post* (9 August 2013).

Sidebar Notes

a Decca Aitkenhead, 'Johnny Depp: "I'm Not Ready to Give Up My American Citizenship"', *The Guardian* (6 November 2011).

b *Ibid.*

c Bad taste is a sort of parallel culture to so-called high culture. It displays a side that is unsightly, unrefined, often gaudy, overblown, raucous and off the wall. Read, for example, Cal Fussman, 'The Continuing Adventures of Tim & Johnny', *Esquire* (January 2008).

d Emmanuel Cirodde, 'Don Quichotte et la traversée du désert', *Ciné Live* (July-August 2003).

e Logan Hill, 'Attend the Tale', *New York Magazine* (10 December 2007).

f Portia Medina, 'Danny Elfman Discusses Film Scoring, Getting Along with Tim Burton, Johnny Depp the Thief', *Billboard.com* (10 May 2012).

g Aitkenhead, *op. cit.*

Numbers in *italics* refer to illustrations.

A Nightmare on Elm Street 8, 8, 175, 179
Alice in Wonderland 14, 44, 53, 137, 142–9, 151–5, 176, 182
Allison, Lori Anne 8, 175
Arizona Dream 14, 46–59, 74, 80, 82, 86, 122, 175, 180
Atkins, David 47, 180
Attal, Yvan 171, 175, 181
Atwood, Colleen 32, 148, 179–80, 183
Avital, Mili 61, 67, 180
Badham, John 12, 62, 175, 180
Baecque, Antoine de 40, 151
Bale, Christian 125, 130, 131, 182
Ballard, Hank 24
Barrie, James Matthew 137, 150, 181
Basquiat, Jean-Michel 137
Before Night Falls 53, 175, 181
Benny and Joon 10–1, 14, 40, 61, 90, 98, 174, 175, 179
Bergen, Polly 26, 179
Blake, William 70–1
Bloom, Orlando 107, 118–9, 181–2
Blow 130, 175, 177, 181
Bonham Carter, Helena 143, 150–1, 163, 163, 181–3
Brando, Marlon 12, 17, 21, 28, 50, 76, 80, 81, 86, 96, 102, 104, 136, 175, 180
Brave (The) 14, 57, 78–82, 84–91, 122, 175, 180
Bregovic, Goran 50, 180
Browning, Tod 42, 58
Bruckheimer, Jerry 107, 157, 182–3
Burrough, Bryan 125, 182
Burton, Tim 7, 12, 14, 21, 28, 31–2, 37, 40, 42, 42, 43–4, 44, 47, 53, 58, 76, 82, 90, 96, 105, 112–3, 135, 137, 140, 143–4, 148, 150–1, 154, 155, 157, 175–6, 179–83

Cage, Nicolas 8, 175
Cagney, James 125, 140
Cannell, Stephen J. 8, 179, 183
Carroll, Lewis 137, 143–4, 148, 182
Chaney, Lon 40, 42, 102, 108
Chaplin, Charles 40, 49, 102, 108, 122
Charlie and the Chocolate Factory 42, 53, 90, 112, 137, 143–4, 148, 175, 181
Chechik, Jeremiah S. 14, 40, 175, 179
Clift, Montgomery 50
Cocteau, Jean 82, 122
Cooper, Gary 62
Coppola, Francis Ford 83, 96, 136, 180
Corpse Bride 7, 143, 175, 181
Costner, Kevin 80, 90
Cotillard, Marion 125, 132–3, 135, 182
Cox, Alex 93, 180
Craven, Wes 8, 175, 179
Crook, Mackenzie 108, 181–2
Cruise, Tom 8, 26, 31, 58, 83, 125
Cruz, Penélope 107, 181, 183
Cry-Baby 14, 16–28, 31, 57, 93, 96, 126, 175, 179
Curtis, Edward S. 73
Dahl, Roald 137, 181
Dances with Wolves 80, 90
Dark Shadows 150, 154, 157, 167, 176, 177, 183
De Niro, Robert 50, 53, 86, 125, 130
Dead Man 14, 60–77, 79–80, 82, 86, 96, 98, 122, 143, 164, 171, 175, 180
Dean, James 17–8, 21, 28, 40, 171, 175
Deep Sea 171, 175
Del Toro, Benicio 93, 97–8, 100–1, 102, 180
Dembrowski, Christi 137, 183
Demme, Ted 130, 175, 181
Depp, Johnny
 Blackmar, Axel 14, 46–59, 70, 175, 180

Blake, William 14, 60–77, 79, 122, 171, 180
Cry-Baby 16–28, 43, 126, 179
Dillinger, John 14, 124–36, 138–41, 182
Duke, Raoul 14, 92–103, 105, 163, 175, 180
Hanson, Tom 8, 9, 57, 175, 179, 183
Mad Hatter 14, 44, 53, 142–9, 151–5, 163, 182
Raphael 78–82, 84–91, 180
Scissorhands, Edward 21, 30–45, 49, 70, 80, 122, 135, 144, 148, 158, 171, 176, 183
Sparrow, Jack 80, 106–12, 114–23, 125–6, 130, 136, 144, 148, 151, 157–8, 163, 175, 181–3
Tonto 14, 86, 156–61, 163–9, 176, 183
Wood, Ed 15, 37, 42, 53, 53, 96, 102, 122, 143, 151, 154, 163, 180
DiCaprio, Leonardo 125, 180
Dillinger, John 14, 125–6, 130, 135–6, 140, 182
Di Novi, Denise 40, 179–80
Diving Bell and the Butterfly (The) 83
Don Juan DeMarco 53, 76, 80, 174, 175, 180
Donnie Brasco 14, 76, 93, 175, 180
Dugan, Dennis 171, 176, 182
Dunaway, Faye 47, 50, 54–5, 56, 57, 82, 130, 180
Dunmore, Laurence 112, 175, 182
Dylan, Bob 104, 137
Eastwood, Clint 112, 167
Ed Wood 14, 15, 42, 42, 53, 53, 61, 76, 90, 96, 102, 108, 122, 143, 148, 175, 180
Edward Scissorhands 14, 30–45, 47, 50, 53, 57, 98, 122, 143–4, 148, 162, 175, 179

Elfman, Danny 37, 150, 179–83
Elliott, Ted 122, 181–3
Fairbanks, Douglas 123, 130
Family Guy 43, 171, 176, 183
Farmer, Gary 61, 68–9, 70–1, 72, 73, 75, 180
Fear and Loathing in Las Vegas 14, 74, 92–103, 105, 108, 137, 175, 180
Finding Neverland 137, 144, 162, 175, 177, 181
Flynn, Errol 24, 42, 44, 108, 123
Ford, John 62, 167
Forster, Marc 137, 144, 175, 181
From Hell 12, 74, 126, 174, 175, 181
Frusciante, John 80, 175
Gable, Clark 135–6, 140
Gaffez, Fabien 12, 40, 154
Gainsbourg, Charlotte 171, 181
Gallo, Vincent 47, 48, 49–50, 57–8, 180
General (The) 112, 164
Gibney, Alex 171, 176
Gilliam, Terry 12, 83, 83, 90, 93–4, 94, 96, 98, 102, 175–6, 180, 182
Ginsberg, Allen 137
Gish, Lillian 40
Glover, Crispin 143, 180, 182
Gonzo: The Life and Work of Dr Hunter S. Thompson 171, 176
Grant, Cary 50
Grazer, Brian 17, 179
Griffiths, Megan 176, 183
Hall, Howard 171, 175
Hallström, Lasse 7, 175, 180–1
Hammer, Armie 157, 159–61, 163, 164, 166, 168–9, 183
Happily Ever After 171, 175, 181
Harlow, Joel 157–8
Hathaway, Anne 143–4, 182
Hedges, Peter 90, 179

Hitchcock, Alfred 50
House of Earth 137
Hulk 83
Hurt, John 61–2, 180
Imaginarium of Doctor Parnassus (The) 12, 176, 182
In the Land of Head Hunters 73
Ingres, Jean-Auguste-Dominique 148
Interview with the Vampire 83
Into the Woods 169, 176, 183
Intrusion 12, 175
Invisible Man (The) 96, 126
Irving, Washington 137, 180
Jackson, Michael 24
Jailhouse Rock 24
Jarmusch, Jim 61, 67, 70, 73, 76, 79, 82, 164, 175, 180
Jenco, Sal 7
Kasem, Casey 42
Kaurismäki, Mika 171, 180
Keane, Walter 40
Keaton, Buster 40, 62, 74, 108, 112, 164, 167
Kerouac, Jack 7, 47, 104, 137
Kid (The) 49
Kids (The) 7, 8, 113, 175
King of the Hill 171, 175, 181
Knightley, Keira 107, *109–11*, 181–2
Koepp, David 137, 175–6, 181, 183
Kubrick, Stanley 148
Kusturica, Emir 47, 49–50, 52, 56, 57–8, 76, 79, 82, 90, 175, 180
L.A. Without a Map 171, 180
Landau, Martin 15, 130, 180
Ledger, Heath 12, 182
Lee, Christopher 143, 181–2
Legends of the Fall 83
Leone, Sergio 167
Leutrat, Jean-Louis 80
Leven, Jeremy 53, 76, 175, 180
Lewis, Jerry 47, 49, 49–50, 52, 180
Libertine (The) 112, 175, 182
Little Big Man 158
Locane, Amy 17, *19–20*, 26, *26*, 179
Lone Ranger (The) 14, 156–61, 163–9, 176, 183
Lord of the Rings (The) 143
Lords, Traci 19, 26
Lorre, Peter 42
Lost in La Mancha 83
Loy, Myrna 136
Lucky Them 176, 183
Lugosi, Bela 42, 44, 50, 180
MacGowan, Shane 108, 175

Maguire, Tobey 97–8, 180
Man Who Killed Don Quixote (The) 83, *83*, 175
Manhattan Melodrama 135
Mann, Michael 90, 125–6, 128–9, 130, 135, *135–6*, 140, 176, 182
Manson, Marilyn 113, 144
Marshall, Rob 107, 169, 176, 183
Marx, Groucho 148
Matthau, Walter 108
McCarthy, Todd 140, 148
McDonald, Gregory 79, 180
McGregor, Ewan 98, 183
Melville, Jean-Pierre 140
Michaux, Henri 74
Mitchum, Robert 28, 61–2, 66, 130, 180
Moitessier, Bernard 107
Molina, Alfred 67, 73, 181, 183
Monroe, Marilyn 53
Mortdecai 176, 183
Müller, Robby 61, 73, 180
Murray, Bill 105, 180
Nathanson, Jeff 122
Newell, Mike 14, 76, 175, 180
Nick of Time 12, 62, 76, 175, 180
Ninth Gate (The) 13, 14, 67, 74, 105, 130, 135, 137, 178, 180
Oates, Warren 125
Oldman, Gary 58
Orphée 82
Ossard, Claudie 57, 180
Osterberg Jr, James Newell (a.k.a. Iggy Pop) 7, 20, 26, 61, 64–5, 79, 86, 113, 180
Pacino, Al 50, 86, 125, 130, 136, 171, 175, 180, 182
Paradis, Vanessa 29, *29*, 113, 175–6
Parker, Sarah Jessica 42, 53, 180
Peckinpah, Sam 167
Pecorini, Nicola 98, 180, 182
Penn, Arthur 158
Perkins, Anthony 62
Perkins, Carl 24
Pfister, Wally 12, 154, 167, 176, 183
Philipe, Gérard 123
Phoenix, River 58
Pirates 108
Pirates of the Caribbean 14, 74, 90, 106–12, 114–23, 130, 140, 143, 148, 154, 157–8, 162, 164, 169, 175–6, 181–3
Pistone, Joseph. D. 175, 180

Pitt, Brad 58, 83
Platoon 8, 175, 179
Point Break 83
Pogues (The) 108, 113
Polanski, Roman 14, 67, 105, 108, 135, 137, 180
Porter, Edwin S. 70
Presley, Elvis 21, 24, 26
Price, Vincent 31, 43–4, *44*, 179
Private Resort 8, 179
Public Enemies 14, 124–36, 138–41, 143, 176, 182
Pulp Fiction 83
Pyle, Howard 107
Rackham, Arthur 144
Ravich, Rand 12, 175, 180
Ray, Nicholas 17
Rebel Without a Cause 17, 21
Reeves, Keanu 28, 58, 83, 93
Ricci, Christina 98, 180–1
Richards, Keith 12, 108, 117–82–3
Rickman, Alan 143, 182
Riley, Billy Lee 24
Robin Hood 83
Robinson, Bruce 154, 157, 176, 183
Rolling Stones (The) 96, 108
Rose, Penny 163
Rosenbaum, Jonathan 74, 76
Rossio, Terry 122, 181–3
Roth, Tim 83
Rum Diary (The) 137, 154, 157, 167, 176, *177*, 183
Rush, Geoffrey 107, *109*, 181–3
Ryder, Winona 29, 31, 37, 43, *43*, 58, 175, 179
Salinger, Jerome David 49, 137
Saroyan, William 82
Sattler, Kirby 157
Schnabel, Julian 53, 83, 175, 181
Schwarzenegger, Arnold 57
Secret Window 137, 175, *178*, 181
Filac, Vilko 57, 79, 82, 180
Shakespeare, William 12
Shaw, Artie 130
Sheen, Martin 96
Slater, Christian 83
Sleepy Hollow 12, 14, 42, 53, 67, 74, 94, 105, 137, *137*, 143, 151, 175, 180
Smith, Patti 116, 148
Smith, Robert 32
Sondheim, Stephen 150, 182–3
Speed 83
SpongeBob SquarePants 171, 176, 182

Stevenson, Robert Louis 107
Stewart, James 62
Stone, Oliver 8, 175, 179
Swayze, Patrick 83
Sweeney Todd: The Demon Barber of Fleet Street 12, 113, 130, 143, 150, *150*, 162, 172–3, 175, 182
Talking Heads 8
Taylor, Lili 47, 57, 180
Thelma and Louise 83
Thompson, Caroline 31, 179, 181
Thompson, Hunter S. 12, 93–4, 96, 98, 102, 104, *104*, 105, 130, 137, 154, 175, 180, 183
Thunderheart 90
Tierney, Gene 18
Tierney, Lawrence 125
Time of the Gypsies 47
Time of Your Life (The) 82
Tolstoy, Leo 137
Top Secret 171, 175
Transcendence 12, 154, 167, 176, *178*, 183
Treasure Island 107
21 Jump Street 7, 8, 9, 17, 28–9, 31, 47, 57, 122, 174, 175–6, 179, 183
Tyrrell, Susan 20, 26, 179
Under the Black Flag 107
Unraveled Tales of Bob Dylan (The) 137
Van Dyke, W.S. 135
Veidt, Conrad 40
Verbinski, Gore 107, 112, 135, 157–8, 164, 167, 175–6, 181–3
Vicar of Dibley (The) 171, 181
Wasikowska, Mia 143, *145*, 146–7, 149, *151*, 182
Waters, John 14, 17–8, 21, 24, 26, 28, *28*, 42, 44, 58, 76, 82, 108, 175, 179
Wayne Gacy, John 144
Welch, Raquel 18
Welles, Orson 62
West Side Story 17
Westerman, Floyd 'Red Crow' 80, 180
Whale, James 96, 126
What's Eating Gilbert Grape 7, 12, *13*, 14, 61, 82, 90, 143, 150, 175, 179
When You're Strange 7
Wiest, Dianne 31, 33, 179
Winston, Stan 32
York, Patty 148
Young, Neil 180
Zimmer, Hans 108, 116, 182–3